ROBIN RHODE WALK OFF

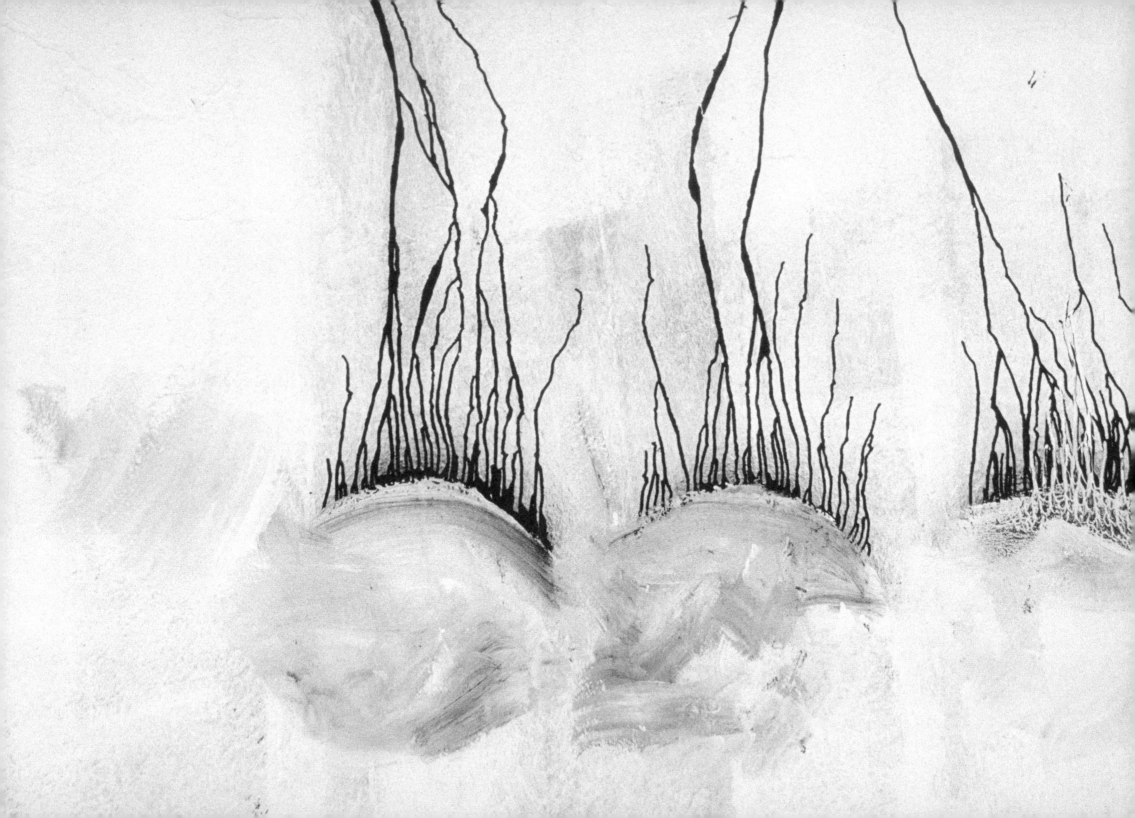

WALK OFF
ROBIN RHODE

Edited by

Stephanie Rosenthal

with contributions by

Thomas Boutoux

and

André Lepecki

HATJE CANTZ

CONTENTS

STEPHANIE ROSENTHAL

Walk Off

"In baseball, a walk-off home run is a home run which ends the game. It must be a home run that gives the home team the lead in the bottom of the final inning of the game.... It is called a 'walk-off' home run because the teams walk off the field immediately afterward."[1]

It was Robin Rhode himself who first used the term "walk off" for his work: "It's a point which reflects the dimensionality created by the drawing and the interaction, if any exists, between what is real and what is not."[2] In his eyes the last picture in a series of movements, or the last line made in a drawing—establishes the tone for the work in question. This is the walk off, the moment when Rhode leaves the field and hands the work over to the viewer. And the work will only come into its own if the walk off is right. The aim is always to make that final mark without destroying the magic of the work.

Extrapolating from this, I would like to apply this term to Rhode's work as a whole and to suggest that while he achieves the walk-off home run within individual series, at the same time—as his works confirm—it is hard to secure this kind of victory in a world that is primarily a world of appearances and, hence, of unfulfilled dreams. I would further suggest that Rhode's awareness of this fact prompts him to undermine the authority of these appearances and dreams and to play with them. The outcome is a form of art that presents life as a game, that is played for its own sake and not for the end result. "Sometimes if you have nothing, you actually have everything":[3] here Rhode in effect articulates his childlike trust in the capacity of the human imagination to create valid realities.

Born in Cape Town in 1976, Rhode moved to Johannesburg in 1984, where he studied art from 1995 to 1998, and film later on. Since 2002 he has lived mainly in Berlin, but Johannesburg still remains the main inspiration of his creativity. The city is both a stage and the screen for his works.

Rhode's works often show one or two people as the protagonists of small-scale actions or events with an identifiable time sequence, and they only create the illusion of being real processes by virtue of the fact that the rest of the image sketches in a background in the shape of a wall or (in photographic images of actions performed lying down) a piece of floor or ground in some public space. The root and ever-new point of departure for his work is drawing, in the (German) sense of setting signs in space [*Zeichnung* and *Zeichen*], making marks, with the body laying down spatial markers (his choreography), but also as the reality of a drawing on the floor, on a wall, on paper. Drawing always stands for itself, but it is also is (or represents) a counterpart—for or against—in his per-formances. Rhode uses drawing to temporarily appropriate an external surface, be it a section of wall, a basketball shot, or a river bed. The protagonist is the human body—his own and/or, since about 1999, someone else's. Ever present is the notion of an exploration into the relationship of one's own body with the space it occupies.

The Beginnings—Impromptu Art

Influenced by the performance art of the 1960s and 1970s, in 1997 Rhode started to interact with the chalk drawings of objects he was making on walls and floors. Then, as now, his performances were often spontaneous actions that just happened, that started with no more than his own person and a piece of chalk. He draws his inspiration from urban life and the media. The immediate trigger for a work can be a wall, a newspaper article, or a particular experience: "I gather information where I can: books, newspapers, comics, photography, literature, films, anything that can be linked to a narrative I have in my mind's eye. It could be anything and

everything. I scribble some ideas on sheets of paper, read books, look at pictures, check the sports, then find a way to realize the ideas. Or I just find a wall and make a drawing without getting arrested."[4]

In the early days his actions happened without an audience. As such they could not necessarily be categorized as art, although there were always chance viewers who inevitably also became participants. "I started performing live by chance. My work at that time existed as video documentation of performances. I just decided to perform in front of an audience to test the reaction. At that point I began to understand the potency of the live act and its communicative power."[5]

The works, characterized by the playful, light, yet serious tone that typifies children's play, are also intrinsically precise. Allan Kaprow importantly paved the way for this particular approach to art and life. Kaprow was one of the first to go out into public spaces and present ordinary activities—like collecting trash—as Happenings.

Photographic Series and Animations

In 1998 Rhode started to use photography to record his performances; that same year he also started to animate them and to present them as video projections: "I stumbled onto photography while studying film in Johannesburg. I was already an active artist, ironically without an income and decided to attain more knowledge by enrolling into the film school. It was while studying and majoring in production design that I became fascinated with storyboards.""[6] With this comment Rhode positions himself in the tradition of performance artists such as Vito Acconci, Valie Export, and Bruce Nauman. Like Allan Kaprow, their photographs are not the outcome of chance and, in fact, could not be more precisely composed. The effort Rhode makes to find the correct angle for the camera and to choose the right clothing for the setting shows that the role of chance in his photographs is very carefully planned. Rhode's "stage sets" look entirely arbitrary at first sight, in striking contrast to the meticulousness of the dramaturgy and composition of the image.

In 1998 he made *Classic Bike* (pp. 38–39): a chalk drawing of a bicycle on a wall and a figure whose face is always hidden from sight, who wears jeans, blue sneakers, a medium-blue tracksuit top with a white stripe, and a red hat with a blue-and-green diamond pattern running around it. Like a storyboard or the classic stop-motion technique used in animated films, the photographs show different stages in a sequence of movements. The figure raises one leg, hoping to get onto the bicycle, leans forward, takes hold of the front wheel, crouches down and checks the chain, bends his knees, and tries to push the bicycle away. The figure takes the drawing seriously, apparently believing that he could take the bike and ride away on it.

Bicycles have often featured in Rhode's work as an object of childish desire. "I became inspired by a specific experience or ritual in high school—a type of initiation rite whereby young pupils were forcefully taken into the boy's toilets by the senior pupils. Chalk was stolen from the classroom and the senior boys would draw elementary objects, such as candles and bicycles, directly onto the walls of the toilets. The younger pupil was then forced to interact with the drawn object, either trying to blow out the candle or to ride the bicycle.... But I also found the bicycle interesting since I had never seen a pupil arrive at school by bike. So I thought that maybe the bike drawn on the toilet wall reflected the dimension of desire, of almost attaining that freedom, that sense of ownership."[7] And chalk, in his eyes, is a means of expression used by pupils whose timetables did not include art lessons.

The individual images make up a coherent progression of events; in other words they are part of the same time sequence and call to mind the early photographs of Eadweard Muybridge that analyzed motion in humans and animals. In Rhode's animation *Street Gym* (2004, pp. 102–3), the conceit is that he is a gymnast on a high bar performing a perfect backflip off the bar and finishing in an outstretched standing position. In fact, he has defied gravity by drawing the high bar on the ground in the street and being photographed from above as he lay down in the nine different positions. His engagement with street culture is typical of this phase of his work.

Both in terms of pictorial composition and content, color is crucial to Rhode's work. He very actively addresses this theme in his work *Color Chart* (2004–6, pp. 108–9), which exists both as an animation and as a 192-part photographic series. In this case there is no sign of drawing and color has taken center stage. A figure dressed entirely in white and carrying a white board successively joins combat with other figures dressed in a whole variety of colors. The opponents that White engages with are Black, Khaki, Red, Green, Yellow, Medium Blue, until ultimately White fights White. The figures come armed with a whole range of weapons: a spade, a bucket—but it is always the white combatant that opens his attack with a brick and fells his opponent. In the end, White is overcome.

My initial idea was to circumvent post-modernist ideas around painting, especially with regards to color.... the idea of "color" has a profound relation to the history of South Africa. The word "color" or "colored" spoke of marginalization and peripheries, of identities formed through segregation. My "color chart" also references the period of Richter's realization of his "color charts," the late 60s and early 70s. During this period in South African history the country was plagued with violence and political unrest, a stark contrast to Richter's cold, systematic and calculated realisation of these paintings. My "color chart" speaks of violence and turmoil with "colors" seemingly fighting to retain a mark on the canvas, in the case of my "color chart," a character dressed in a white canvas jumpsuit resists the charge of the "color characters" by throwing stones or bricks at them. The formal characteristics of the work are undermined by the violent imagery that still remains at a distance on the two dimensional surface.[8]

Shadows of Objects

One of the main forces that drives Robin Rhode's art is the notion of human desire, yearning, longing, self-projection. And the objects of desire are the bicycle, sporting prowess on the high bar, with a basketball, or on a skateboard. The bicycle is not the vehicle but rather the longing for a bicycle. Instead of yielding to the impulse to acquire a bicycle, Rhode plays with this sense of longing. And he allows the bike to take him into the reality of art: he replaces the reality of longing with a different reality in which he casts himself as the creator.

The drawings neither create the illusion of an objective world nor do they stand for the objects in question but rather for the "idea," which—according to Plato—is actual reality. In the spirit of Plato's doctrine of ideas, it could be said that the viewer takes what Rhode has drawn, idealizes it in his or her mind, and recognizes it as true reality. By contrast, the mere sensory world of those same objects is just a shadow. In his metaphor of the cave, Plato shows that the things that human beings perceive as real are in truth only shadows and likenesses of the truly being. The cave stands for the world as it is perceived by human senses, for the ascent toward light of the human being, for the path of the soul upward, toward recognition of the actual center of beingness: the Goodness that is represented in Plato's writings by the sun. Rhode also exhorts his fellow humans not to allow their minds to cling merely to what their senses can perceive but, to open their intellects to new possibilities, to take a playfully creative approach to reality, and to identify longings as exactly that—rather than identifying with them.

At issue here is not the simple fulfilling of certain longings, but rather Rhode's conviction that it is possible for human beings to create a new reality. He pits this reality against the notion of longing and in so doing, he resolves it. For Rhode is determined to smoke the pipe painted by René Magritte who then chose to add—like the ultimate spoilsport—that in fact it was not a pipe.

City as Canvas and Stage

In all Rhode's outdoor works, walls and the ground are never just a neutral background. They always contribute something of their own history, conditions, inherent structures, and colors. As such, they form an important part of the composition and can be a source of inspiration for the drawing: cracks in the finish, moss, dirty and not-so-dirty areas, uneven top and bottom edges to walls (broken bricks or irregular wooden beams in the roof above), holes in the ground, and here and there, the shadows of clotheslines or electric cables. All these are signs of the time or the light that temporarily join forces in Rhode's drawings.

Particularly at the outset of his career, Rhode often chose the same wall or piece of ground as his background. Above all, Johannesburg is the city whose codes Rhode knows, recognizes, and can interpret: "It must be the familiarity of the context and a deep understanding of the inherent subcultural language that strikes a place as home. The context also allows me to engage with an aesthetic language that is unique and varied, mystical and relational, that one needs to be quick to catch."[9] In Johannesburg it was the backyard of his parental home (as in *New Kids on the Bike*, 2002, pp. 100–101, and *Stone Flag*, 2004, pp. 64–65) and a wall in a particular public space that served as his canvas for some years (see *White Walls*, 2002, pp. 98–99; *Table of Contents*, 2006, pp. 80–81). However, in 2006 the graffiti artists of Johannesburg chose precisely this wall as the site for their own creative rivalry. Rhode was unable to persuade them of the importance of his own drawings, which they regarded as substandard, and he had to relinquish the wall as his sole preserve.

Berlin affects him rather differently. The city, but also the German language, is much less familiar to him and this sense of being in an alien situation means he can use the city as a neutral zone that gives him the freedom to develop new ideas: "In Berlin I lost the accessibility of unclaimed space and the 'readymade' audience, rather than the (overly) informed audience of Berlin. I do appreciate very much the effects of art and culture on/in society as I can't even begin to unravel the

Smudger

1.

smudge, *n.*

1. a. A dirty mark or stain, esp. such as is caused by a smear or by trying to rub out a previous mark.

2. a. A smeary condition, substance, etc.; the result of smearing or dirtying.

2. b. *techn.* The scum of paint.

4. a. A photograph, *esp.* one taken by a street or press photographer.

—excerpted from the OXFORD ENGLISH DICTIONARY

An event, as documented by video operator Paul Druecke, on July 15, 2004, outside and inside Houston's Contemporary Arts Museum, at an unregistered time during the museum's normal business hours:

It was documented that a young man of light brown complexion, wearing casual light gray clothes, walked briskly up Montrose Boulevard, as he headed south toward Bissonnet Street. Approaching the museum's main building—located at the intersection of the streets just mentioned—he was videoed jumping into the circular water fountain placed within museum property along Montrose Boulevard. It was also recorded that, just a few moments before the jump, an ambulance had dashed through the traffic intersection with sirens blasting, leaving in the air traces of an anonymous yet pervasive state of emergency. It is not possible to determine at this point the relevance of this fact, as it may or may not relate to the unfolding of the young man's actions. What is certain is that the young man was videoed immersing himself completely in the water, fully dressed, red hood on his head. A passerby can be seen photographing this odd behavior. The man splashed and floated on the water for about a minute, stepped out of the fountain, and ran toward the museum's front door. The camera recorded how he burst into the main gallery, and moved about quickly, shoving a few patrons aside, disappearing behind partitions, panels, and sculptures, as if looking for something. Oddly, only a few in the small crowd seemed to notice the man's presence as he entered the museum, even though his distinct demeanor, his being followed by a video operator, and his soaking-wet garments and shoes made him an unusual presence. Dashing through the main gallery in circuitous manner, he left significant amounts of water tracks on the wood floor. It can be perceived by the camera's motions how the video

2.

In several of his performances, Robin Rhode uses a strategy similar to the one just described: he shows up at a time when the gallery or museum is filled with members of the public, pushes his way into the crowd with the directness of a fighter, or maybe of a burglar, performs an action usually around the creation of a drawing or a painting on an empty wall, and then leaves. Get in, do the job, get out. Fast—since no one ever knows what the future may bring.

There is a formal and direct relationship between the particular qualities of Rhode's way of moving his body in performance and the qualities of his personal way of drawing a line. And, given that not too long ago Rhode articulated the correspondence between his drawings and his performances by stating that his work at large "essentially exists as drawing,"[1] it may be important to summarize what these related qualities of moving and drawing are: fluidity, sharpness, precision, amplitude, focus, quickness, and directness. If for Rhode, "ultimately, the performance exists as a kind of drawing study,"[2] then what feeds the correspondence between these distinct art forms—what intensifies both to their maximum amplitude, like a composite sound—is Rhode's precise, clear, fluid, exact line. And then, the smudging of that line.

Smudging performatively opens a temporal vector toward a future time that is indeterminate. Thus, in Rhode's work, the centrality of the act of smudging a line derives not only from a desire to index a certain precarious condition of the image, but also from a need to create an antirepresentational technique, a politics of art-making under the threat of an imminent danger. Smudge is the technique of choice for whatever can be marked as exceeding the proper boundaries of representation, as all that can be called "the scum of paint."

It is by embracing the scum of paint through public art performances that Rhode recuperates some main tropes of action painting only to deeply (and ironically) subvert them. Not surprisingly, Rhode's subversion of the heroics of action

operator followed the man as effectively as possible, also negotiating the small crowd, trying to keep the man in frame, even as he cut corners and disappeared for moments behind large art works, walls, and doors marked "staff only." When the man was out of sight, the video operator managed to keep track of his route by following the water footprints left by him. At a certain point, we can see some patrons looking sincerely puzzled, particularly two ladies who got slightly wet as the young man, in his hurry, brushed against them. After a couple of minutes of this aimless race, still dripping water, the man stopped before a large white wall, quickly crouched before it, and immediately proceeded to draw the outlines of a car—a figure that, when completed, occupied the entire length of the wall. Because the chalk mixed with the dirt on his hands, it marked the wall with a very light gray. The red-hooded man completed his car in less than thirty seconds, an almost white-on-white drawing, executed with the urgency and clarity of a skilled street graffiti artist. Then, standing by one of the wall's corners, the man placed his hands on the car's rear and tried to push it. As his dirty, wet hands slid on the smooth surface of the white wall, they passed over the chalk lines, smearing the wall with darker tones of gray and black in a mix of handprints, fingerprints, and smudged chalk lines. It was recorded that the man slid a couple of times on his own weight and fell as he kept trying to push his drawing. Each push made the outlines of the car become more and more abstract, blotched, formless, while the floor under the man got increasingly wet, the man's efforts grew more intense, the crowd became more and more present, more attentive. The man went to the wall's opposite edge and tried to push the car from that end. More smudging. After about a minute and a half of attempting to move the immovable, the young man gave up and quickly left the scene. The video operator was not as quick as his subject, but the videotape does catch a glimpse of the young man running at a distance through the museum's main gallery. The documentation ends with the camera tracking the man's footprints (already drying out) to a back door going to a small, tree-lined backyard. A bird can be heard chirping as the camera pans around this confined area and finds no signs whatsoever of the drenched young man with red hood and chalky hands.

Total registered time of the documented event, from the man's falling into the water fountain, to his bursting into the gallery, to his making the drawing, pushing it from one side, smudging it, and then leaving without ever turning back: 5 minutes and 18 seconds.

painting happens through a process of conscious politicization of those traits, that art history tends to confine to the realm of the purely formal. With Rhode, racial, social, class, and geopolitical elements take central role in a critical reworking of the nature and use value of materials, of supports, and of actions in the making of art. Still considering his performance at Houston's Contemporary Arts Museum, it is essential that the artist enters the museum totally drenched and dripping with water. His body becomes the brush; the museum's pristine floor is the unprimed canvas. He expands the potential range of supports for his drawing not only to unmarked vertical surfaces, but to a ground that is politically and economically charged—and not necessarily supportive

Perhaps this is why Rhode has captured the quality of how movement affects his line, and why he has used for this expression all sorts of unconventional supports—especially tarmac and asphalt, cement and brick walls. Whether drawing on the outer walls of the House of Parliament in Cape Town (*Park Bench*, 2000), on the pavement of some Cape Town street (*He Got Game*, 2000, pp. 40–41; *Street Gym*, 2004, pp. 102–3), or on the inner walls of an old water reservoir in Las Palmas [*Untitled (Landing)*, 2005, pp. 72–73]; whether drawing on empty white walls at the Walker Art Center (*Car Theft*, 2003, pp. 118–19; *Car Wash*, 2003, pp. 116–17), or at Houston's CAM [*Untitled (Exit/Entry)*, 2004, pp. 122–23] or at the Perry Rubenstein Gallery in New York (*Night Caller*, 2004), Rhode not only decides how to draw his lines (a question of style), but also where to place his lines and his art (a question of ethics), transforming his drawings and performances into studious enactments of a politics of place.

Place has always informed Rhode's work. As he explained, "initially, I took a more political position, performing in the public realm in South Africa so as to reach out to an audience who had little or no contact with contemporary art. I am still motivated in realizing art as a need."[3] From this moment on, the urban landscape becomes an immediate partner, or "a form of thought process"[4] as Rhode has put it—a process that, in his case, appears as a fine mapping of those forces shaping the plundered terrain he chooses to create his art on: a terrain that, as native soil,

was tainted by a long history of colonial violence and racist violations, a history whose direct impact Rhode's pale skin color could not have spared him from experiencing first hand. Not by chance, in many of his performances (*Night Caller*, 2004) Rhode appears wearing a blue sports jacket with the initials W. P. S. S. S. U. (Western Province Senior Schools Sport Union), an organization prominent for its history of anti-apartheid initiatives and actions.

There is another element) that transpires from Rhode's drawings—of cars, or for his *Untitled (Microphone)* (2005, pp. 136–37) or *The Shower*, 2004—and from his performances. This is the subtle yet well-defined and pervasive temporality (arising mainly from his gestures' exactness, speed, and sharp focus) that could be described as an urgency, even a sense of danger—as if Rhode's speed kept reminding us that something not necessarily pleasant could be about to happen, may perhaps even be happening already. This sense of impending danger generates a temporal paradox that traverses the experiencing of Rhode's work at large. This paradox can be described as a rare mix of the (apparently) quasi-impulsive way he approaches walls to quickly compose his drawings (the way he dashes in and out of the galleries and museums) with the contemplative, almost endless time that erupts from his drawings, endless time as the instant's content. The result is the odd mix of high physical energy and an almost melancholy effect that pervades his work [particularly in his more recent pieces: the touching *Color Chart* (2004–6, pp. 108–9), the danced *The Storyteller* (pp. 138–39), and the amazingly filmic *Candle* (pp. 140–41), both from 2006]. But if one considers for a moment life in colonized contexts, life under the rule of institutionalized racist laws, it becomes clear that there is almost a survival imperative to dominate this paradoxical time in order to keep on living in such places—places where historically the exercise of contemplation by the subaltern was perceived by colonialist powers as proof of native endemic idleness, and where the subaltern's active, agile, and imaginative engagement with the world was cast as the manifestation of a dangerous, rebellious—if not plainly criminal—character. This is why Rhode, in the same interview to Bellini, has to clarify: "In order to survive in the world you have to develop a particular

strategy and psychology."[5] In Rhode's case, this strategy takes the form of producing a temporality that simultaneously places his work in the past (thus the importance of perennial markings, like water tracks slowly evaporating on Houston's CAM floor; thus the crucial task of smudging his own drawings), makes it interpellate the present (thus the intensity of his live presence in performance), while producing a plurality of futures (thus the mix of contemplation and anticipation happening at the infinite speed of thought). The point is to displace time, "locating the work beyond past, present and future."[6] The point is particularly to displace the present as stable referent. This is why even when Rhode steps into museums and galleries to quickly engage in a clear action (drawing, painting, erasing, smudging), it's as if his demeanor and sense of urgency purposefully displaced the eventfulness of the event away from any material objecthood, away from his corporeal presence, even away from his drawings and smudges, in order to redirect the whole eventfulness of the event directly toward the sensation that something indefinable "is about to happen." The creation of a pervasive yet indefinable awareness that "something is about to happen" would be the real event of Rhode's events. It's almost as if Rhode prepares the gallery space for a crime that is about to take place. If the gallery is a scene where Rhode performs, this scene is not really dissimilar to a crime scene.

3.

In a short essay on the relationship between the temporality of the artwork and the globalization of the "monstrosity" (das Ungeheure) constitutive of our late modernity, Peter Sloterdijk reminds us that to live in late modernity is to live in a permanent and all encompassing, "crime scene."[7] For the German philosopher, the methodical transformation of the planet into a globalized crime scene—a transformation Sloterdijk sees as a direct effect of "the Eurocentric era of 1492–1945"[8]—is a result of the concerted acts of "human agents, entrepreneurs, technicians, artists and consumers."[9] The creation of the same (crime) scene as place of choice for our living discloses modern subjectivity as "the renouncing of the possibility of having an alibi."[10]

If Sloterdijk is correct, we could nevertheless add that in the globalized "crime scene" (a scene whose setting coincides with the setting into motion of the European colonialist project), even if no one is supposed to have an alibi, even if there is no possibility to find a *place* that is not also a crime scene, there still remains the possibility for anyone to claim agency, to resist the setting up of living as a voyeuristically macabre forensic spectacle. There always remains the possibility of resisting the traps set up by representation in the persistent renewal of the conditions under which monstrous crimes get to be staged once and again, without reprieve, before our eyes, in our streets, with rigorously predefined and anticipated steps: the steps of habit and indifference. This is why, I believe, Robin Rhode must so frequently refer to burglaries and small crimes in his performances, to a generalized state of urgency, and of danger—for in these performances, he places us all, without exception, and emphatically so, within modernity's crime scene. This is why Rhode so frequently invokes modernity's emblem, the automobile, as a recurrent theme that must be reclaimed, erased, burglarized, destroyed.[11] It's impossible to be present at these events and not realize our inclusion in Rhode's critique.

An event—as video-documented anonymously on May 6, 2003, at the Fondazione Sandretto Re Raubadengo in Turin. Time of day, unregistered.

The video starts with a mixed and relatively large crowd gathered before a wide, empty white wall inside a museum. A young man with light brown complexion, dressed in light gray pants, blue jacket, and red hood is seen already pacing before the said wall, removing from under his blue jacket—a car alarm blasting away. The man is seen engraved with the initials W.P.S.S.U. on its back—a car alarm blasting away. The man is seen placing the noisy car alarm on the floor, by the wall. He is seen walking briskly away from said wall and into the crowd, abruptly pushing people and returning in a hurry—shoving people aside as he headed straight to the wall. The video further shows how the young man restlessly paced back and forth between wall and public, and then slammed himself against it, trying to climb it, defying gravity. It documented how the man tried climbing the wall once and again, how he thrust his body against the hard white surface, how he asked another young man from the audience, dressed in black, for help to lift him up (the audience member excused himself from helping in Italian). Finally, the video shows how the young man fell on his back heavily, how he performed a back summersault and got up quickly, as a cat, or a burglar, and returned immediately to his task. The video shows the man repeating the same sequence a few times: attempting to climb the wall, falling to the ground, getting back to the wall, running and pushing through the audience, returning to the wall, jumping to see if he can climb it, falling again, going back to the floor again, then back to the wall, then floor, then wall, wall–floor–wall, wall, floor, wall. Every time the man's tennis shoes touched the wall, they left dark gray streaks on it, smearing the otherwise impeccably clean surface.

Total time of the event, from the beginning of loud alarm sound until the rushed exiting of the artist through the museum's front door: less than 2 minutes.

One cannot help but to think how far we are here from that other wall-to-floor piece, famously performed by another young male artist working at the intersection of video and performance: Bruce Nauman in 1968. The distance between the two pieces can be measured not only by the inclusion of the audience in Rhode's cases, but by the visceral impact of the danger zone created by Rhode's attacking of the wall in a strident sonic environment—as opposed to the solipsistic, more composed, more formal, and certainly much more stylized and quiet Nauman piece (*Wall-Floor Positions*, 1968). Rhode's performance at the Fondazione Sandretto Re Raubadengo is particularly interesting because it is one of the few where he departs not from drawing, not from painting, but from an alarm sound, an institutional art space, and his own sheer physicality. The only markings that make an appearance are the smudged tracks of his shoes on the wall. Once again, under the simplest of performances, smudge becomes an effect of movement. This means that Rhode smudges not as a way of representing movement, not even as a way to indicate the perennial nature of his work, but as a transducer of life's motions in a moment of danger. The question then is not at all one of theatrics, or of symbolic gestures that would represent a particular sensation (fear), or state (emergency), or mood (excitement). It is mostly a question of when to draw lines and when to smudge lines—to effect and activate movement or to block it.

6.

And here, with Rhode's work conceived as an ongoing project of strategically deciding when to block and when to animate movement, the last definition of smudge found in the epigraph of this essay becomes of particular relevance: "a photograph…taken by a street or press photographer." That is, smudge is also the name of that other crucial medium in Rhode's work. Not that Rhode's photography is documentary, as press photography might be. Here, smudge points to a mode of photographing grounded on street life, on the smudger-photographer's fast eye and quicker hand, on the artist enmeshed in the world, out in the open, dwelling in the city, seizing life as it unfolds in its multiple velocities, and capturing it ahead of time, so as to catch it unawares. A smudge is then a photograph activated precisely by the sense of urgency that the photographer's careful intuition (which, as Deleuze tells us, is not an instinct, but "thought happening at infinite speed") conveys. Contrary to the press smudge, Rhode's photographic work relies on careful staging, on careful temporal and spatial composing, on serializing. But still, in this sense of an imminent "about to happen" that the photographic smudge conveys, we return to the theme of living in a state of emergency, to modernity as inescapable crime scene. In the anterior future of the smudge's "any minute now," in that anticipatory temporality that turns the smudge from being a mere representation of a trace into being a full event, photography becomes an emergency zone, a violent document. In other words, it is a profoundly modern object, or act, which is cut by Rhode's line, its horizon.

* * *

NOTES

1 Andrea Bellini, "Robin Rhode. The Dimension of Desire," *Flash Art*, October 2005, p. 92.
2 Ibid.
3 Ibid., p. 91.
4 Ibid., p. 92.
5 Ibid.
6 Khwezi Gule, "At the Centre's Edge," *Art/South Africa* 4, no. 1 (Spring 2005), p. 28.
7 Peter Sloterdijk, *L'Heure du Crime et le Temps de l'Ouevre d'Art* (Paris, 2000), p. 9.
8 Ibid., p. 20.
9 Ibid., p. 9.
10 Ibid., p. 10.
11 On the automobile as modernity's emblem, see Peter Sloterdijk, *La mobilisation infinie* (Paris, 2005).

"Wait a Minute, This Is Heineken, This Should Be Black Label…"

TB When we first met, in South Africa, early 2002, I was doing research on the fallouts of the two Johannesburg Biennales of 1995 and 1997, examining how productive as an interface between the local and the international art worlds, the "peripheral contemporary art biennials" were. I would like to come back to this, and discuss your relationship to these two events, which despite all their flaws, have contributed a lot to the exposure of a whole new generation of South African artists in nineties. You were very young when these two events took place. Did you visit them, were they influential in a way or another?

RR When the first biennale took place in 1995, I was a first year student at the Witwatersrand Technikon, there was a college project that was incorporated into the biennale, a street parade, an event, something related to the sculpture course in relation to the biennale, but funnily enough, I didn't take part in it. I had no idea what the biennale was and spent my time totally alone, avoiding the other students. But I ended up stumbling into the biennale by chance, by accident. It was a time in my life where I never experienced such social freedom. I came from a high school that was completely the opposite, very disciplined and where we suffered corporal punishment, I was one of the victim's of corporal punishment, I had the reputation of being beaten up the most by the teachers [laughs] because I was really mischievous, I had disciplinary problems. I was known as "the artist" in the school. The guy who does the drawings, who took the school tie—we all had the same uniform—and was

TB So by the time of the second biennale, in 1997, you were more conscious of what it was and what was at stake maybe in this show.

RR I don't remember so much the art on display to be honest, but what I do remember very well, was being quite stunned by the space and the scale of the show, the size of the installations, especially in the exhibition at the Electric Workshop in downtown Jo'burg. So it was probably a key moment for me, as well as for many artists of my generation in South Africa, in the sense that it was an exhibition like no other before, it provided us with a horizon in a way, and gave us a very strong momentum. What I remember of the Johannesburg Biennale is that I just wanted to see my work incorporated in such a show [laughs].

TB Were you aware, were your teachers telling you about the strong interest coming from the international art world at the time for the post-apartheid situation? About the fact that art world was getting more and more inclusive of the peripheries of the Western world and especially of contexts like the South African one, postcolonial post-apartheid contexts?

RR Well, principally I was aware of the chance for young people like myself, colored people and black people from the post-apartheid generation to have the right to speak and be heard. Compared to the generations that preceded ours. I was aware of having the chance to come forward. I was given a voice and I said to myself, "use it, use it, use it." So I started reading a lot of art history. I was one of the very few students who was deeply interested in the international art scene, and this is how I encountered the work of Marcel Duchamp, or Vito Acconci, and Dennis Oppenheim. I recall the *Gingerbread Man* from the second biennale. So because of my fascination in the international scene, researching all the art magazine periodicals, and in parallel, researching my own thoughts, my own cultural experience like these great artists I was discovering seemed to do. This is how I realized the importance of this classroom experience, this initiation experience I had where senior pupils would draw objects onto the walls and force the younger ones to interact with them. This and a lot of other experiences, mainly focused around removing the cotton threads of the school tie, and then creating new patterns into the school tie. It became a high school trend, everybody was doing it. I was also burning the plastic pens that the school provided, and changing the shape of the pen so that it bends over the hand or into other organic shapes. I had this creative side that led me to the art college, to the Wits Technikon. We were two or three colored students in the entire art faculty, and the others were white students who had art lessons in high school, which wasn't my case. I really struggled to adapt, I found it difficult to attend the lectures, the drawing class, and felt out of place. I would just escape to meet with my friends outside. So I failed hopelessly, I was the worst student and branded a no-hope. I struggled on and only during my second year of studies did I gradually become more conscious about what I could achieve by gaining more knowledge about the history of art.

TB Was there some sort of trigger to this consciousness? I understand it wasn't the biennale.

RR Yes, absolutely. The trigger was while going through an art magazine and stumbling upon a piece by Kendell Geers, the "bottle-neck" [*Self-portrait*, 1995]. This fascinated me tremendously, and as soon as I could identify and associate my personal experience and my life with art, suddenly it opened doors for me—when I realized that the objects with which you are familiar can become art and that you can end up reading about it in an art magazine. I had known that people smoked with the bottleneck, and now all of sudden this was a sculpture that was published in an art magazine. But I thought: "Wait a minute, this is Heineken, this should be Black Label, it shouldn't be a Heineken." That's what I thought. Then I read the interview of Kendell in the magazine and I thought: "I can do this, I can make art like this." That was *the* moment.

TB What were the other students doing, what types of work?

RR They were all making very beautiful drawings, very refined, precise works, or very well-finished sculptures. I think the word I'm looking for is "academic." But I realized that I could create something that would be quite unique here, because what I'm going to do, they don't know.

daily objects, the bicycle for instance. And this is how I began drawing and performing in the public realm, which was completely at odds with what the other students were doing.

TB You were still in college when Stephen Hobbs, who was a young curator, only a little older than you, invited you to exhibit at the Market Theatre Galleries. And when Kathryn Smith, also of your generation, begun writing on your work. This whole post-apartheid generation of artists and cultural producers very quickly took care of herself without waiting for the approval of the previous generation, that of your teachers.

RR Yes, Stephen Hobbs was the first to extend an invitation. I was in my third year of studies and he seemed to have spotted something in me. He was also part of this post-apartheid generation as a young artist and young curator and he felt that my work had potential. I'm not speaking here in terms of market value, because there was no market issues in South Africa at the time, well, none that I was aware of, but more in the sense of the impact the work can have on a community of viewers, and to create something new within this rapidly changing context. My work revolves around this notion of the "potential" or the "possibility," about the viewer seeing a line drawn with chalk or charcoal, then having it open up something within themselves, so there is more than just an elementary drawing on a wall. The best thing I remember from this time is that there wasn't any commercial pressure. I didn't live *off* art, I lived *for* art. The motivation after college was not to find a gallery. There was only one gallery, the Goodman Gallery, where only well-established senior artists showed. If I look at what is happening here [in Europe], as soon as an artist graduates the main motivation is to find a gallery, it was completely different in South Africa. I wasn't expecting anything from art except doing projects and having interesting conversations.

TB With whom did you have stimulating conversations at the time, apart from Steven Hobbs and Kathryn Smith?

RR Apart from them, there was Emma Bedford in Cape Town, previous curator at the South African National Gallery, who has always been supportive of me;

Barend de Wet and Peet Pienaar also in Cape Town, who took the first photographs of my performances; in Johannesburg with Tracey Rose, who I spent a lot of time with when I was living there; Moshekwa Langa, an artist who has inspired many and who remains a close friend. I did a lot of things with these people—projects. We were all more or less emerging as artists, curators, critics, sometimes all this at the same time, and we had common interests: the younger generation of art practitioners were trying to define what was new for the history of South African art. It was this sort of association between us.

TB You said you were not living from art or selling anything, and I know there was a lack of state funding for the arts after the demise of the biennales in South Africa. How did you all manage to survive?

RR After college, I spent a year wandering around: I ended up at the stock exchange working as a stockbroker trainee, and then worked for a perfume company, selling perfumes. I eventually went to film school, which was a wonderful and key moment for me. I had finished my art studies and had spent a year making art and participating in exhibitions, while working part time, and then I decided to go back to being a student again. Most of the other students came directly from high school to the film school, whereas I had a lot more clarity of what I wanted from it, and why I needed to learn the language of film. I went there for my artist's work or as a kind of research, and more precisely or explicitly, it was to understand more about the construction of the moving image. Since I majored in production design my main focus was to translate the script of the director into a visual storyboard. This kind of work really helped me understand how I could recreate a script or a performance into sequential frames. And that's how I developed this shift into the photographic series.

TB So you never wanted to become a film director or move into the cinema world, but you were consciously using the film school to foster your artistic intentions?

RR I didn't want to have my work determined by economics or by commerce. This was, and still is, a very important factor for me in realizing ideas. I don't want

to be dependent on a financial system for making work. And cinema seems to be about that. My fear is that it doesn't seem to exist outside of this very complex financial system. Underground cinema does. Whereas I wanted to hold on to an experimental condition, an exercising condition. I wanted that the work had a lightness so that I could push it, push it, try out, more, more.

TB What is the percentage of what you do that we don't see, how many ideas do you have that you try out but don't turn out as well as you had imagined?

RR Not as much as you would think [laughs]. Maybe I should work harder. Or work more. No, honestly, not so much. I've done a lot of drawings in the studio that disappear, that I throw away, but with actions, very rarely. I don't know what the ratio is for other artists, painters for instance. Painters I respect immensely. By the way, there's something I wanted to add about those days back in Johannesburg, which is the definition of what my work is: is it street art, or graffiti artist, what is it? Since the beginning, this question has been chasing me. I never considered myself to be a street artist or a graffiti artist, but it has happened quite often in the artworld, in South Africa, that I would be framed as a street or graffiti artist. There is a funny story that happened to me last year, which I think is extremely relevant. I was in Johannesburg last year, completing a piece on a wall in the street, and I was approached by graffiti artists, because I had bombed their graffiti tags on this wall; I had painted over their graffiti piece to do my work, but they had bombed mine months ago. So these guys came to me and one said: "Look, you've been doing this work over ours, this is a bit disrespectful, you know." I said, "But isn't graffiti about contesting space, challenging space, isn't it about ownership, about changing ownership?" And the guy said, "Ok, ok, I'm cool with that, but what you're doing is so abstract, there's nothing that you communicate, your works exists on the roll of film, this isn't graffiti, you should be doing that in the studio, dude." And I thought, well, this is really interesting: graffiti artists don't see me as one of them, they see me as a painter or photographer and they are advising me to working in the studio. The reason for that is that my work is not about what I leave behind in the street context, since what remains is completely abstract. This is different in an art context, what is it that remains on the wall after the action and drawing performance? I refer to this as the "after-drawing." I found this really interesting how art people can see me as a graffiti artist and on the other side real graffiti artists see me as a painter. It highlights how people misuse or misunderstand the term "graffiti" or the concept of street artist. I never at any point considered myself a graffiti artist or a street artist. This is one of the few things I'm very strict about, without losing street credibility.

TB Let's go back to your biographical trajectory, and to the moment when you decided to leave South Africa and to live in Europe. This was 2002.

RR It was very dramatic.

TB It was a very complex decision, wasn't it? There were family reasons, but also career reasons obviously, not in the sense of being careerist but of finding the right working context; at least this was part of the equation. This was the year when I was in South Africa, and a lot of the artists of your age, but also older ones, and curators, too, that I met in South Africa at this time were all asking themselves this question: should I stay or should I move to Europe or to North America? Somehow the international connection had been a little broken since the demise of the Johannesburg Biennale, and people in the South African artworld were feeling a little bit isolated again.

RR I wanted to be closer to my family, so we had to make a decision, either we decided to all live in South Africa or I would move to Europe to be with them. I think I made the right decision.

TB And there was no anxiety on your side that outside of the South African context, from which you had drawn all your projects from very directly, the inspiration would be lacking somehow?

RR Never. This was really not an issue. It was difficult at the beginning to work when I relocated to Berlin because I didn't have access to the walls that I wanted, needed. I was missing the familiar spaces, but I had no anxiety about being able to develop my work here. I was, on the contrary, very much interested in finding out a way to bridge the South African experience with the Western

discourse and its art history, to bridge it differently from the way I was doing it when I was in South Africa. This reversal was a healthy challenge. Before that, in 2001, I had shown work in the UK, I did a performance for the exhibition called *Juncture* at Studio Voltaire in London, and then I had a short residency in Gasworks, also in 2001. This was very challenging because I had the sensation that now I could challenge the canon, I could partake in a different language, a different discourse outside of the one that was so familiar to me, and which was somehow suffocating, because it was always leading back to post-apartheid discussions and not so much about art itself. In the UK, I saw that what I was doing could be interpreted in very different ways. It was really about the process of art. I had this joke at the time when I moved to Europe, where I was saying I didn't want to make art, I wanted to *become* art. This can sound very naive, cliché, romantic, probably ridiculous, but this was really the feeling I had: it was to see my life engaged with art completely, to perceive everything around me through art; that my practice helps me understand the world that I lived in. And this wasn't exactly how I was seeing things before, when I was making art in South Africa. There was always a filter to this ambition. How I perceived my relationship to art or what art is, wasn't as deep as it became when I moved here. Which maybe sounds a little difficult to believe because usually one thinks that this is the initial ambition and then it becomes diluted by pragmatics, but in my case no, it was really revealed here in Europe. Somehow the new South African art context prevented this ambition.

TB I think I see what you mean by that. But when I was mentioning the possibility of having anxiety that you would miss the South African context, I was also thinking about the specific audience that you had there, which is very different from the one here in Europe. In Johannesburg, working in the public realm you had a very diverse audience, the kids, the passers-by, it was much more than just an art audience, whereas in Europe, art is much more bourgeois and confined to art spaces than it is in Johannesburg.

RR This is very true. The South African context meant so much to me in this sense. By making the conscious decision to work in the public realm, it was also so that my viewers wouldn't be the art educated, it wouldn't be a social elite of museum goers and gallery goers, it was people on the street on their way to work, unemployed people, who were engaging with my work. I remember doing this bicycle performance in downtown Johannesburg in 1999, and while I was doing it, a security guard came to help me ride this drawn bike, he helped me climb on my drawing. And after he had helped me, I turned to him and said: "Well, now *you* go, and I help you get on the bike," and everyone was like, "shit"—it really broke a barrier. Something happened, something in that moment shifted my practice completely. It wasn't about me anymore, the artist wasn't the subject of the gaze, suddenly the viewer became part of the work. This was a turning point, and this was a very spontaneous moment. Whereas of course here in Europe, if I was to do this on the wall, I wouldn't be helped to climb on the bike, I would probably get arrested by the police, and the only thing that can prevent this from happening would be to say this is a work of art [laughs]. This moment was a very important one for me because it helped me understand the psyche of South African people in general. I come from a culture that is very spontaneous, that has a lot of humor, that has a sarcasm. People can laugh at themselves quite easily. After going through such a horrendous political situation, they can still find humor in themselves. And I think a lot of my work stems from this South African mentality, where you recreate things, and make them funny, subvert it and make it funny again. It has to do with freedom, with the possibility of imagining or re-inventing another world quite rapidly. So yes, in Europe my work functions differently, I don't have those viewers. But I realized I had to develop my practice differently. I realized that the viewers, the situation I was accustomed to in South Africa, was a luxury. It was too easy. And I thought now is the time to develop the language for the viewer, other viewers. It was a challenge but a healthy one. In South Africa, I could repeat it over and over, whereas here I needed to rework these experiences to allow it to become more relational.

TB And it really came that easily?

RR Here in Germany, I started to do more photographic work. I would find a

space and document the action, but no one would really see the action. It became more of an inner experience. At the beginning it was very difficult for me. I would go to galleries or museums, and what I saw would be very refined, very cold, calculated, very intellectually motivated work that I tended to reject, it felt so distant. I would feel lonely and isolated. I couldn't see myself as part of this scene.

TB But also, very quickly, you got incorporated into a new framework, or scene, though not a local one, but international and generational: the young global artists, even though the expression is probably not the best one. You took part in the exhibition *When Latitudes Become Forms* for instance, which clearly stressed this moment in the history of contemporary art. Weren't you able to find artistic affinities with the other artists in the show?

RR Oh yes, absolutely: Jennifer Allora & Guillermo Calzadilla, Marepe, Can Altay, Anita Dube, Santiago Cucullu of course, a lot of us, it's true. For all of us it was the same thing: we were coming from these geographical peripheries, whether it's Asia, Africa, or Latin America—I've always been deeply inspired by Latin American art and practices since the art school days, Gabriel Orozco, or Helio Oiticica for instance, the way Oiticica's work was so close to his life, that it was one and the same, where clothing becomes kinetic sculptures, I've always loved that—so, we were all coming from these different peripheries, working through practices that where very light and immediate in a way, that didn't require big production set ups to exist, and which were not as calculated as the ones I could see in the German galleries for instance. It's very true it was a shared feature among the artists that Philippe [Vergne] invited in *Latitudes*. It was a very important show for me because of the conversations I had with Philippe during that period. The show was touring to different venues, from Minneapolis, to Italy, to Mexico, and so we discussed how each new context can influence the work, and what I could bring to the show as it evolves in time while touring. What can I add to the show? During this period we discussed a lot about the status of the performances I was creating in the museum context, and the relationship to the specific audience, what was the role of the viewer/

audience during a performance in the white cube context, passive or destabilized recipients. This is when I came to this idea of the escapist in my performances and to avoid getting trapped in the white cube. I had to find a way to escape, to give the impression to the viewer that I wasn't supposed to be here, or that, now that I'm placed here I'm finding a way out. This was very influential for the future performances, especially the ones in New York [at Artists Space or at the New Museum].

TB The last time we spoke I had the impression that you were becoming more and more reluctant to perform in museums on the occasions of openings.

RR I just don't want that it becomes systematic, that each time I take part in an exhibition, the viewer can expect a performance at some point. It goes back to what I was just saying. Museums—walls in museums—are nothing like walls in the public realm. There's always something that happens beyond my control, a shadow, something going on that pushes me to change my plans or ideas. I never thought about it in the past and now I'm completely into it. This is really magical, I love when it happens, when things happen beyond my control. I let go. Of course I allow the conditions to let it go. For example, I never completely storyboard a work, I only do one sketch, one page, that's it. I draw the action on one page. I used to draw many little frames prior to the action, but now it's just one page, very basic and so it gives me room to maneuver, it shouldn't be too rigid. I have an idea, I think "this is what I want, this is how it goes" and then I go to the space, and then "ok, fine, let's go" and there, it's about thinking on your feet, fast, working against time, before the light changes, before a shadow appears, adapting, etc. Something very beautiful happened when I was doing my most recent photographic series, it was unbelievable. I was in Johannesburg and I was plotting to do this piece called *Juggla* (2007, pp. 88–89). I was planning to do this work on my beloved wall in downtown Jo'burg, on this wall that I discovered in 1999, where I did my first piece, *Big Bike*, a five-meter-high bicycle and it's a single photo of me standing in front of the bicycle. And I did many many pieces on that wall (e.g. *Pulling the Load*, 2004, pp. 58–59; *The Stripper*, 2004, pp. 104–5). But walls are autonomous,

people can't know where the wall is, in which city, when they look at my work. But I have an emotional tie to this wall in Johannesburg. But now the problem is that I can't work there anymore because it has become a kind of wall of fame, lots of graffiti artists are getting commissions to do work on that wall.

TB And you were never able to find such a wall in Berlin?

RR Until now it doesn't exist and I would never be allowed to do something like that here. People call the cops.

TB But you could ask for authorizations?

RR No, never. That's the point. I found a very nice wall last year, where I could develop a project that I wanted to do for many years, since I was a student, but I could never find the right wall for this, it needed to be very high. And I found it in Las Palmas in the Canary Islands. This was for this piece *Untitled (Dream Houses)* (2005, pp. 68–69) based on a very funny story in South Africa, from the area called Hillbrow, it's a story about how people celebrate New Year's eve in Hillbrow, they throw old furniture out of the windows. And peo-ple got killed over the years by falling microwaves or somebody's sofa [laughs]. The idea is that they sacrifice the old stuff so that the new year brings pros-perity that will allow them to buy new devices. It's a very fascinating subcul-tural tale. So in this piece you can see me catching a TV being thrown out of the window, and then a chair, and then a table, coffee pots, cups, I catch them all, and then a car comes down [laughs]. It's a very funny piece.

TB Do you keep some sort of record of your ideas that you couldn't accomplish because you still haven't found the right wall to do it. Do you have notebooks full of ideas and storyboards?

RR No, I never write anything down. I might make a quick sketch on a napkin or piece of paper, but then I end up giving it to someone. If I have an idea I just hope the idea is good enough for me to and to hold on that at some point down the line, two years, three years, it comes back to me. But most ideas come out of the context of an exhibition anyway. So to go back to the *Jugula* piece, I did it in Johannesburg, on a wall of an old restaurant, a restaurant that fascinated me as a child because we were passing by everyday on our way to pick my father up from work. I was always quite curious of what was inside this restau-rant that served very basic, typical African food such as "pap." But now this restaurant didn't exist anymore, it had become a supermarket, and then the supermarket shut down and the building became somehow abandoned. Later this space was used by panelbeaters, guys who repair and repaint car wrecks. And these guys who repaint cars used the walls there to test their sprayguns; it's actually quite beautiful there because they make these very abstract paintings on the walls. So when I went back to South Africa wanting to do this *Jugula* piece on my beloved wall, I realized that it wasn't possible to work on that wall anymore because it had become this kind of wall of fame for graffiti artists, I began looking for an alternative space, I decided to work on this area of the panelbeaters. And when I arrived there the panel beaters were gone, it was completely desolated. But it was beautiful. So I was there preparing for this piece, and I was getting a little anxious because there were two guys watching me on the other side of the road so I invited these guys over, told them "come here." And I explained to them what I was preparing, that it was an art piece, that I would paint on the wall and that photographs will be taken. I decided that they would assist me in doing this piece, and that I would pay them for their work. They were waiting for a job outside of the factories, they were coming here every morning, very early waiting for a day job from one the factories in the vicinity. So they helped me repaint the wall layer after layer, we discussed the piece, the movement, everything. It gave another layer to the piece. It felt similar to what happened with the security guard in 1999.

TB Before we end this interview, I wanted to ask you about the recent appropria-tions, or rather plagiarisms of your works by brands like Nike and Gap for their commercials, which they copied using your system of framing, using chalk, optic illusion, etc. In the same way, that Fischli & Weiss's *The Way Things Go* was also recently appropriated by Honda for a commercial. How do you perceive it?

RR Oh, that!

TB You could see it as a kind of homage in a way, or recognition, or an accomplish-ment even, of having managed to make an aesthetic pass from subculture to

the art world and then to mainstream television. That's not necessarily what I think, but I was wondering how you took it?

RR I seriously don't know what to think of this. I find the debates that these appropriations have generated really interesting. I've been reading about them on the internet, where many discussions center on this idea of appropriation, and the way people I don't know, maybe people who have encountered my work in exhibitions somewhere, become such strong advocates of my work, for instance. That was a big surprise to see people care so much about the work.

TB Thanks very much.

RR Sure, thanks.

* * *

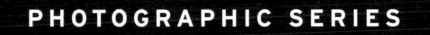

PHOTOGRAPHIC SERIES

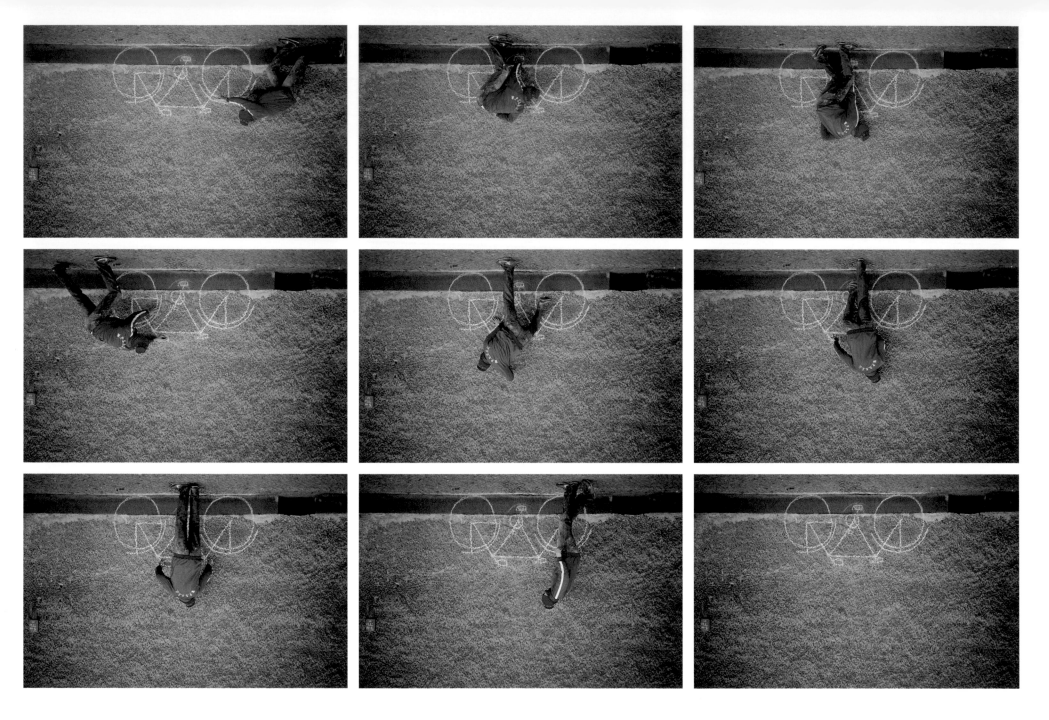

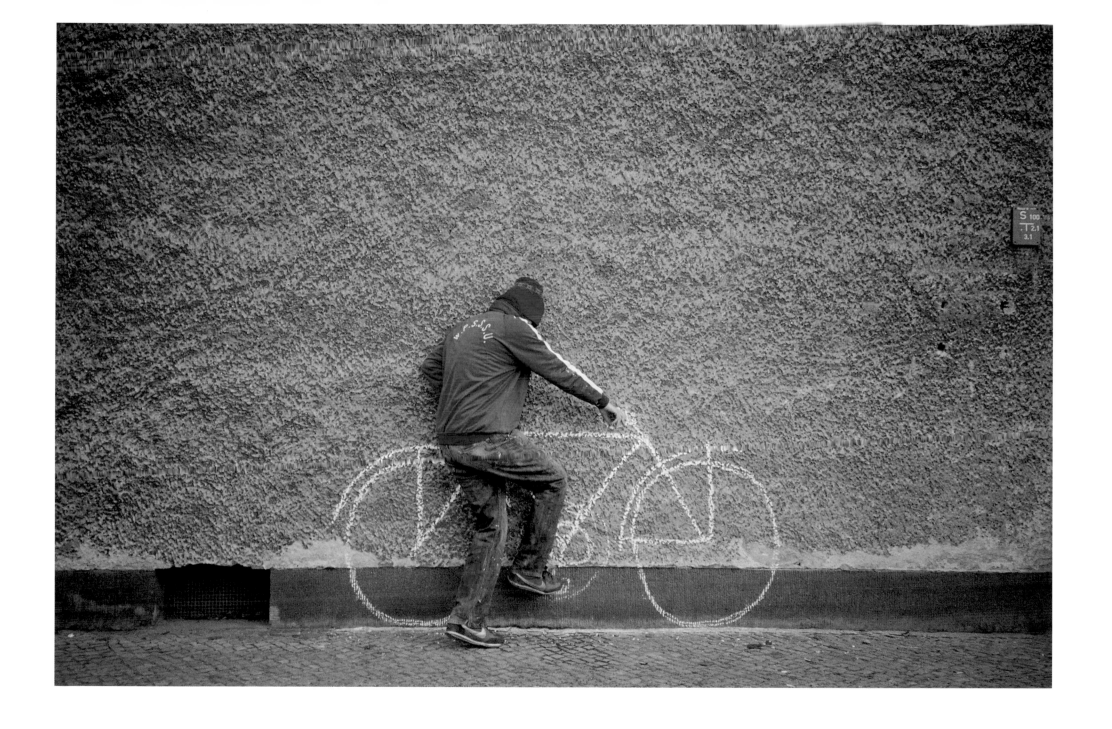

CLASSIC BIKE 1998

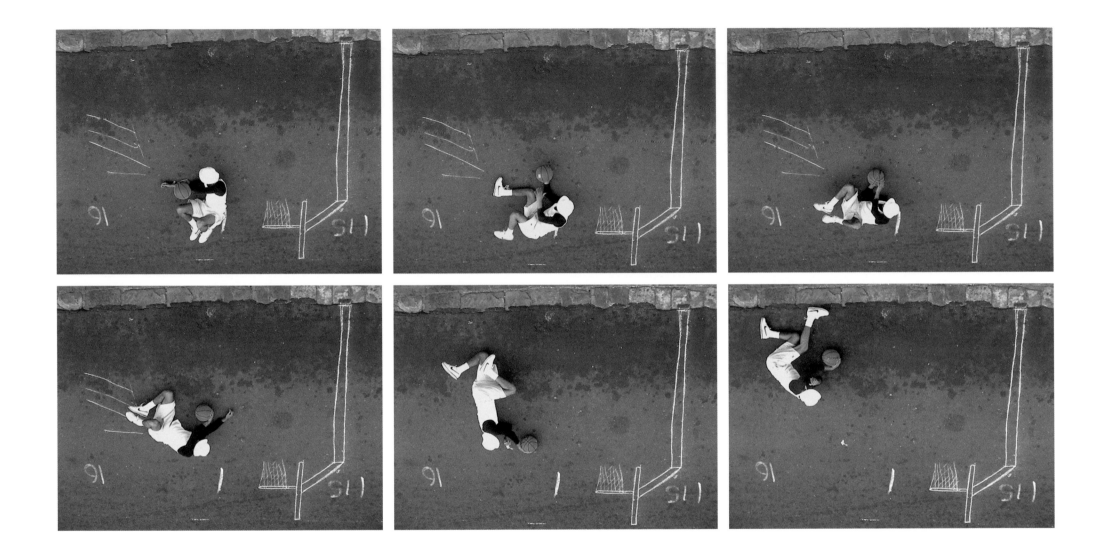

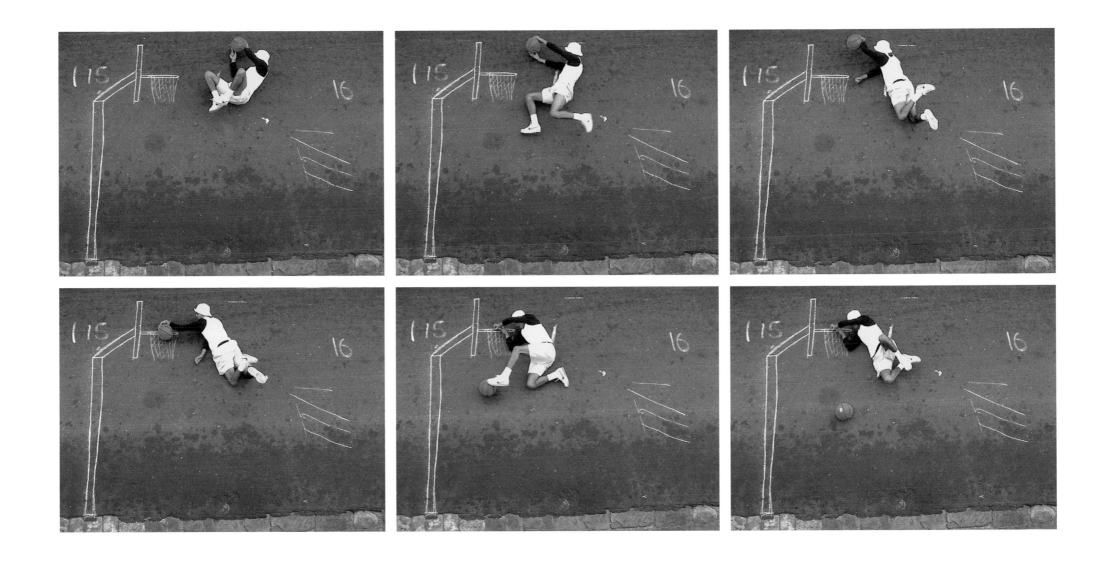

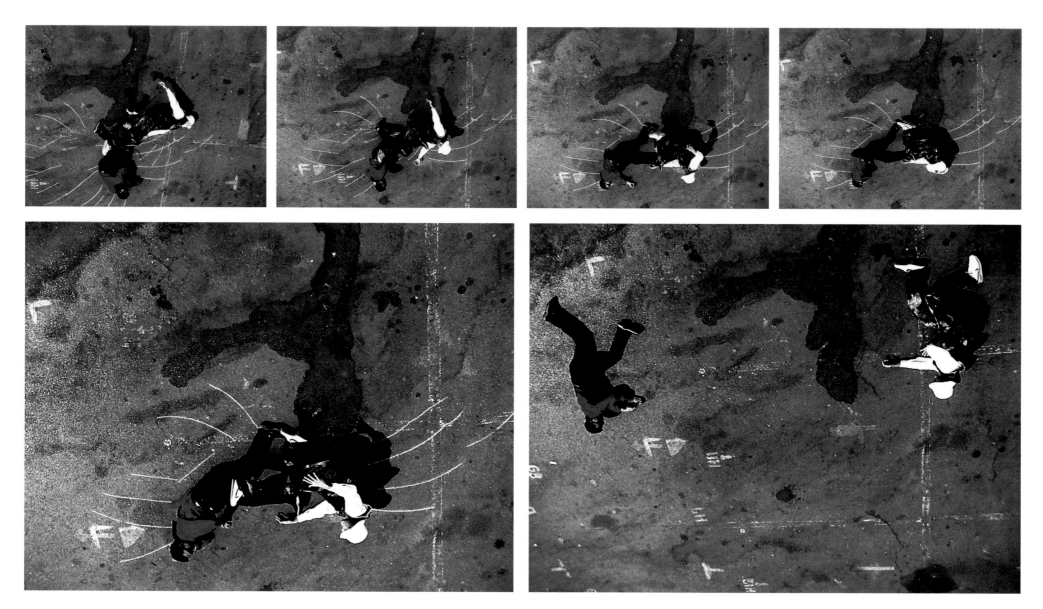

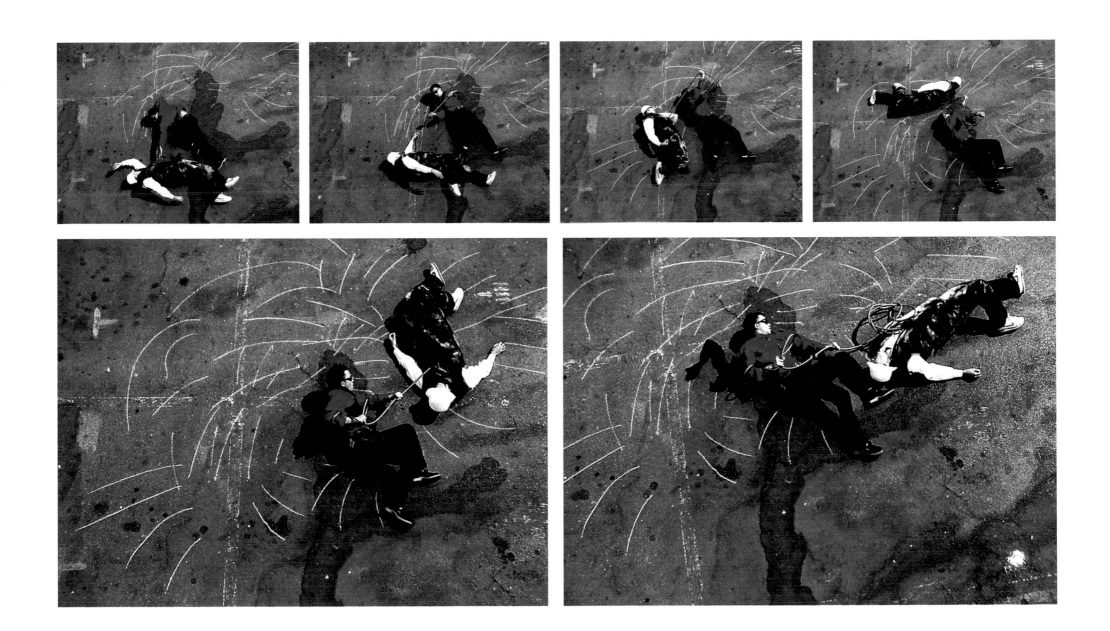

THE MATRIKS 2001

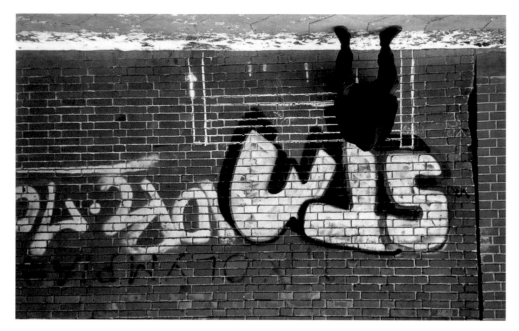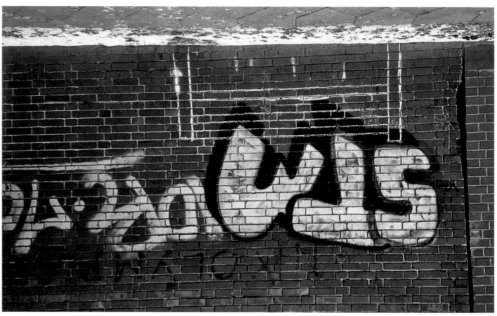

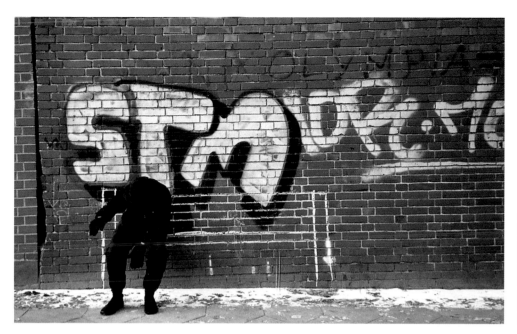
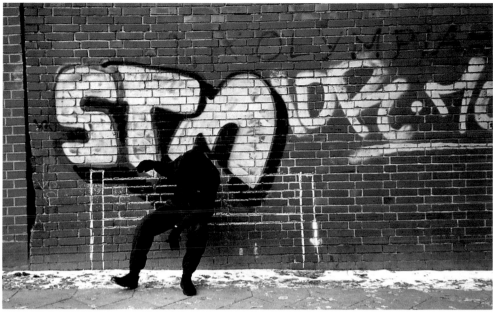
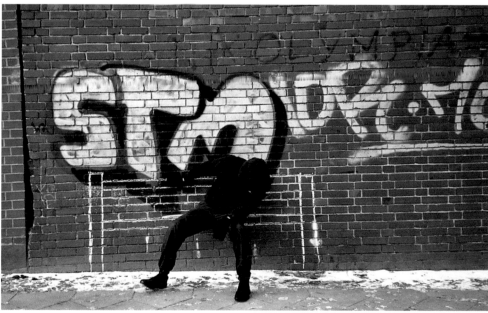
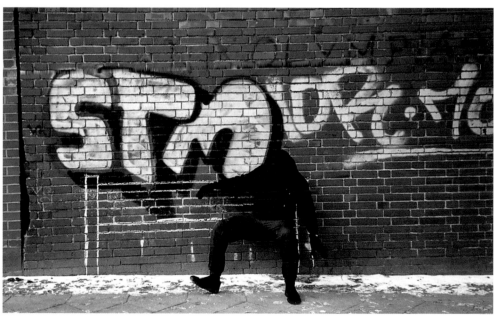

BENCH SLIDE 2002

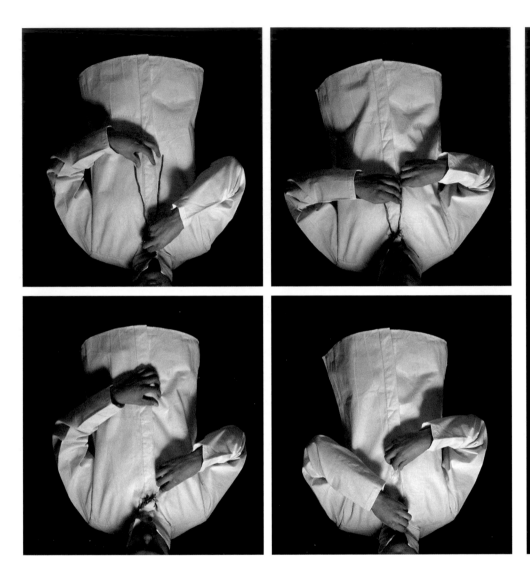

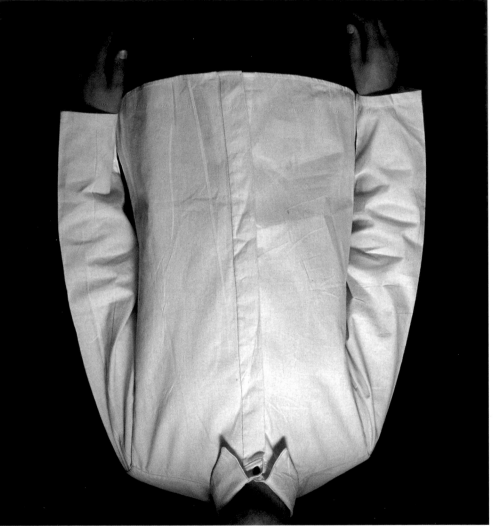

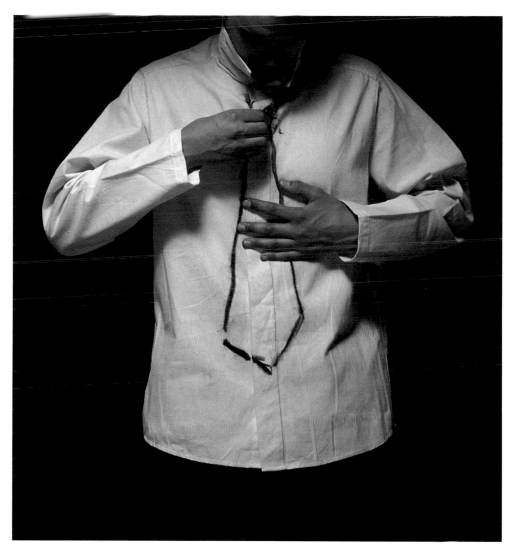
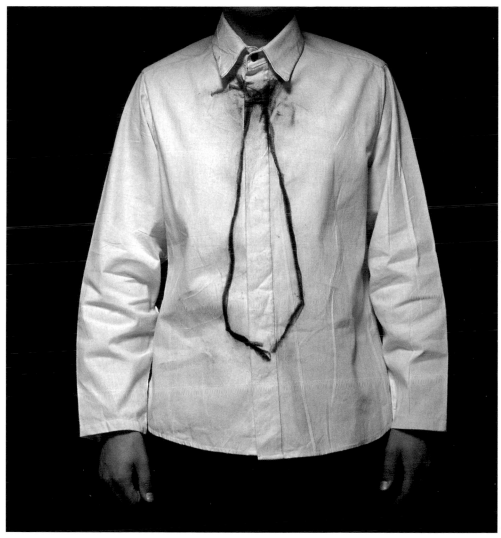

BLACK TIE 2003

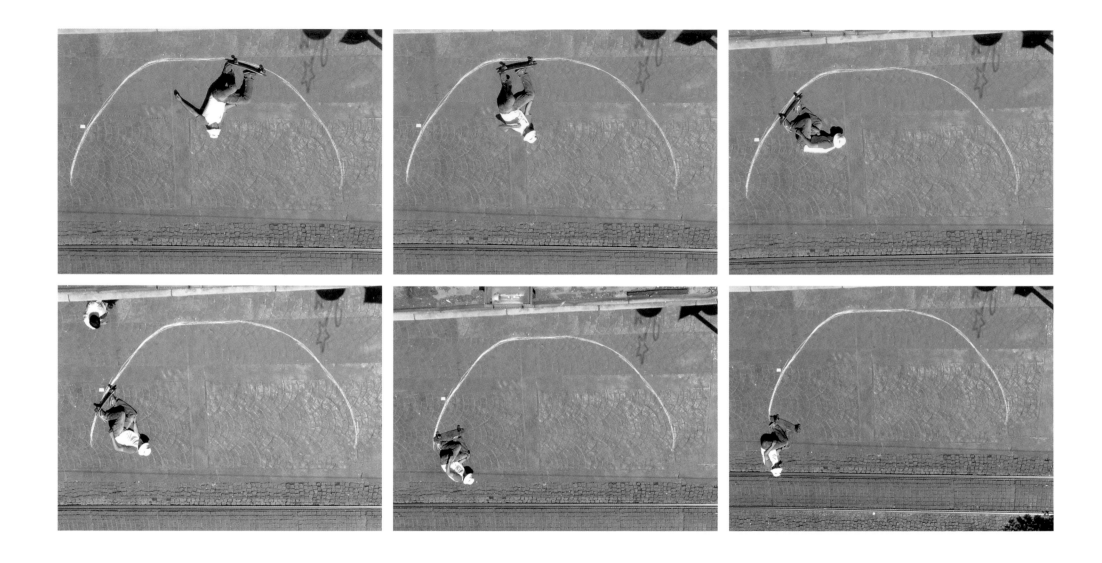

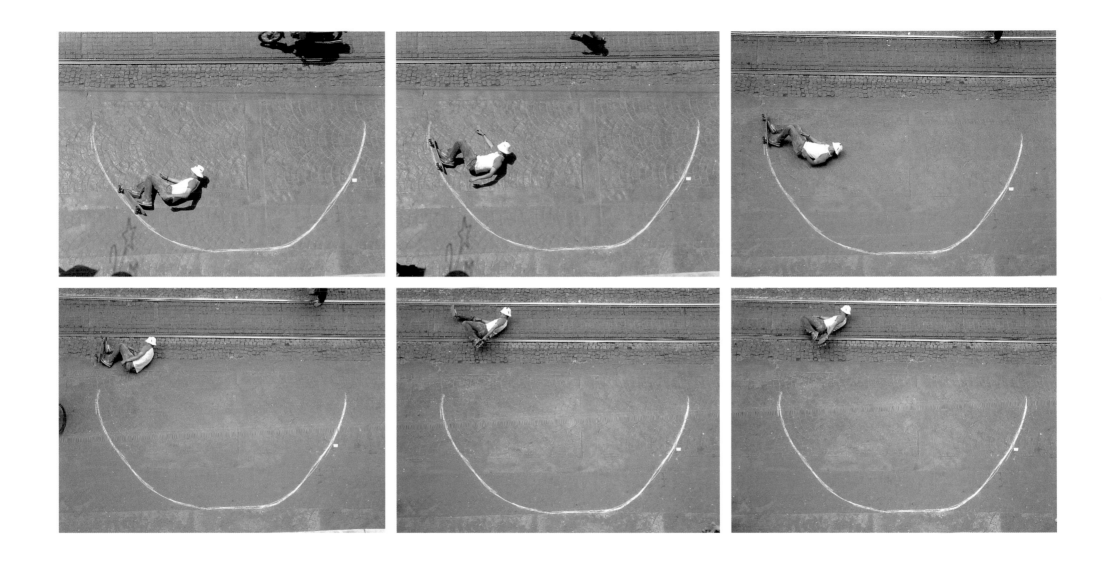

CATCH AIR 1991

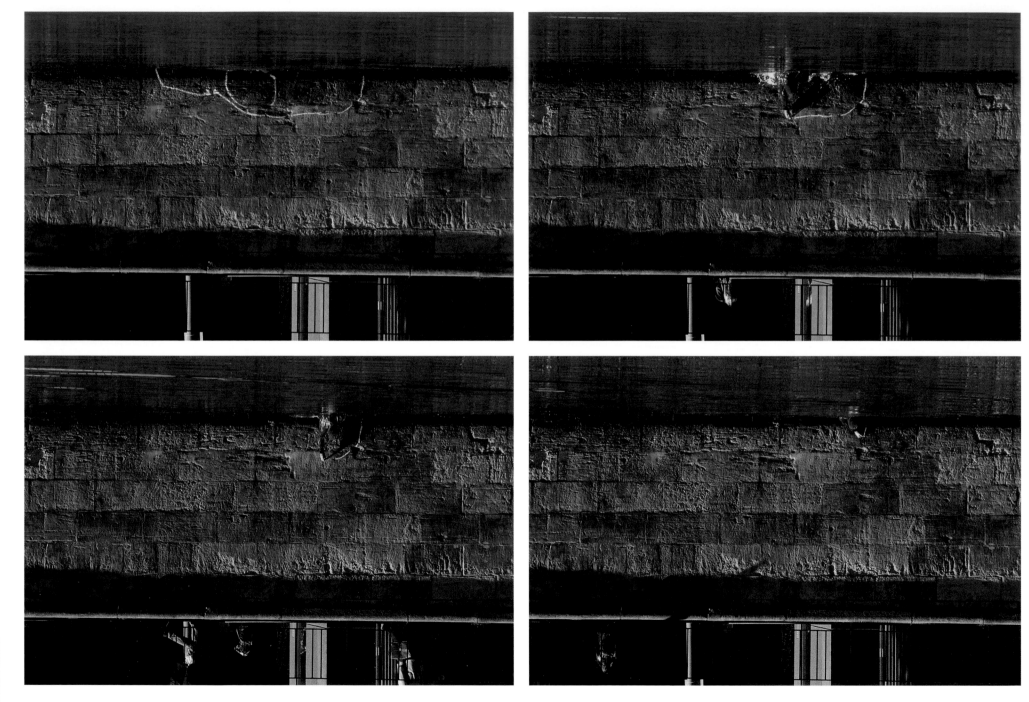

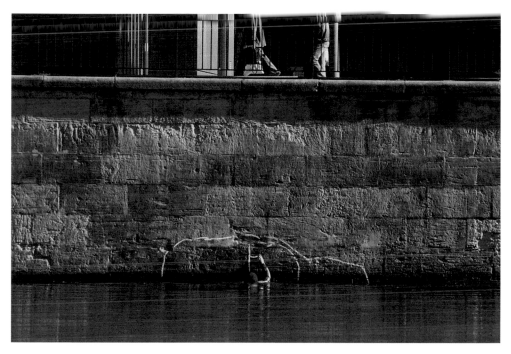
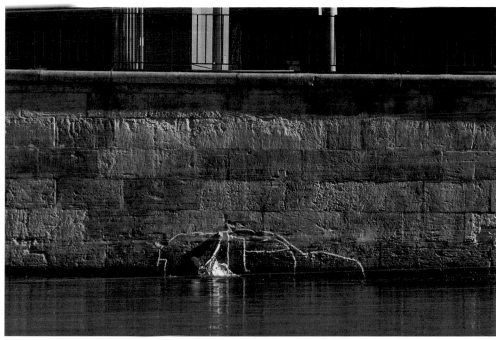
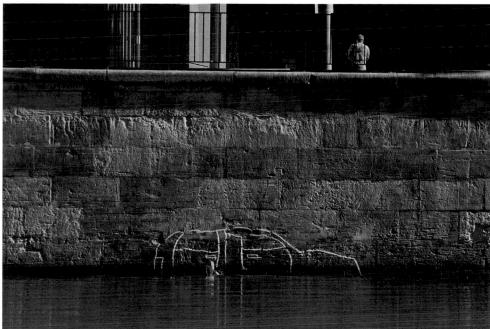
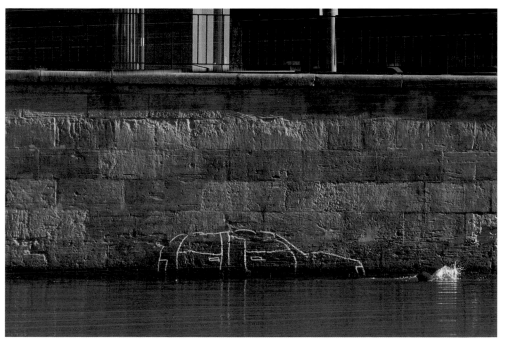

AUTOMATIC DROWNING 2004

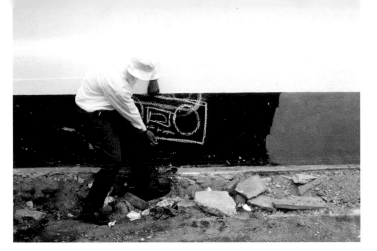

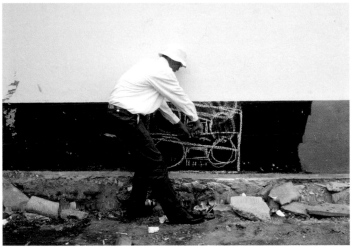

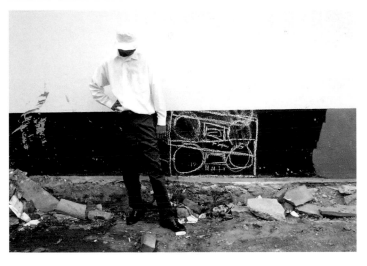

MASTER BLASTER 2004

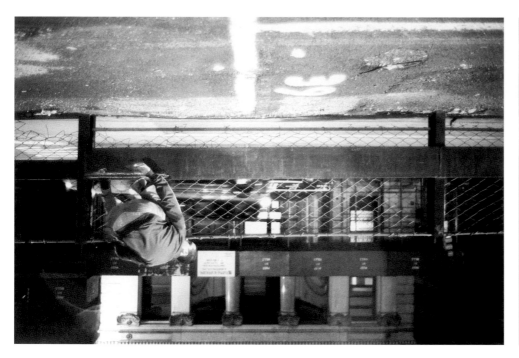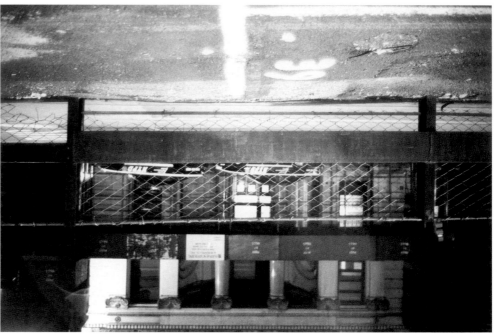

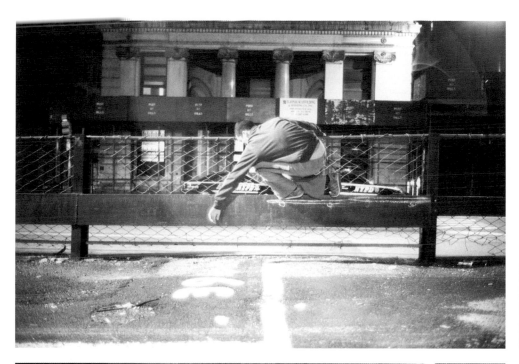
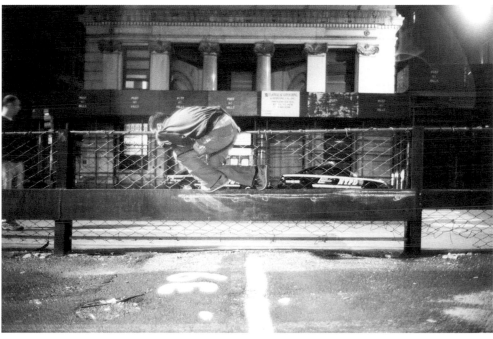
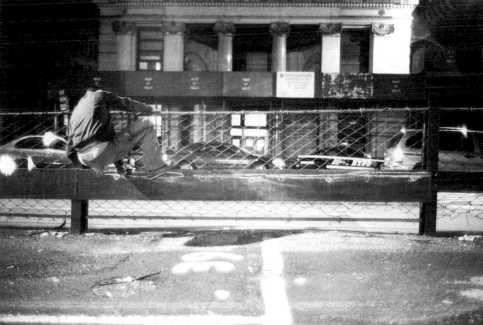
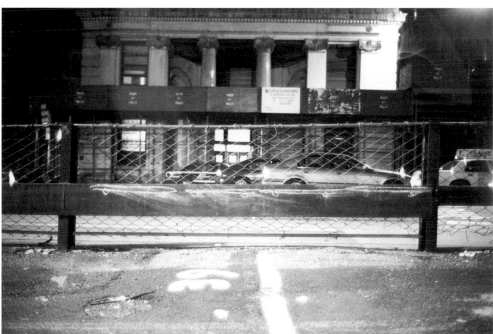

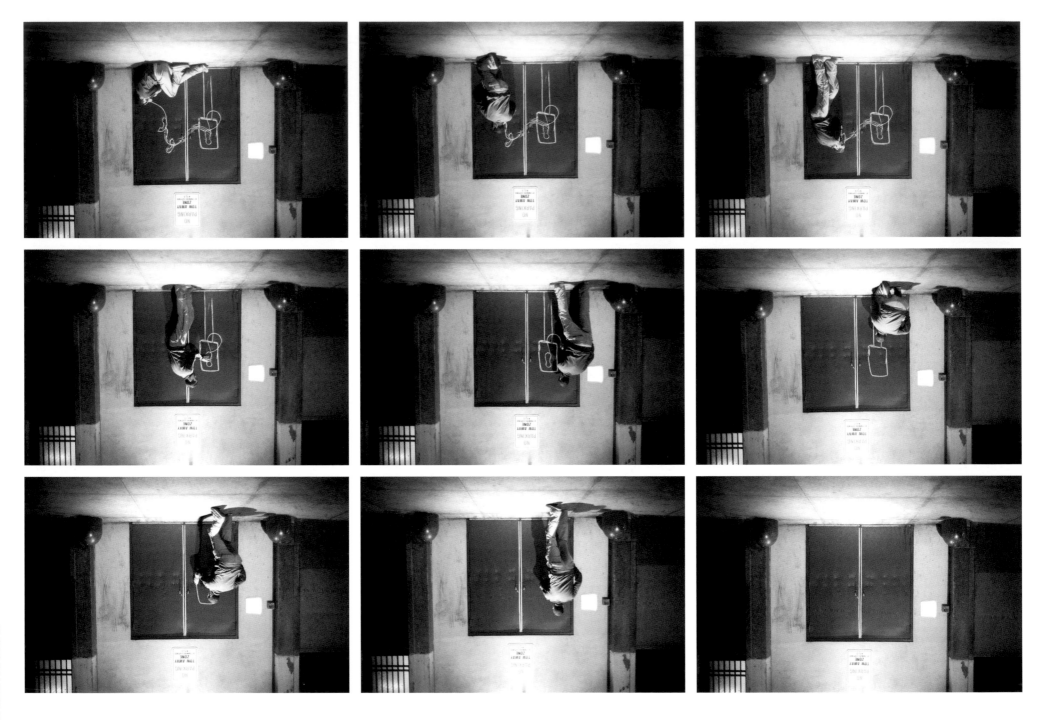

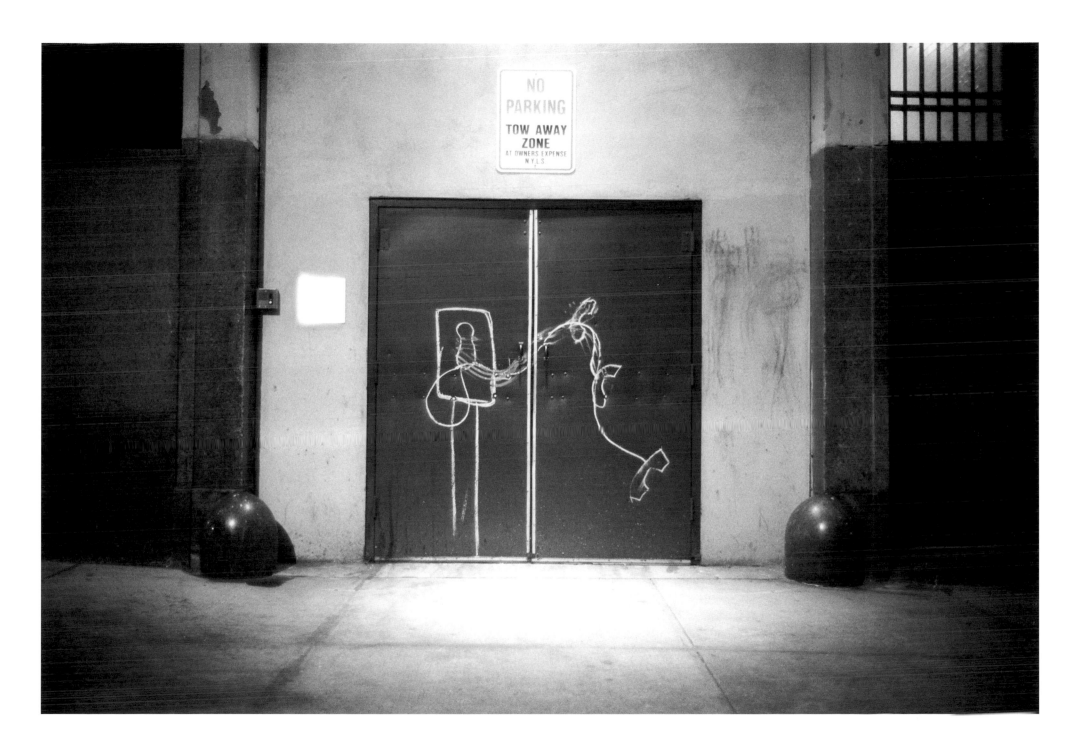

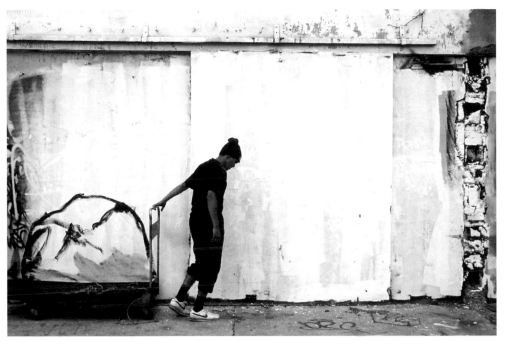
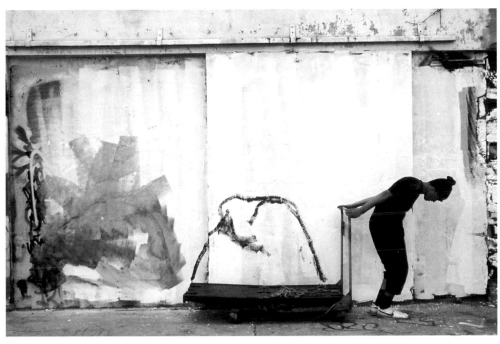
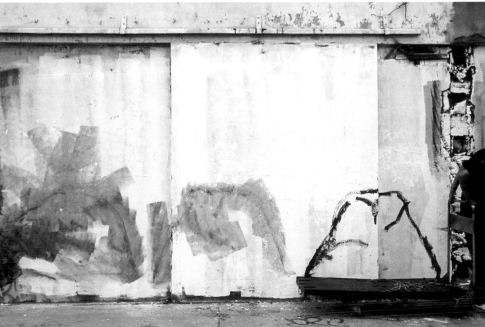
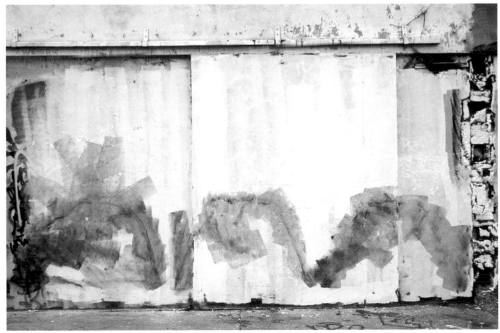

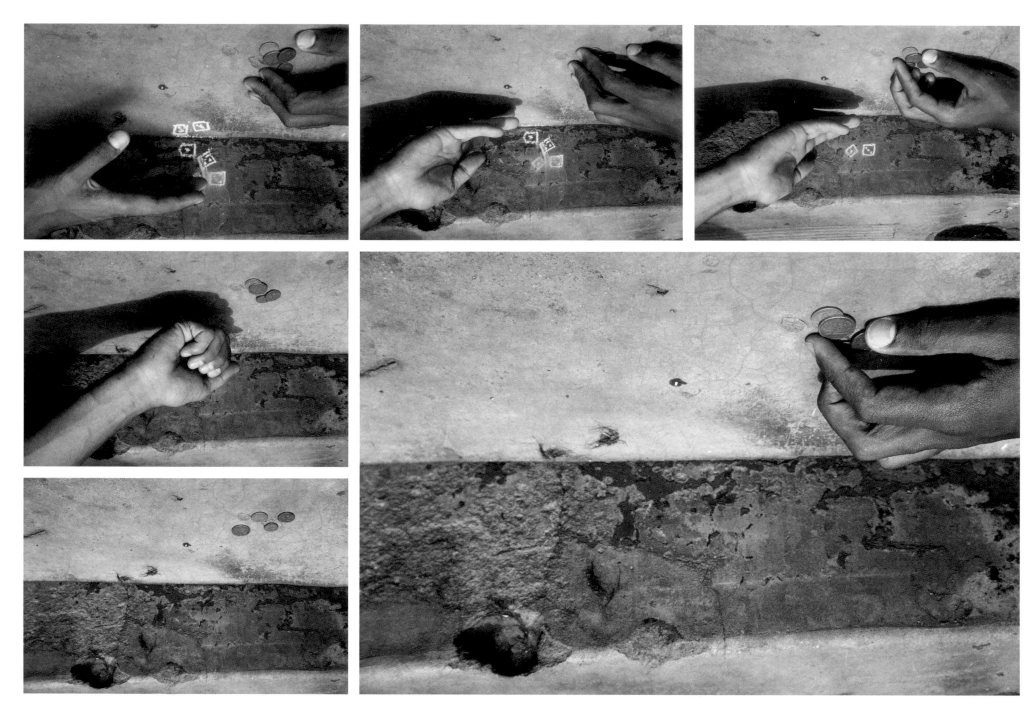

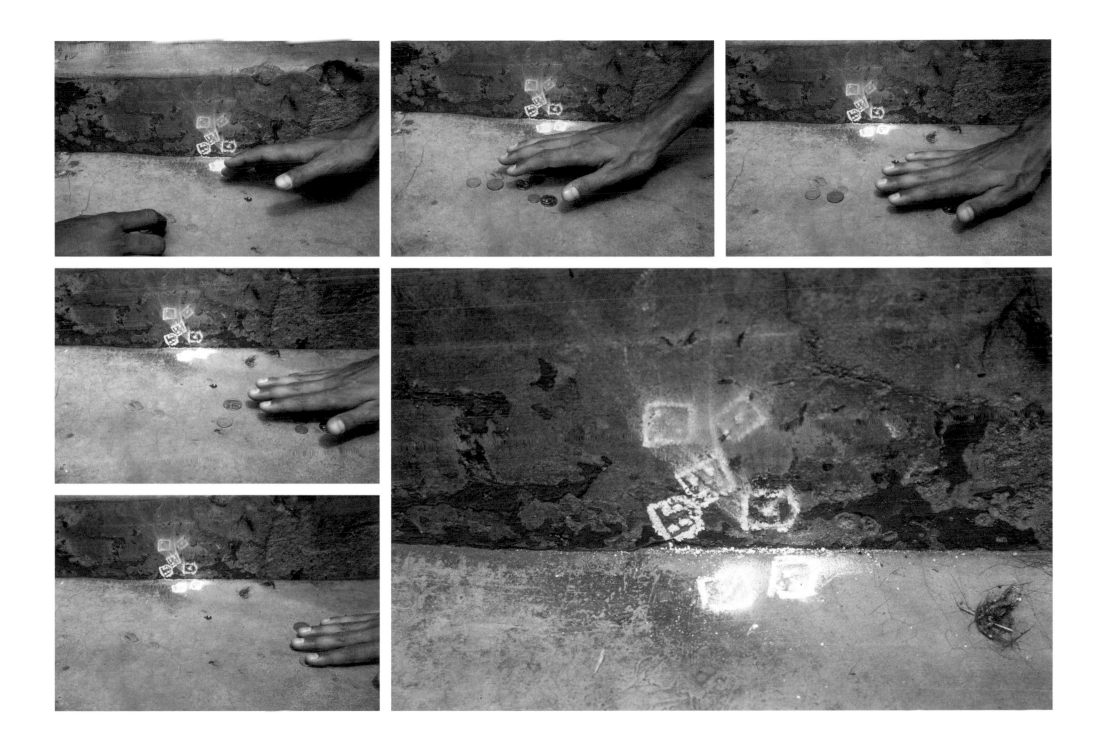

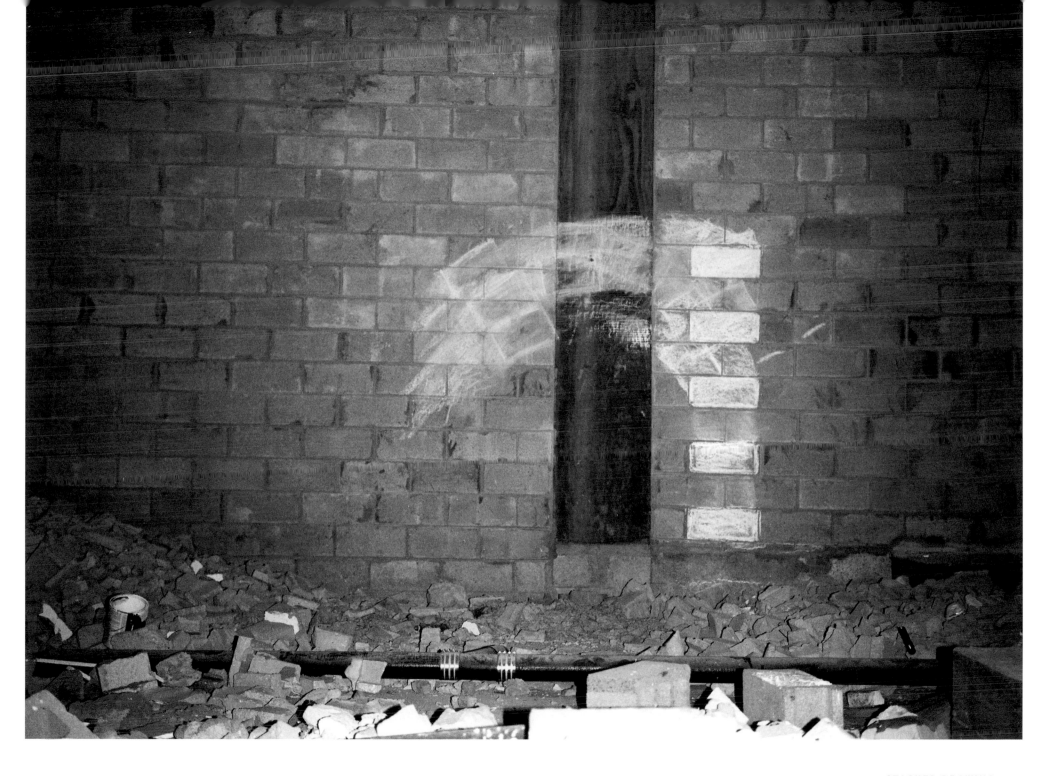

STACKED DRAWING 2004

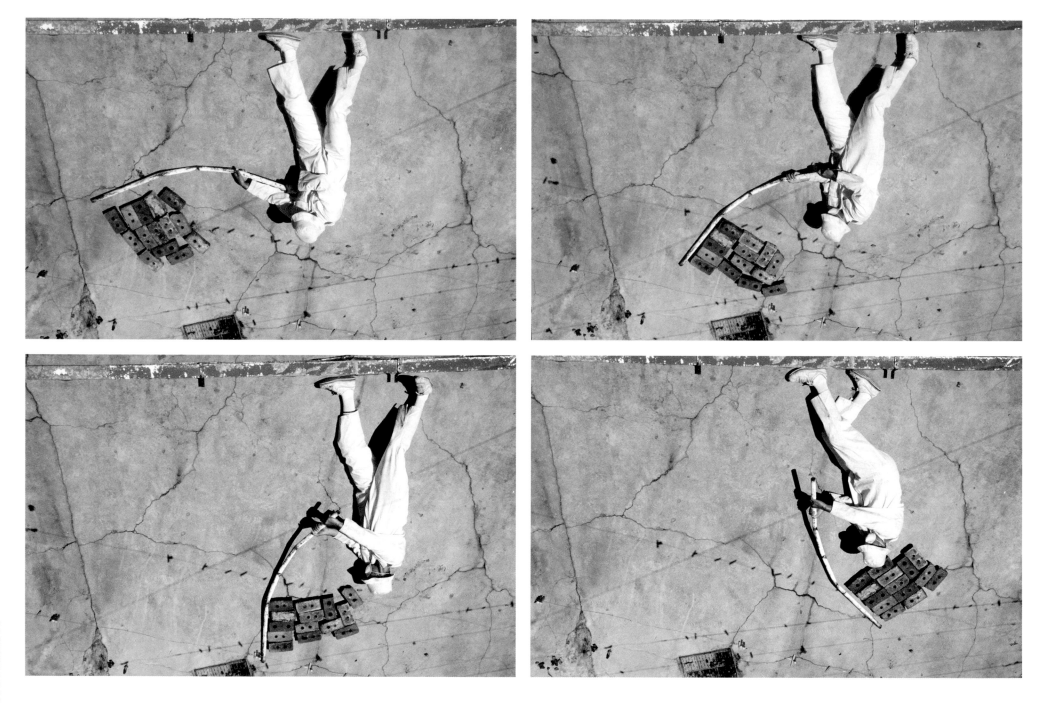

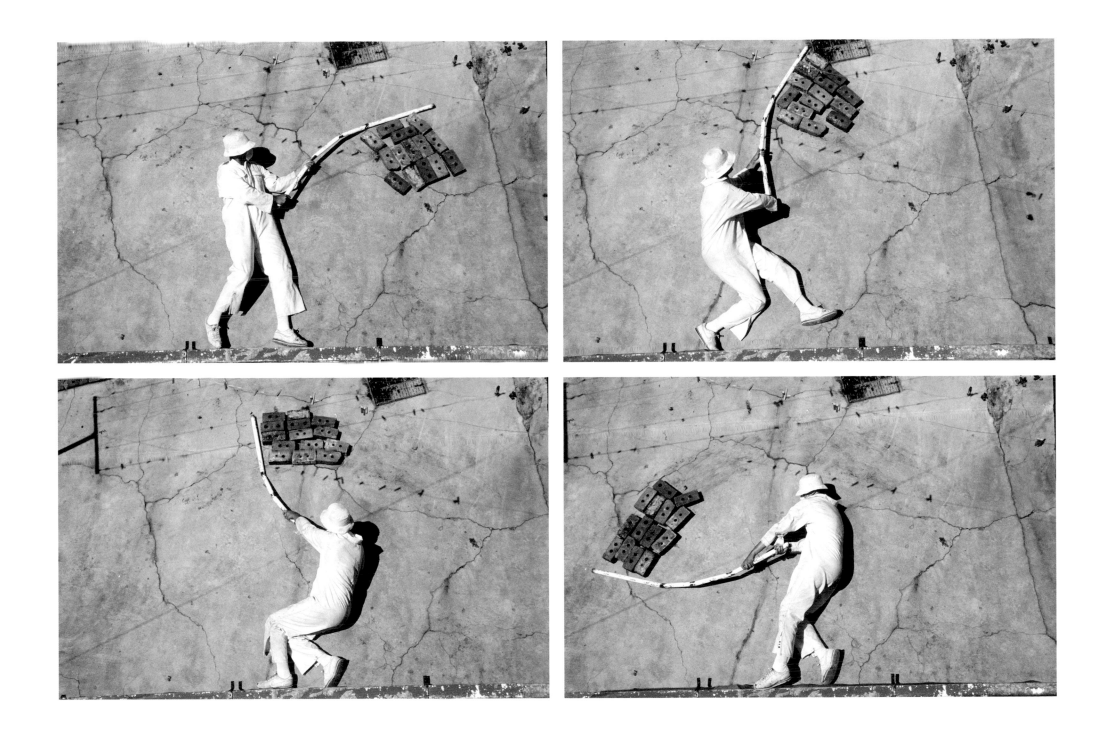

STONE FLAG 2004

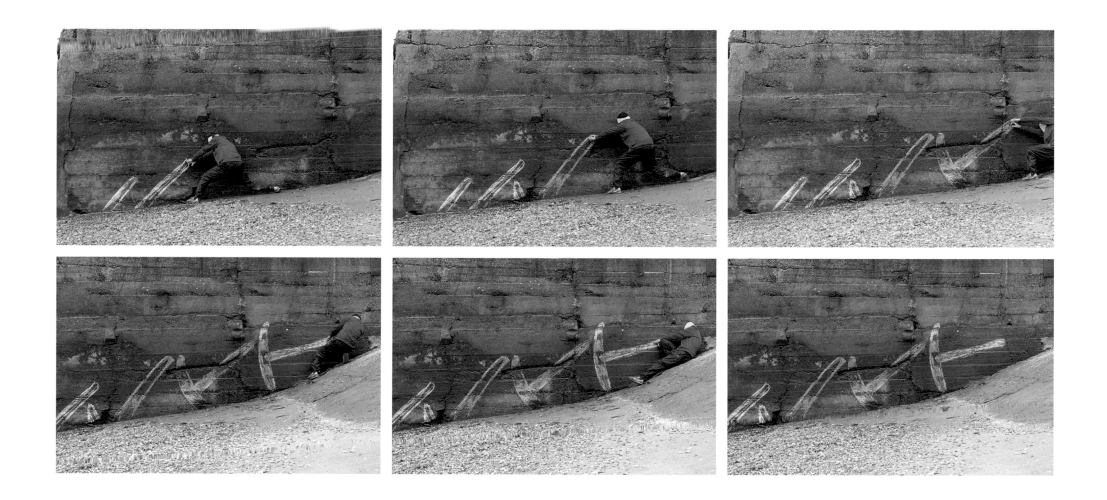

67

UNTITLED (ANCHOR) 2005

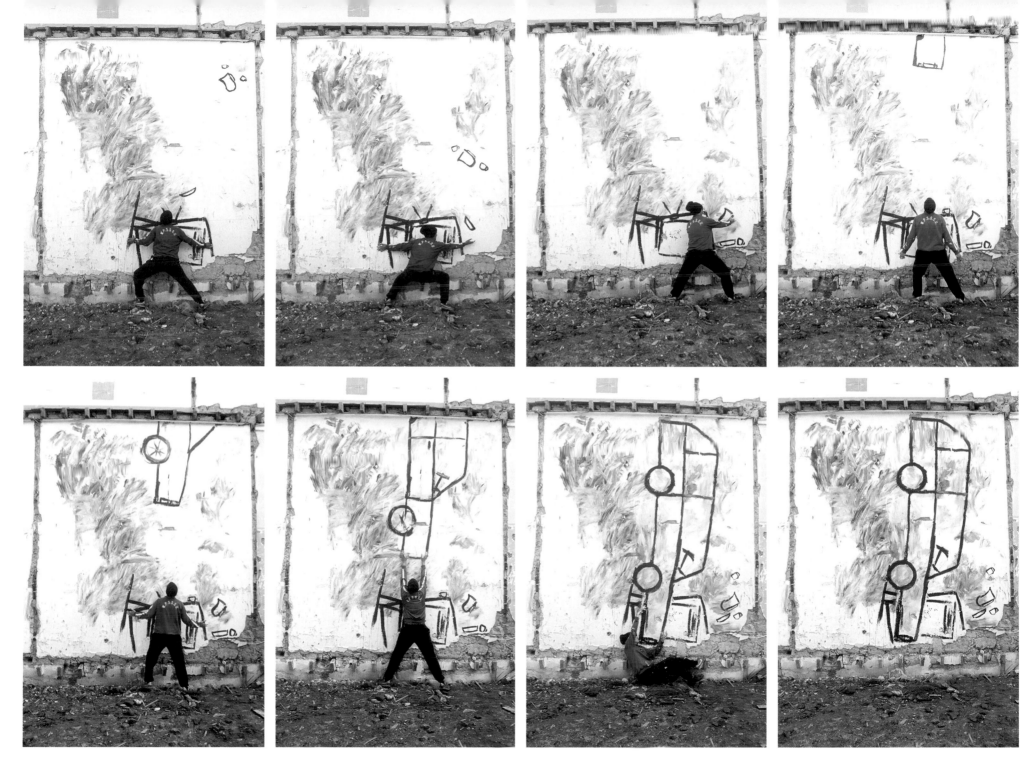

UNTITLED (DREAM HOUSES) 2005

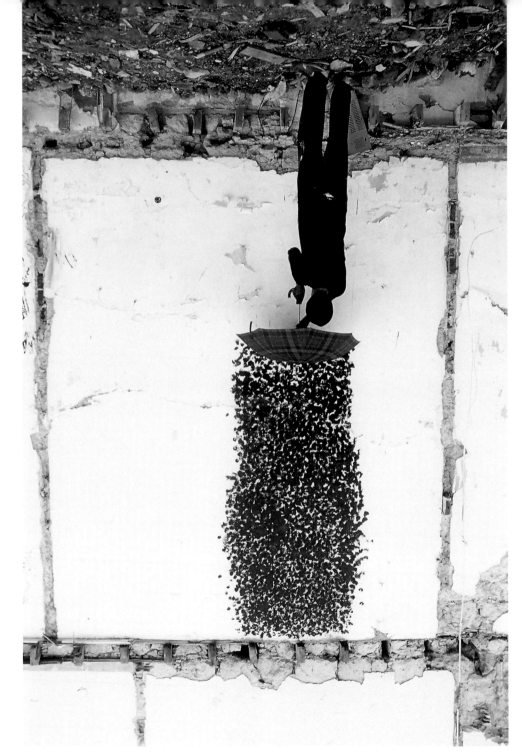
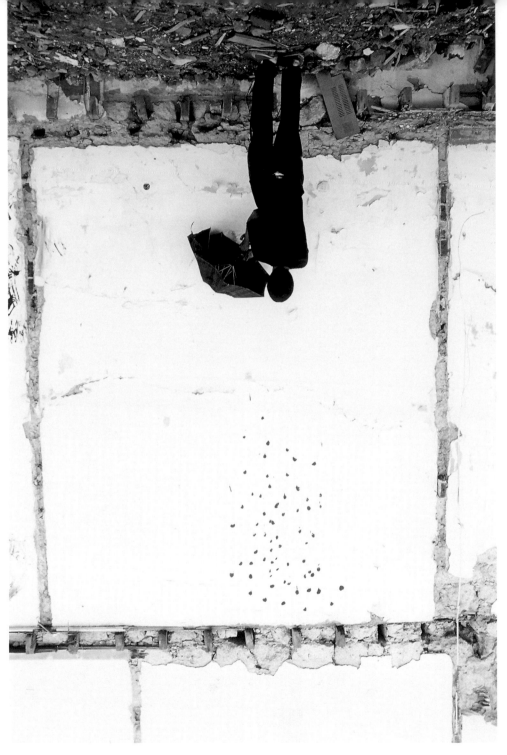

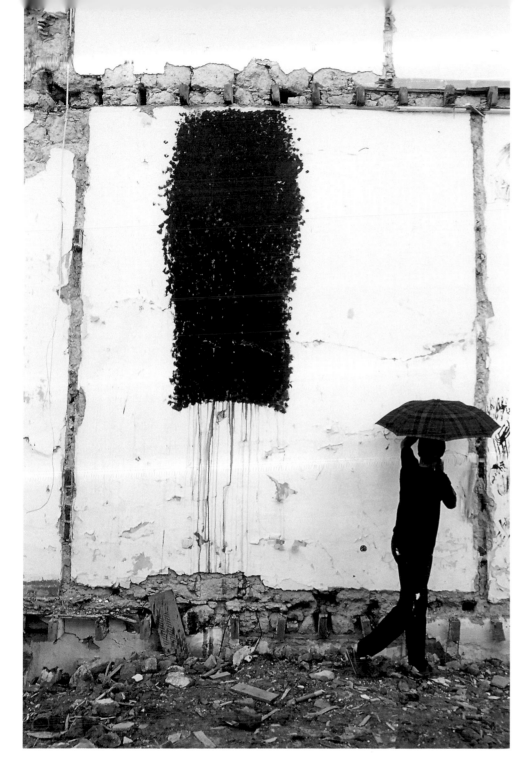
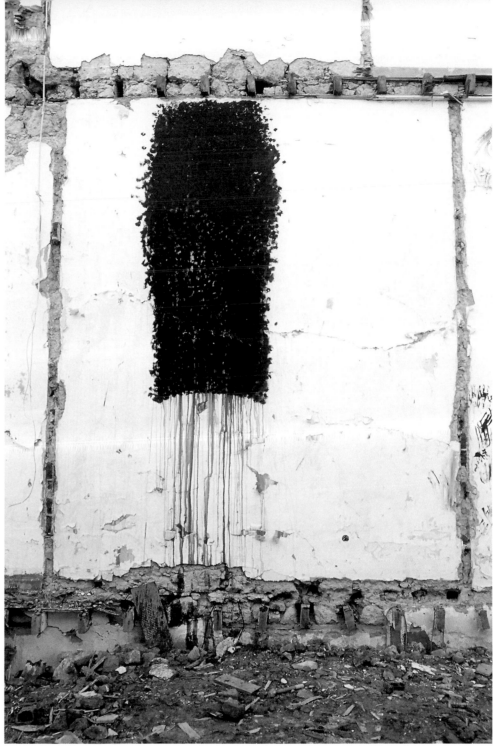

UNTITLED (HARD RAIN) 2005

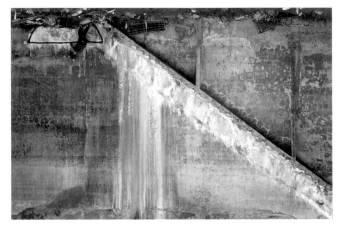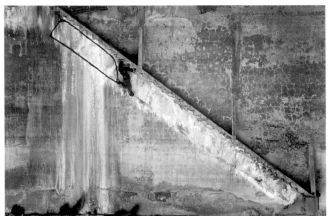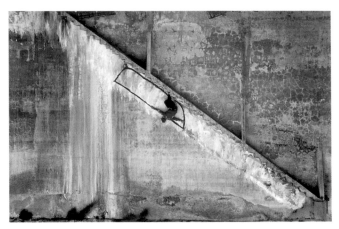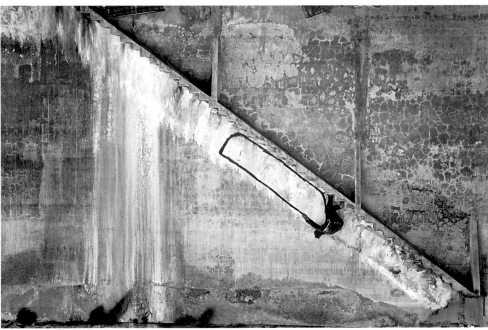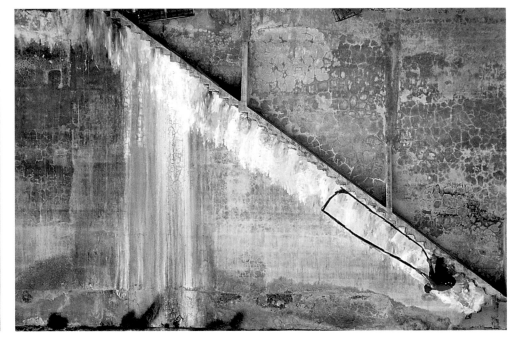

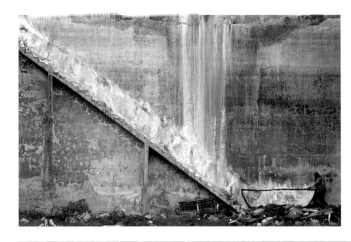
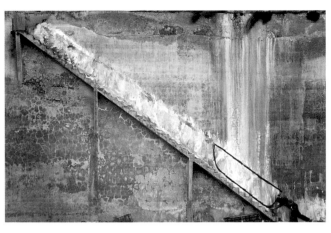
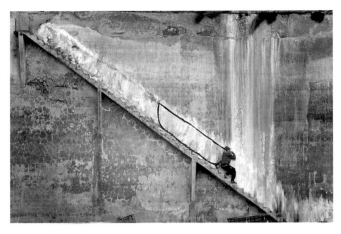
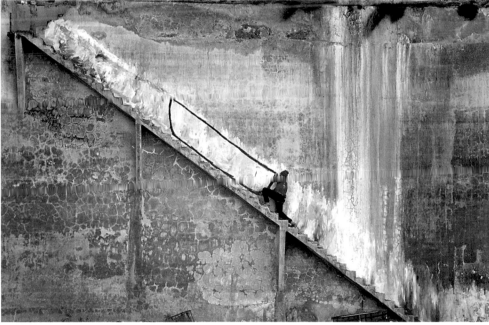
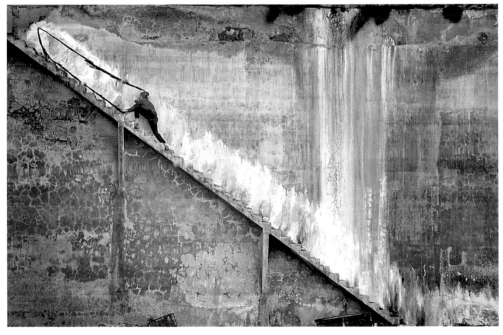

UNTITLED (LANDING) 2005

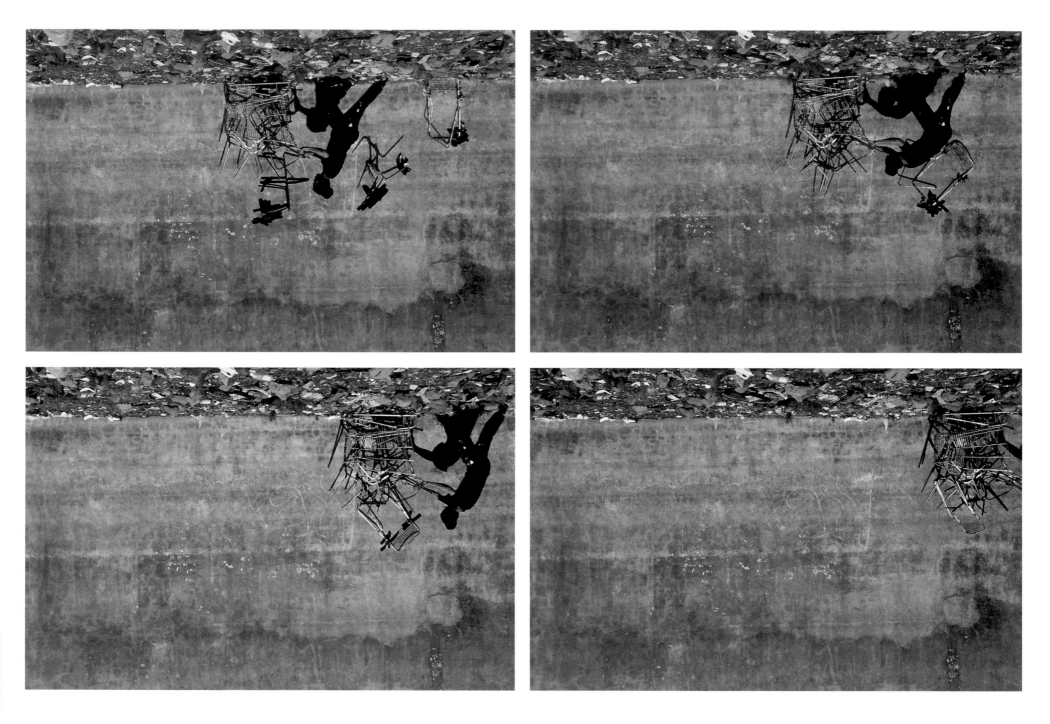

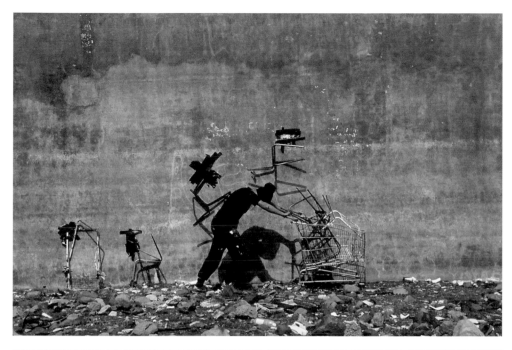
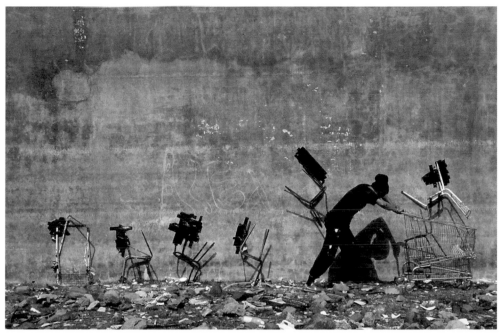
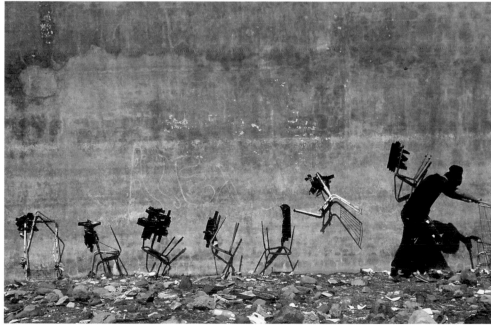
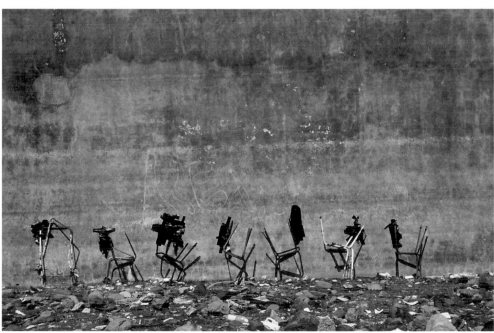

UNTITLED (SCHOOLED CHAIRS) 2005

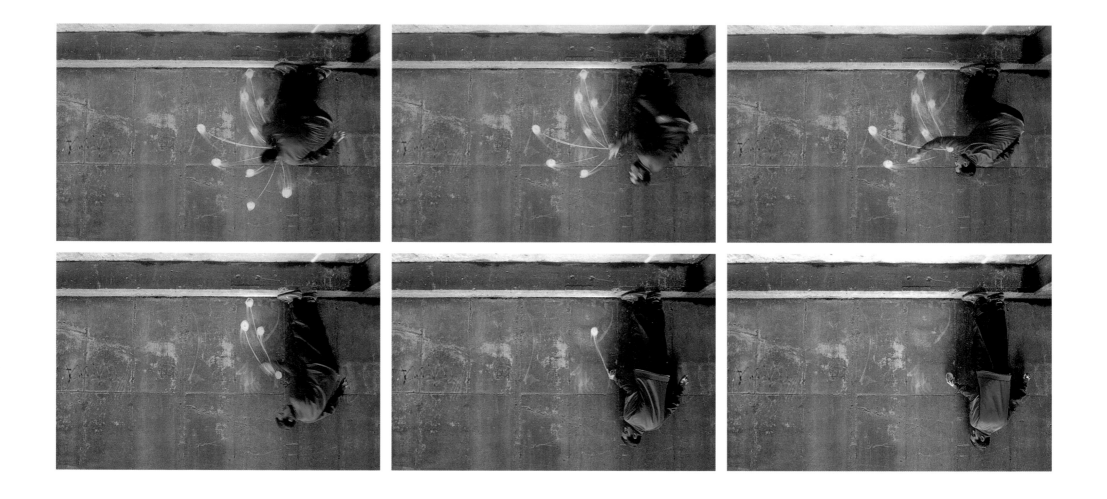

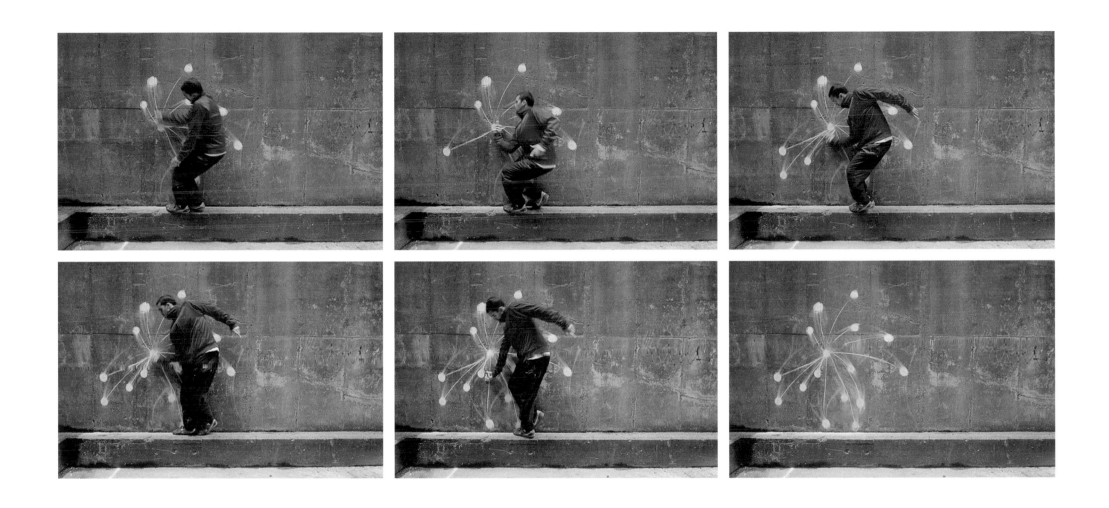

UNTITLED (YO YO) 2005

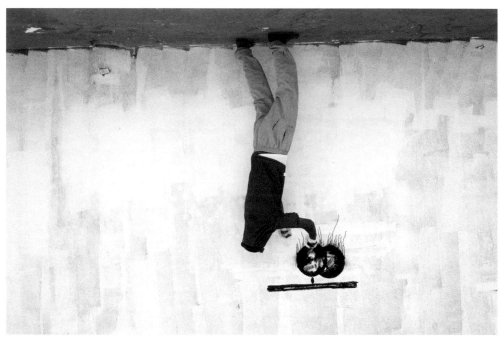
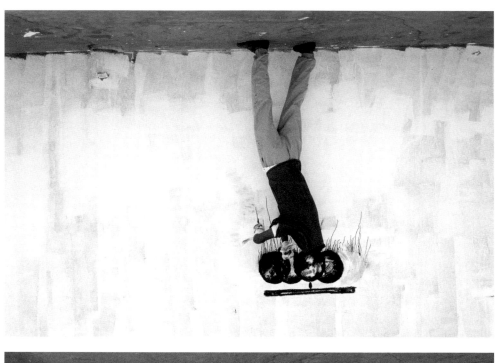
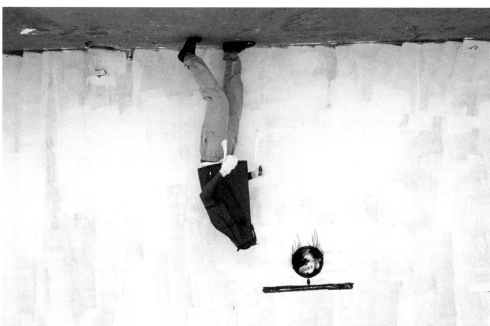
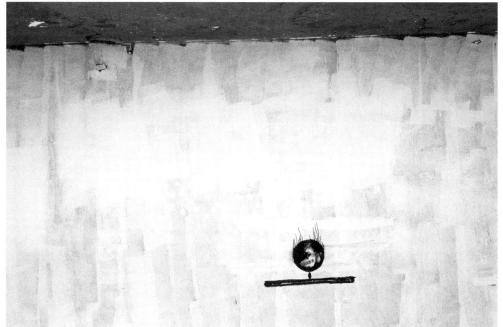

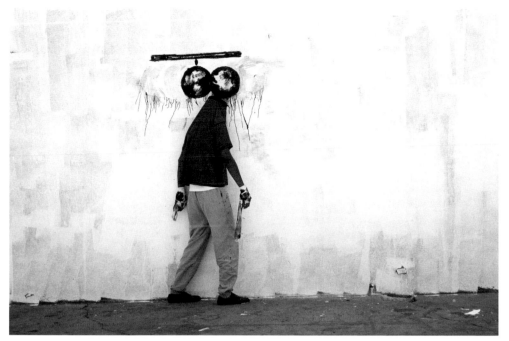
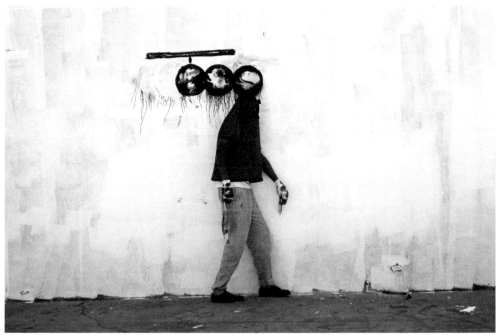
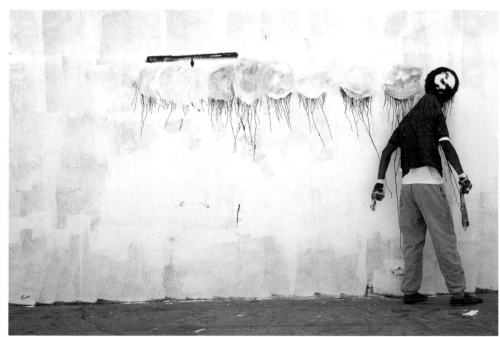
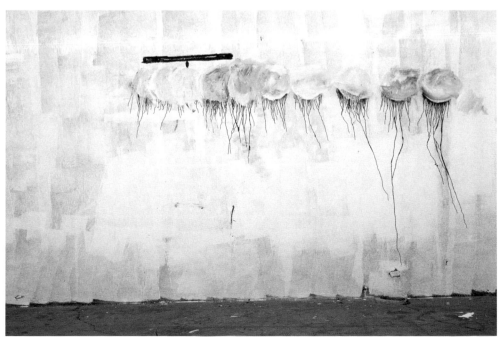

BLACKHEAD 2006

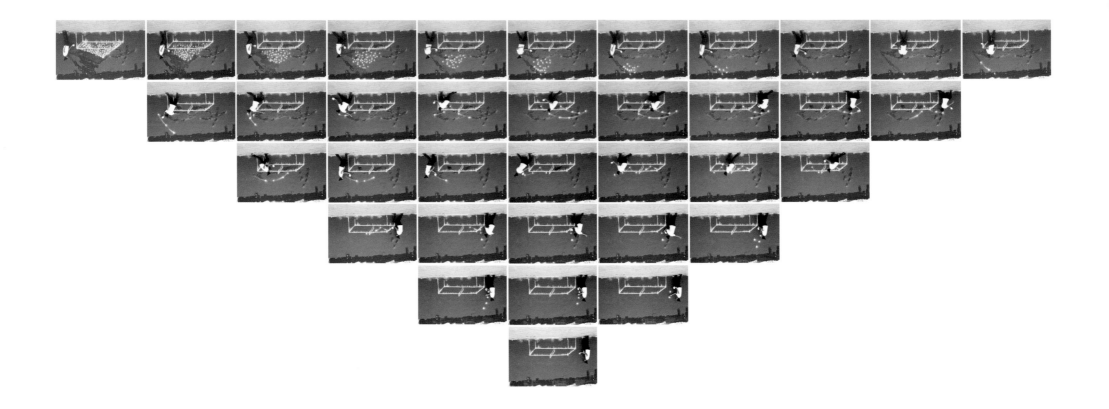

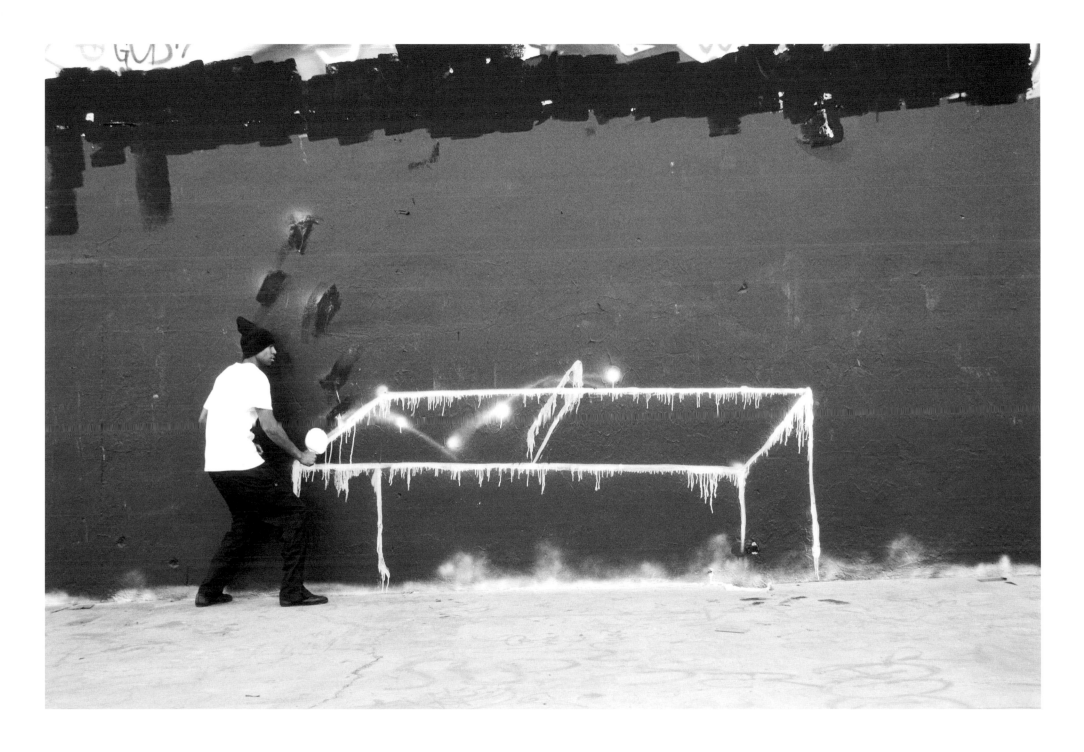

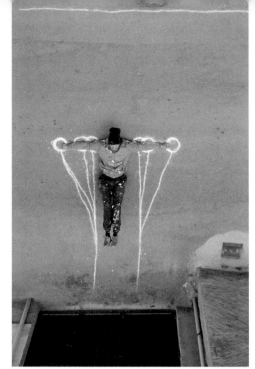
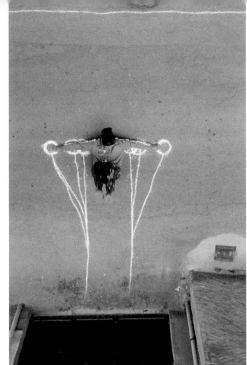
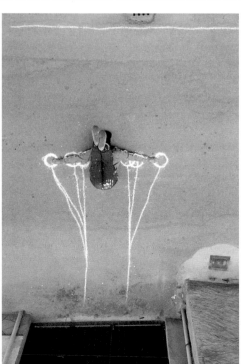
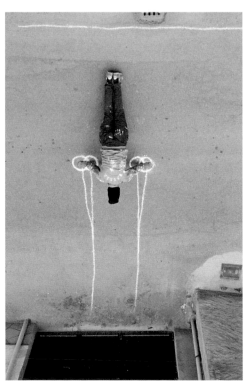
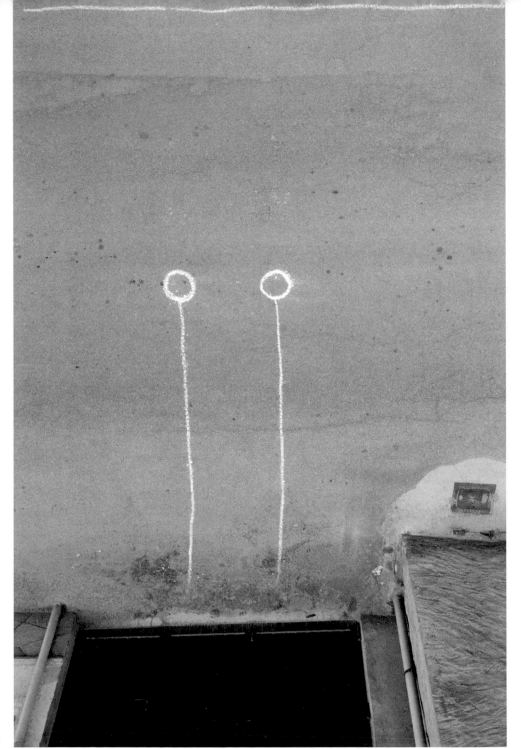

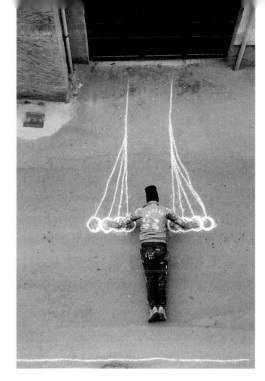
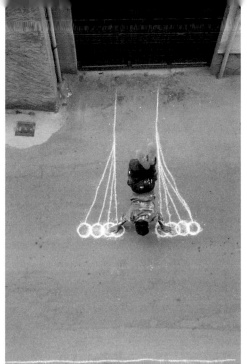
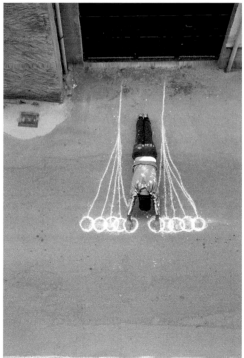
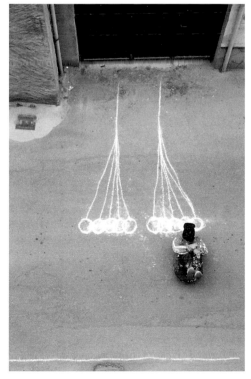
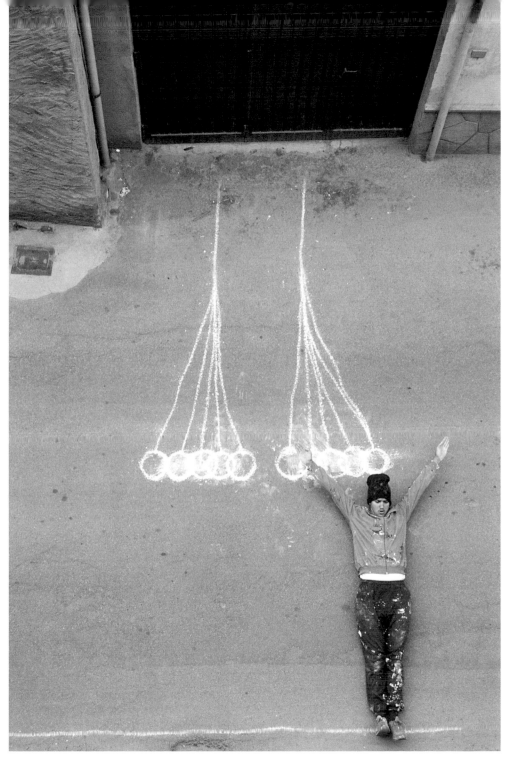

UNTITLED (RINGS) 2006

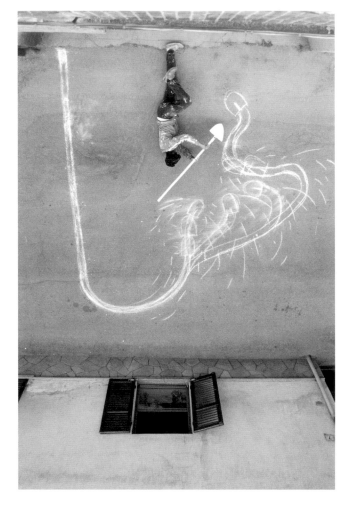
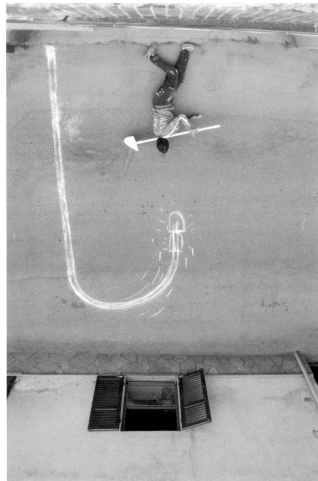
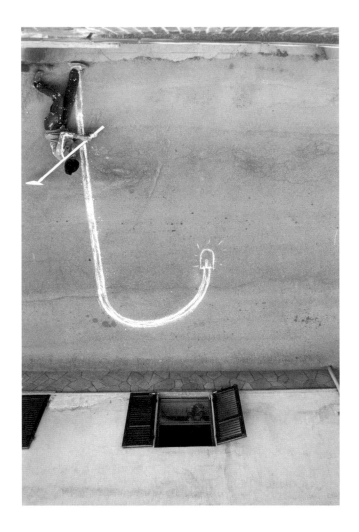

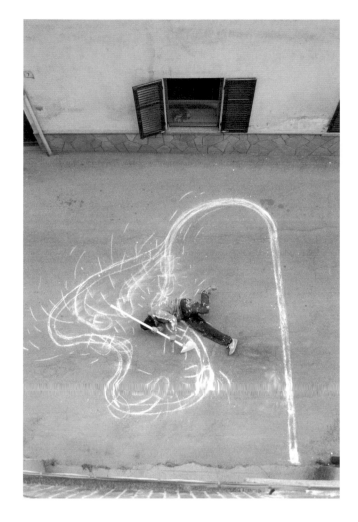
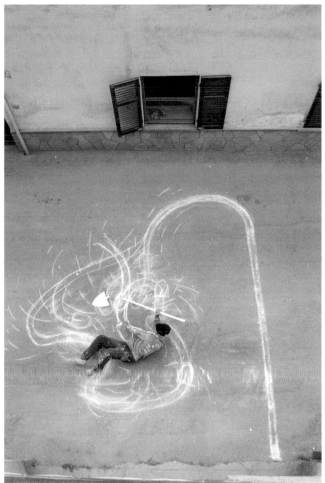
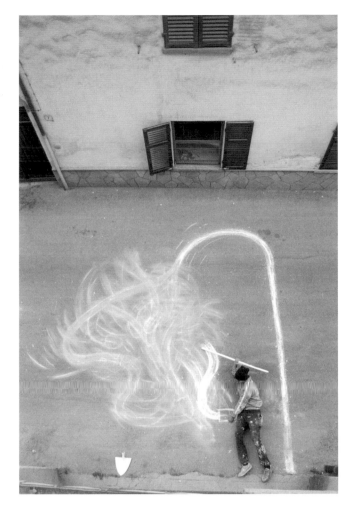

UNTITLED (STREET LIGHT) 2006

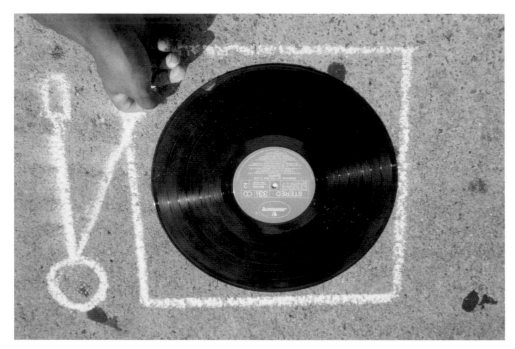
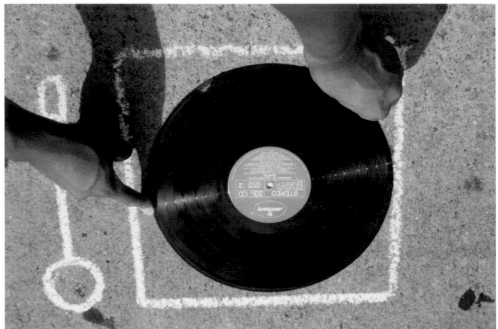
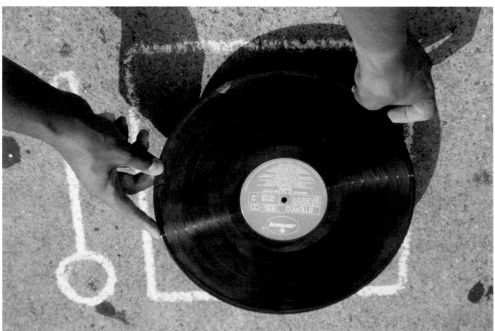

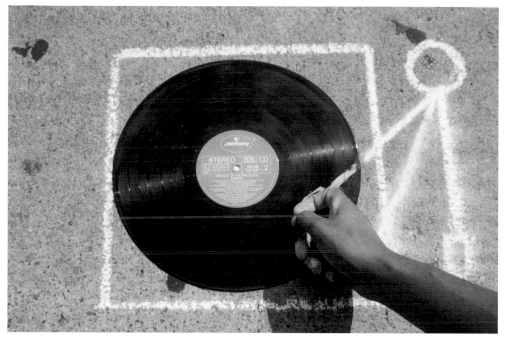
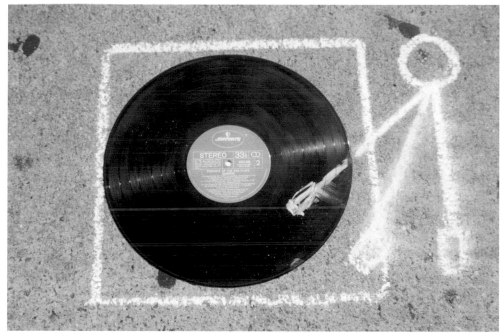
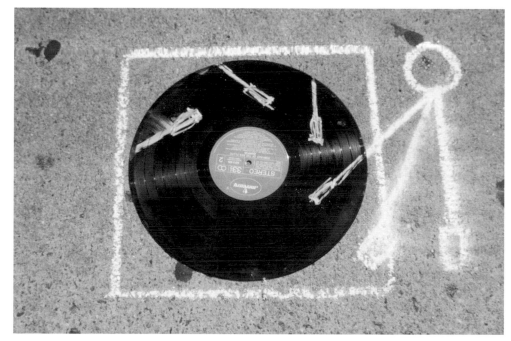
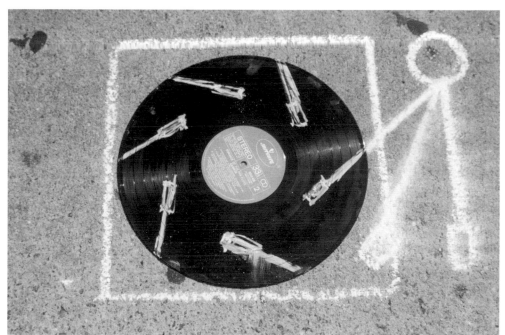

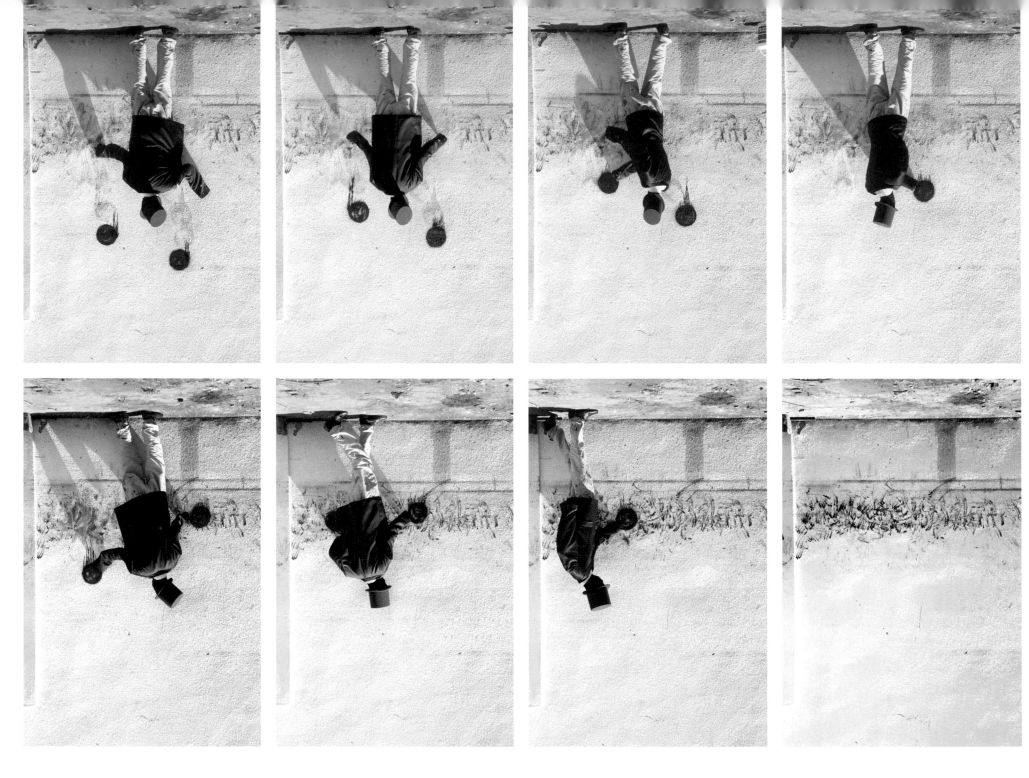

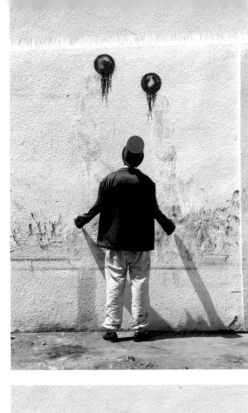
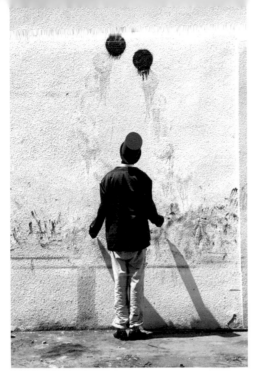
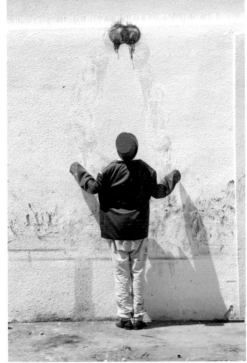
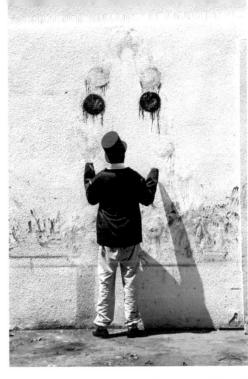
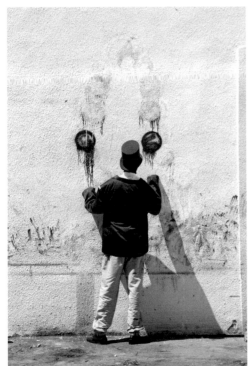
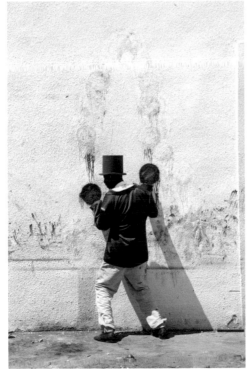
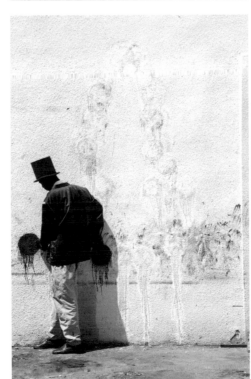

JUGGLA 2007

ANIMATIONS

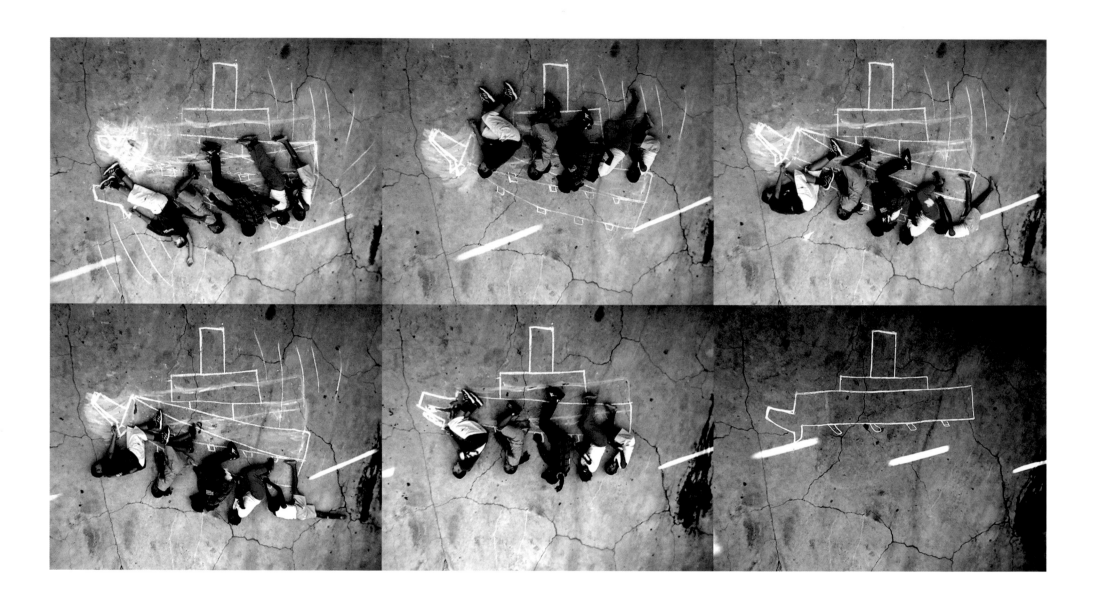

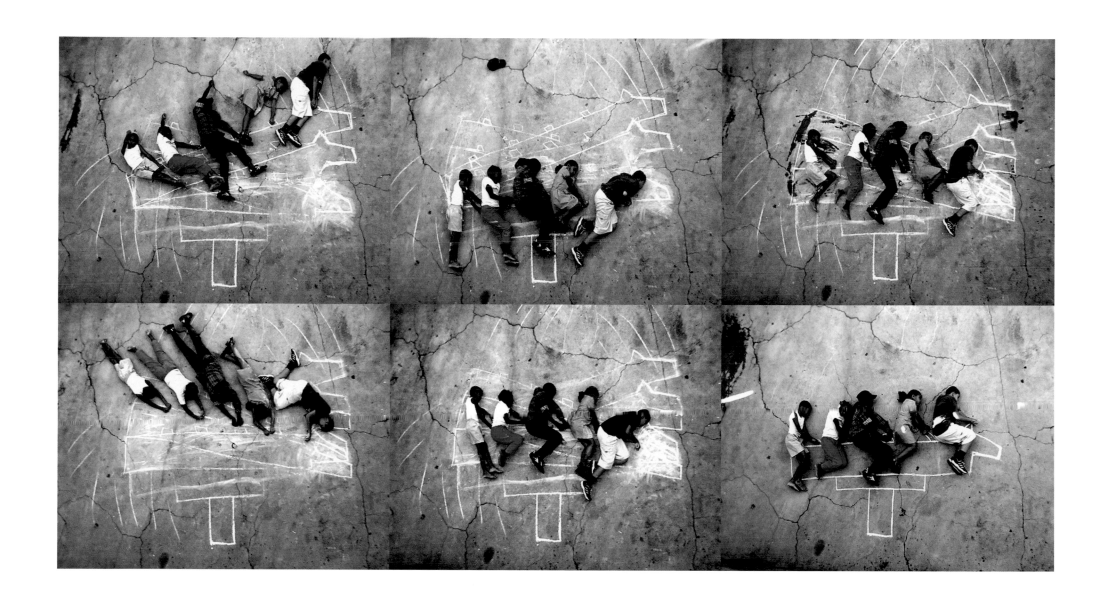

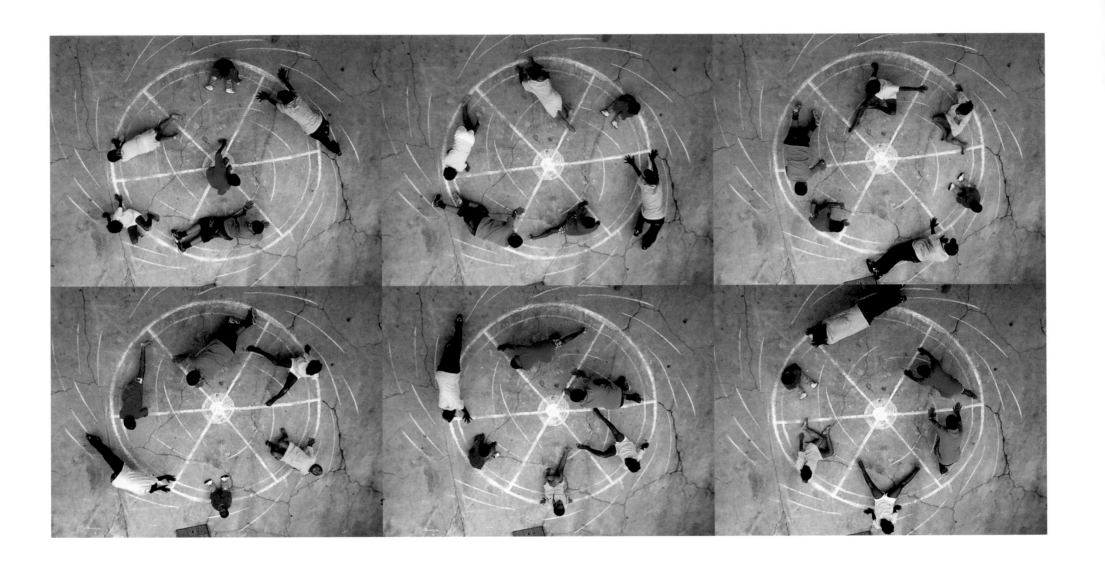

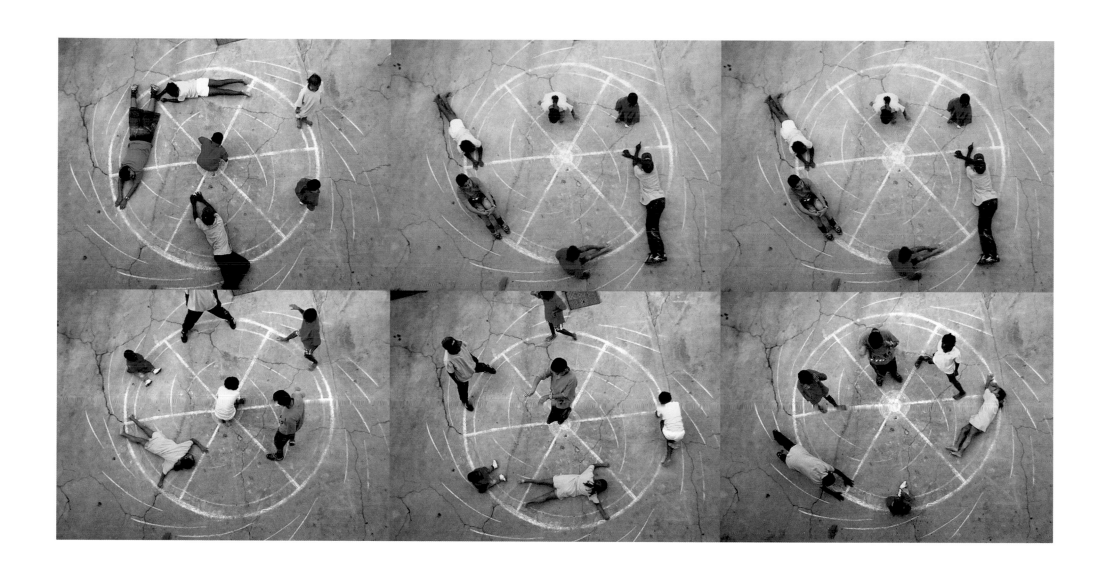

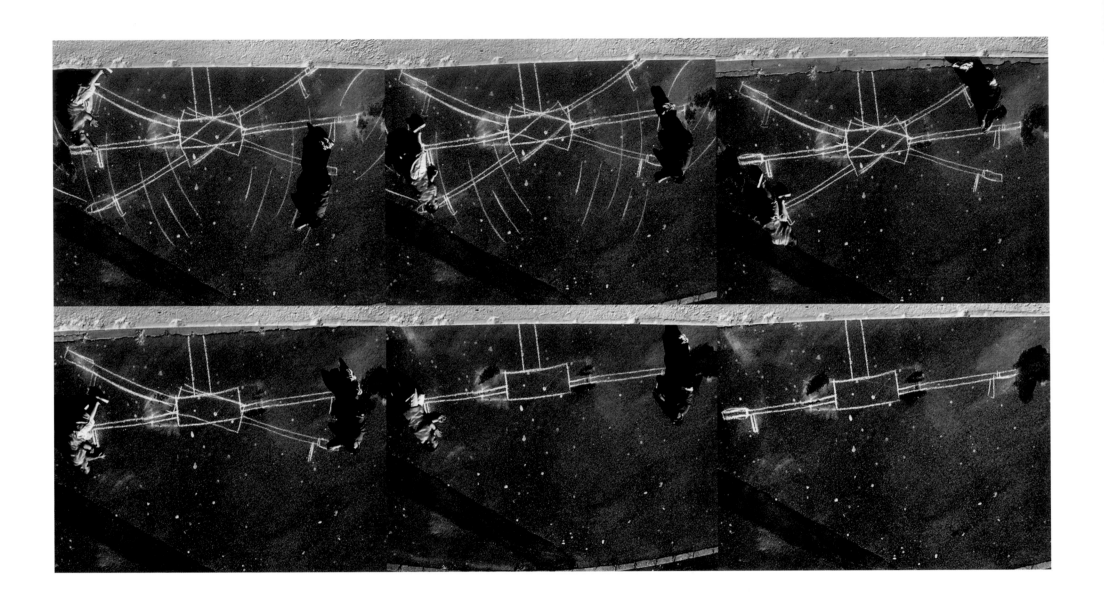

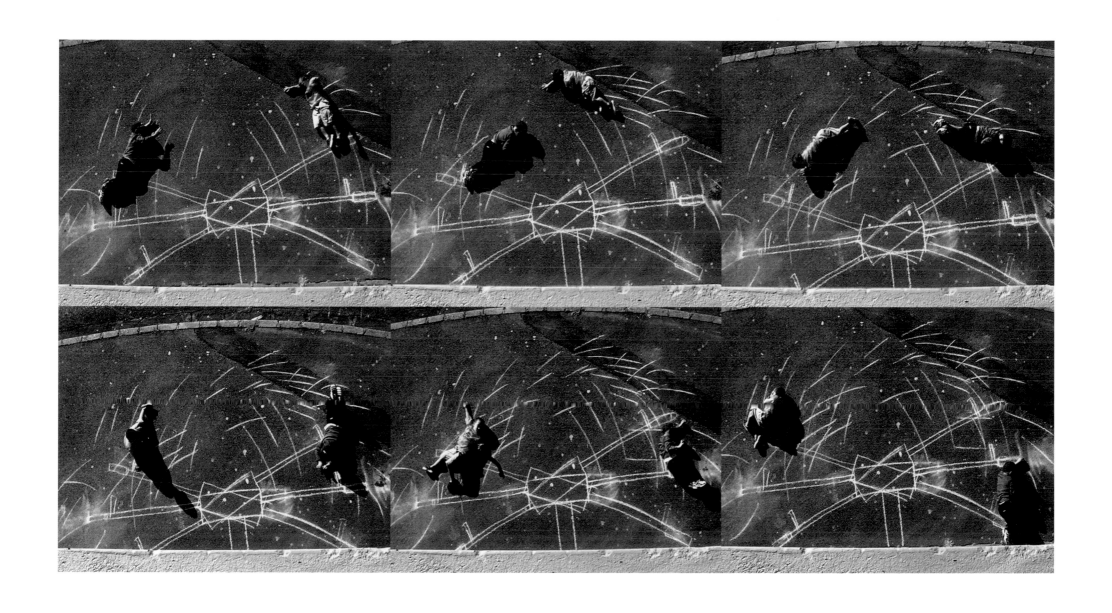

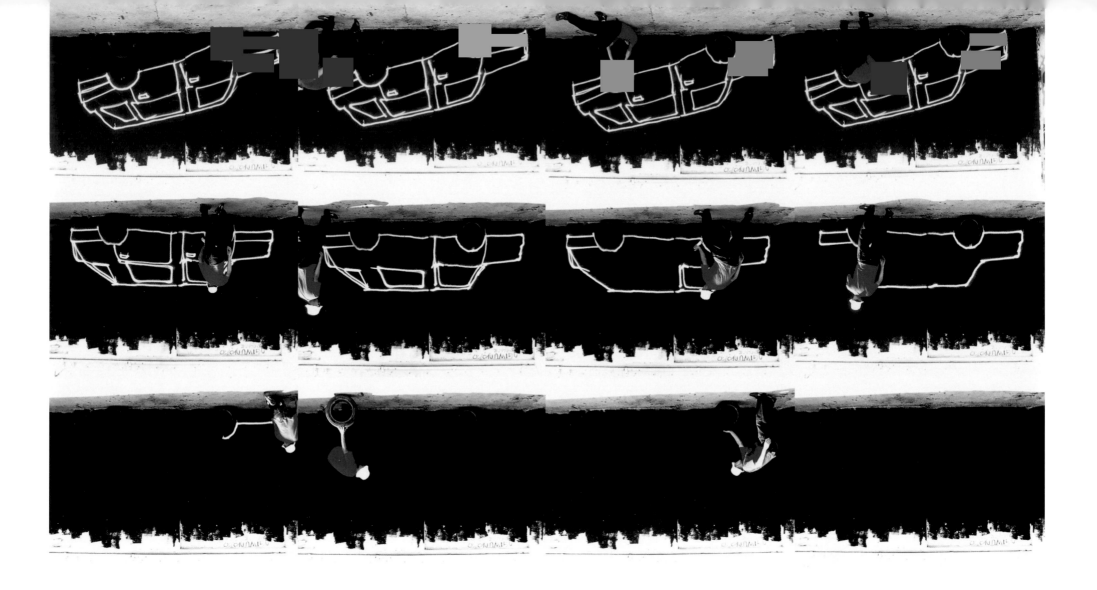

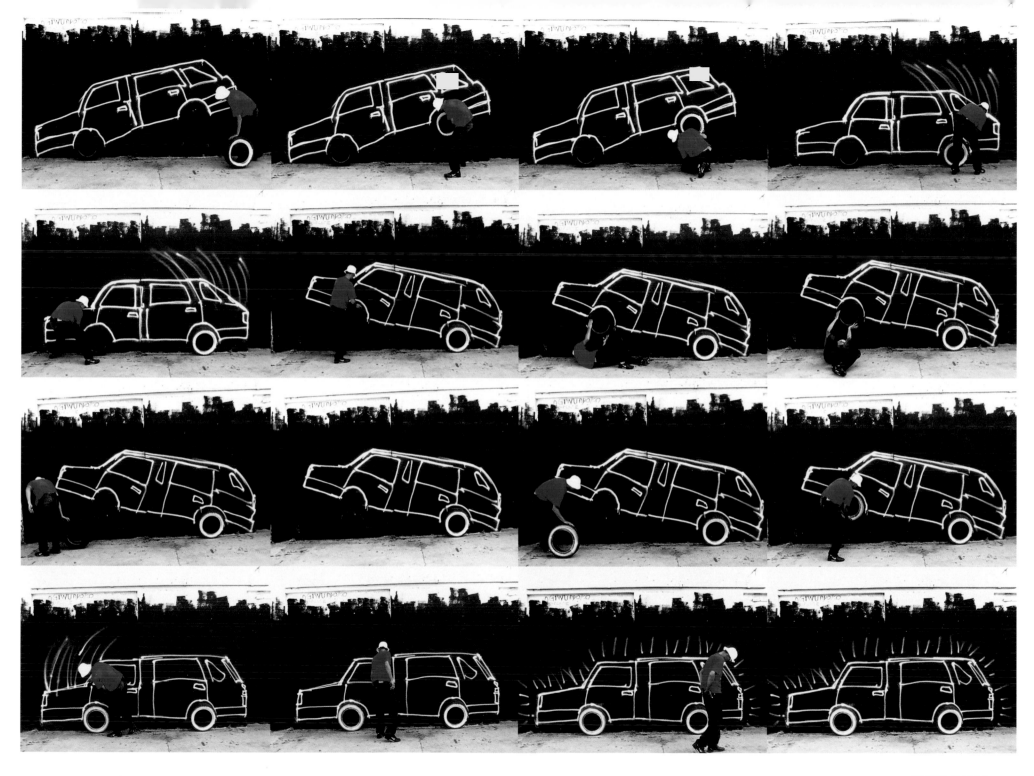

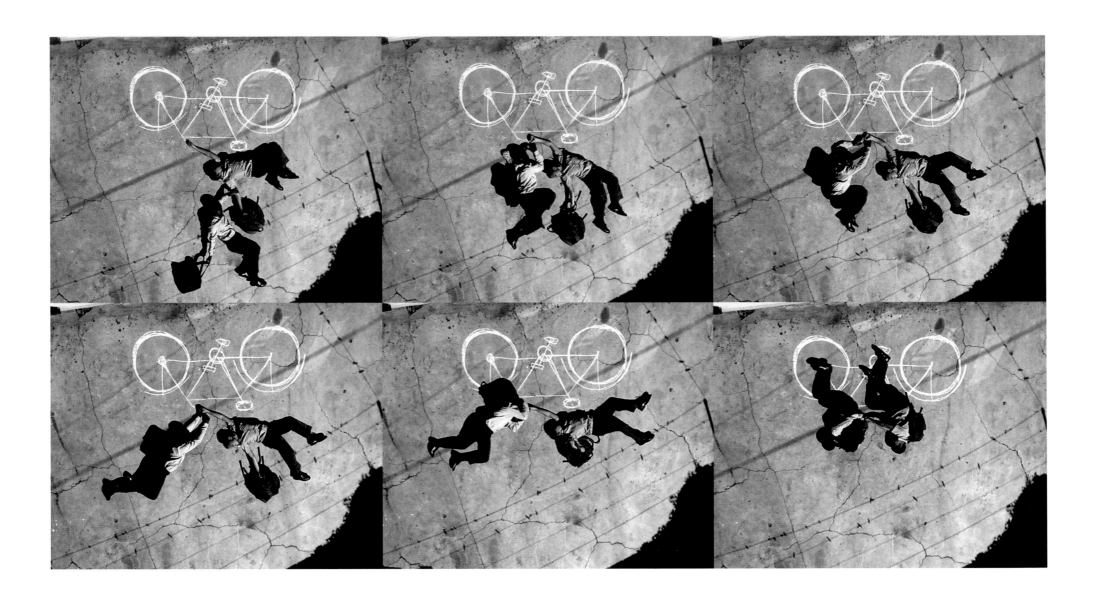

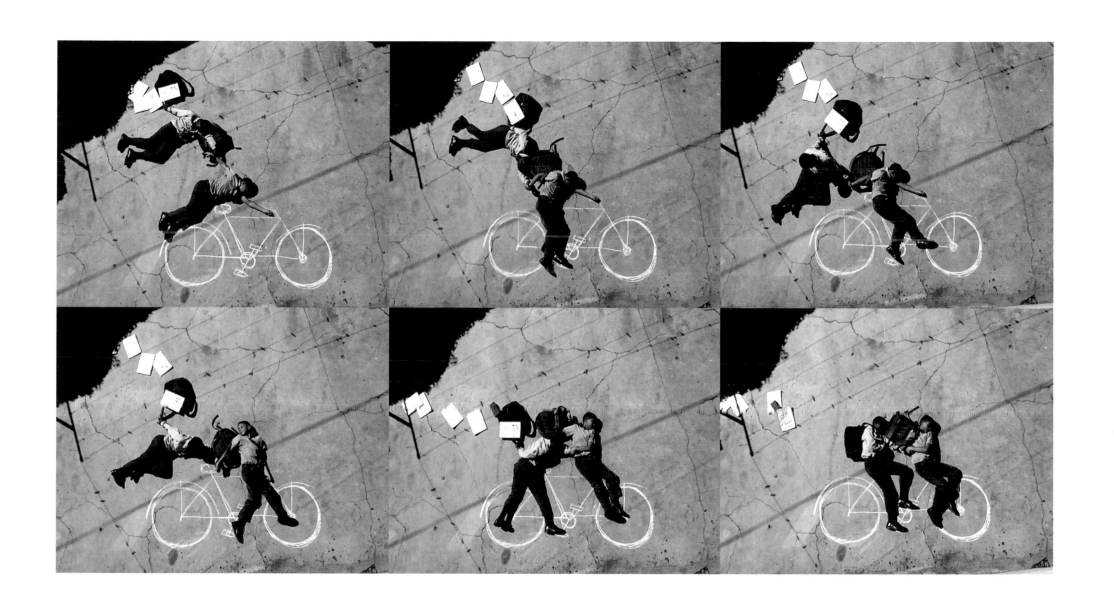

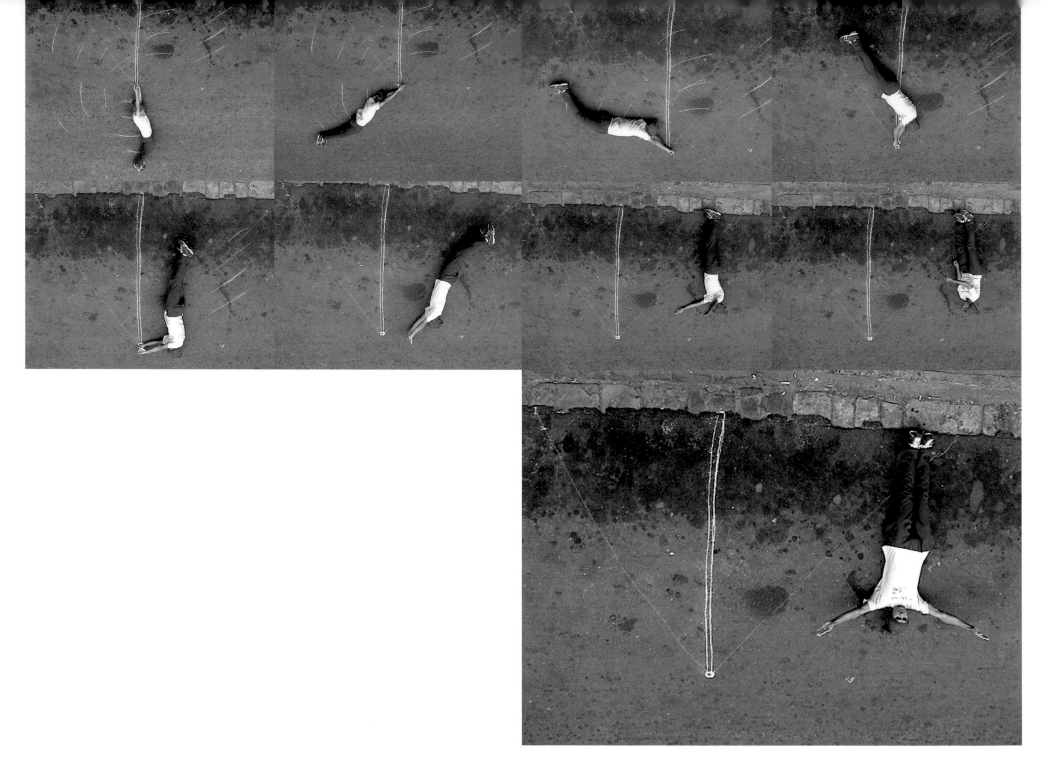

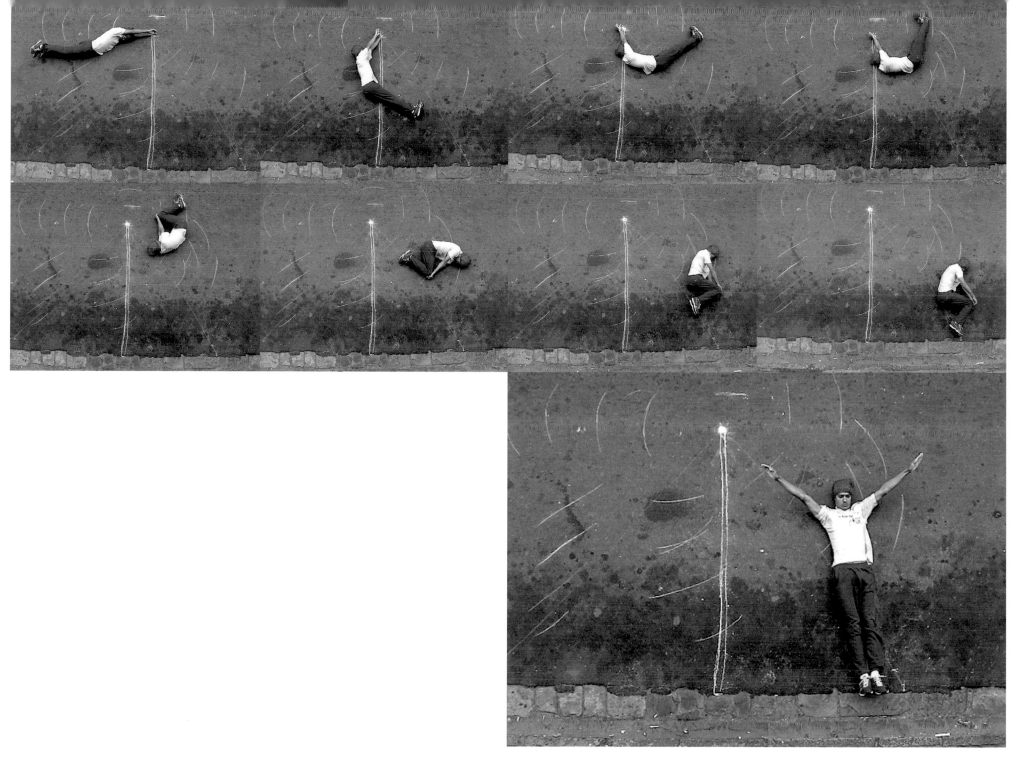

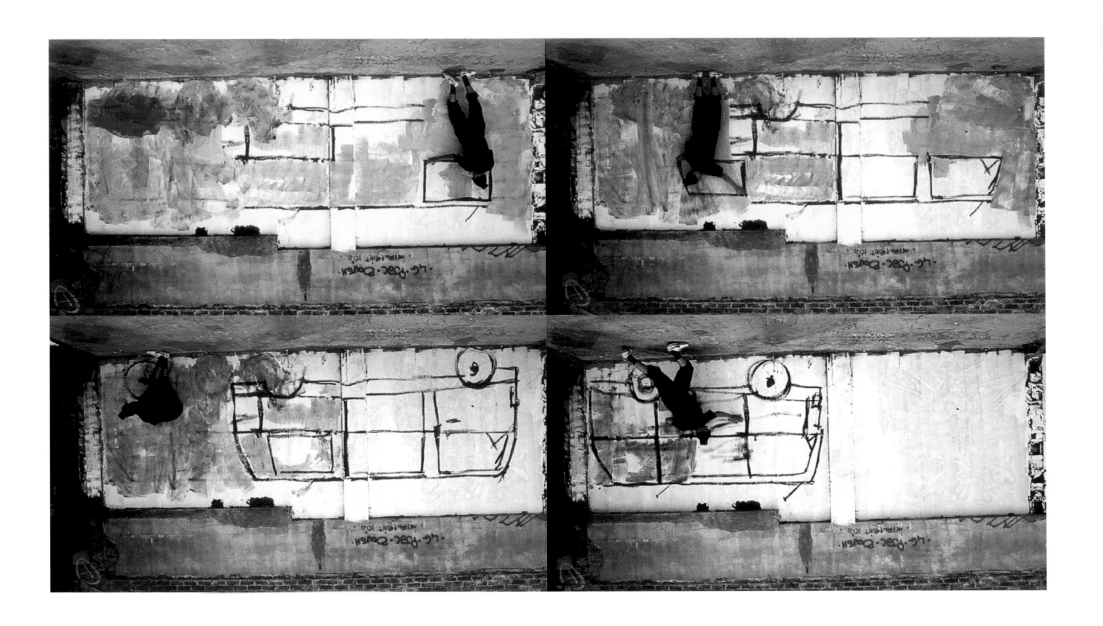

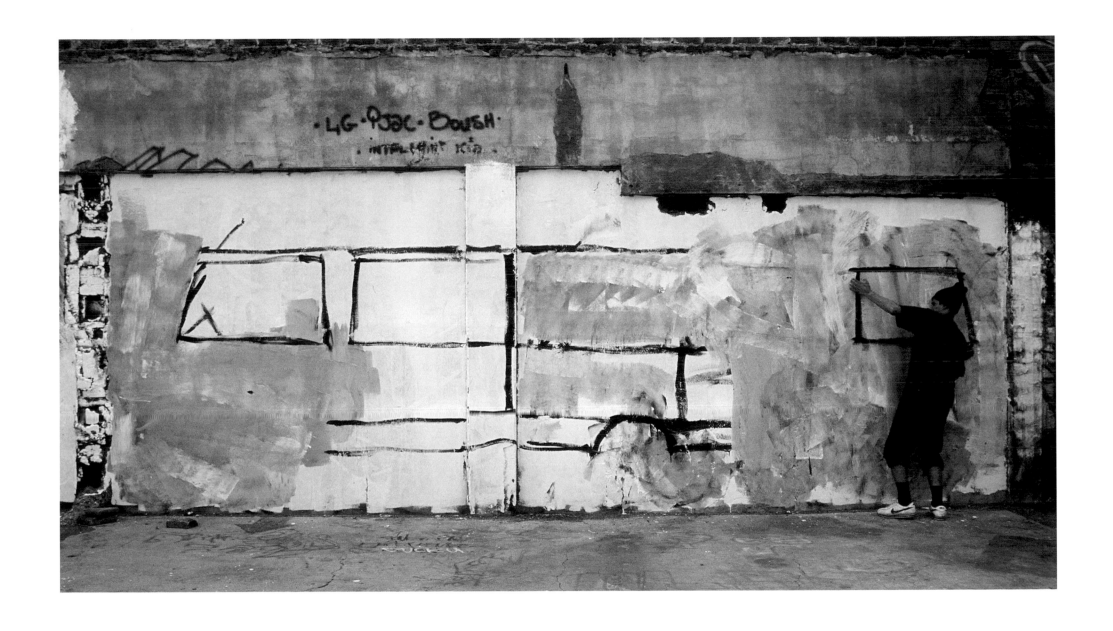

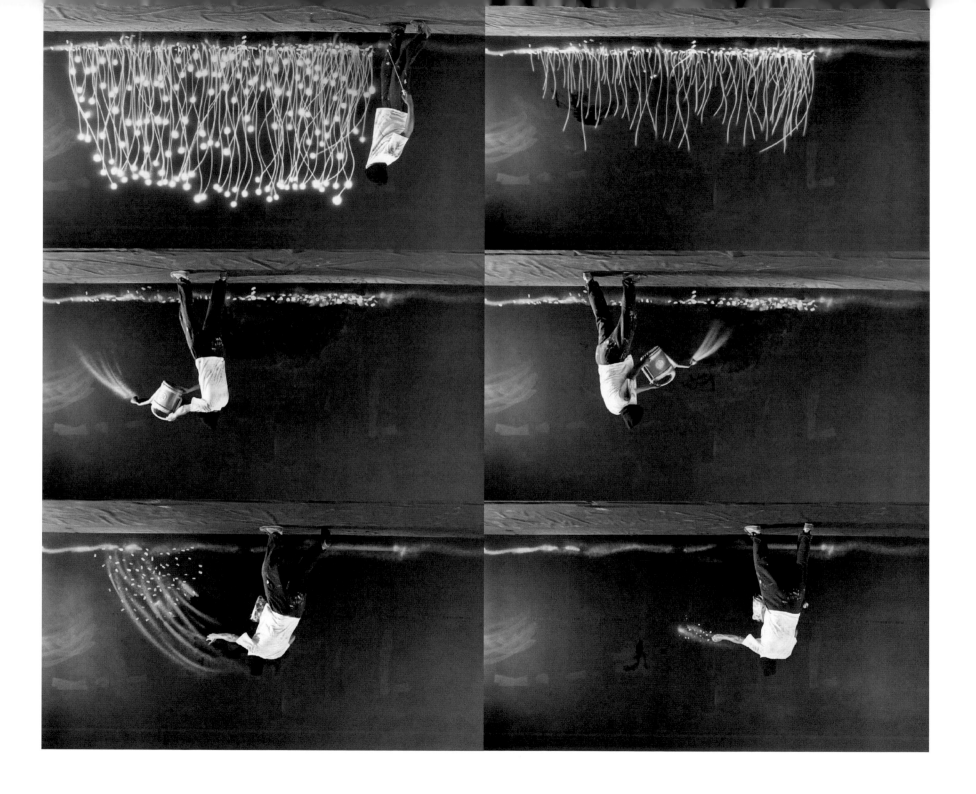

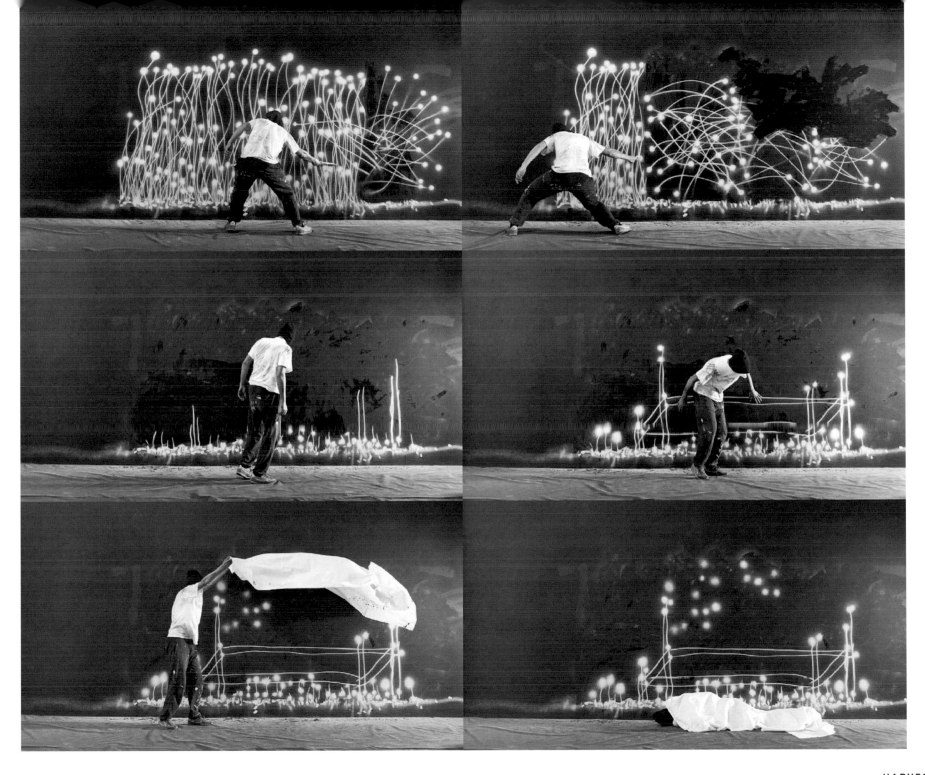

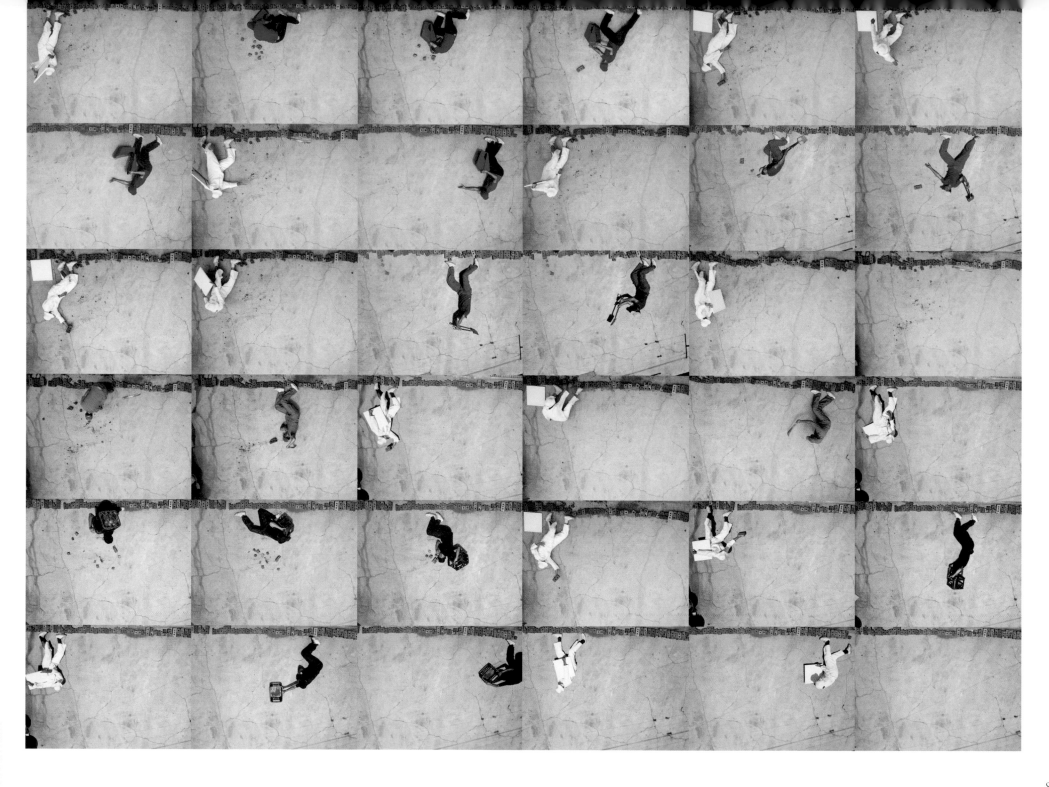

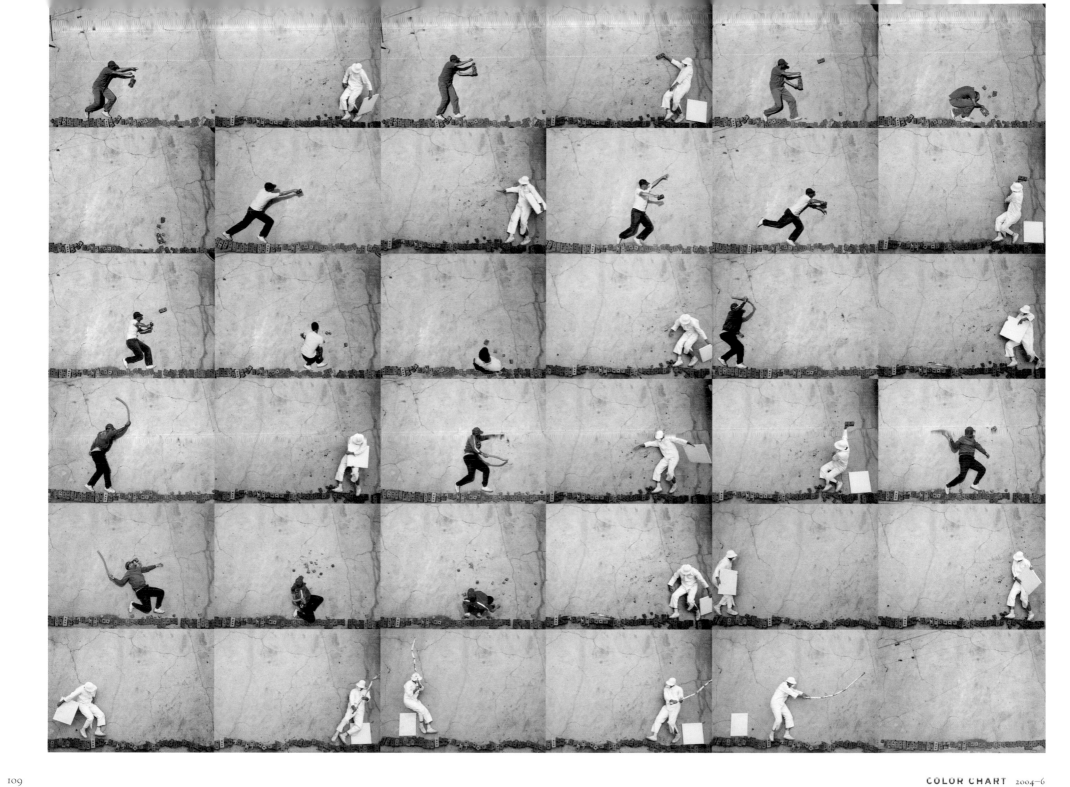

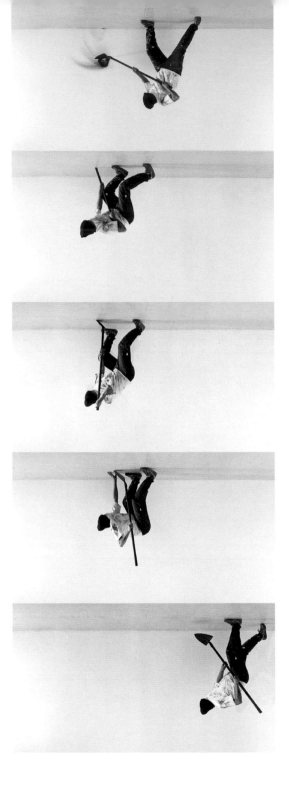

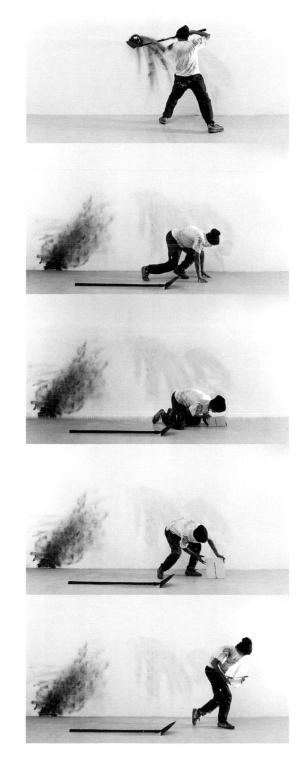

UNTITLED (SPADE FOR SPADE) 2005

PERFORMANCES

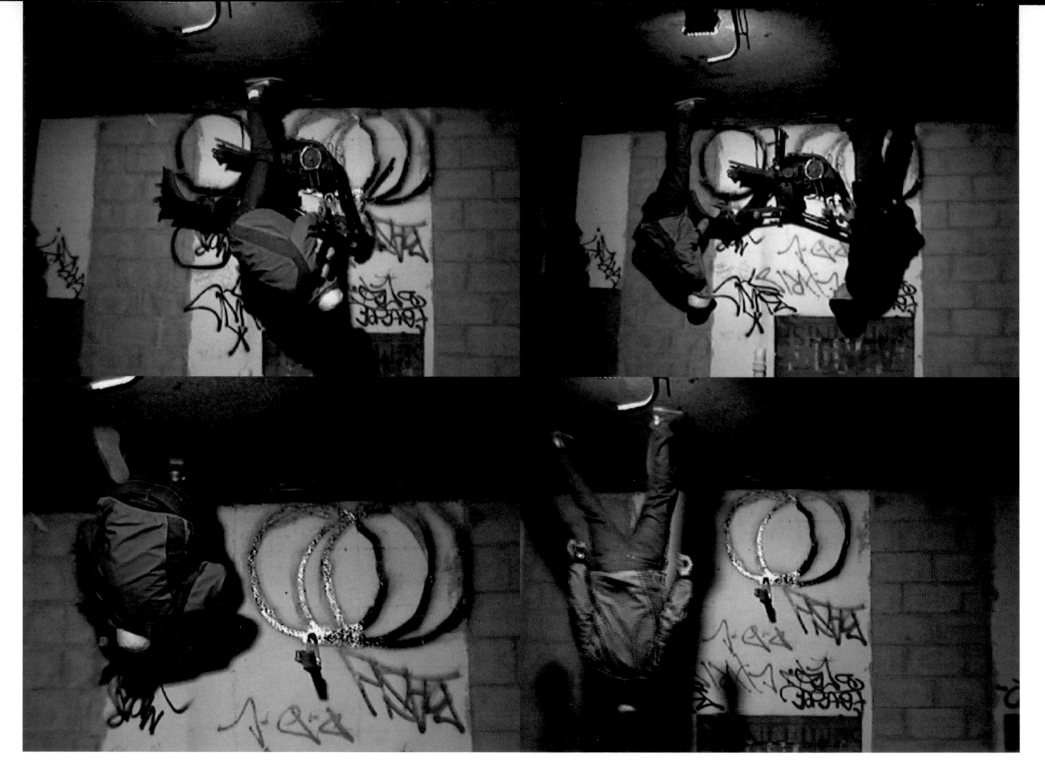

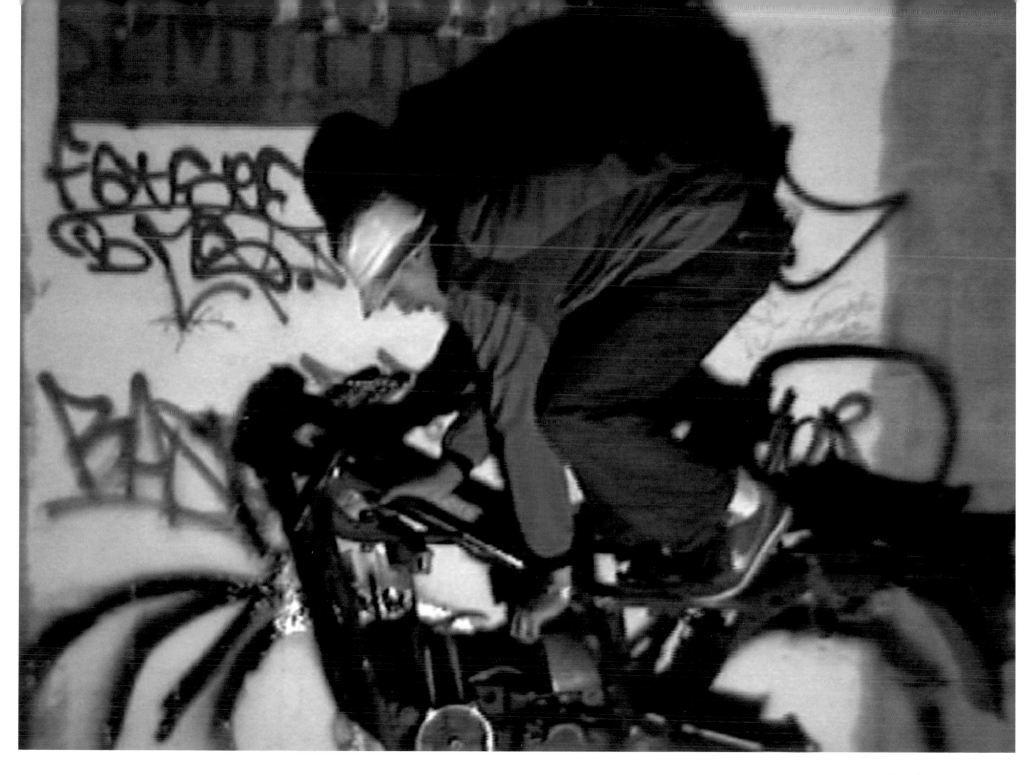

MOTORBIKE Gasworks Gallery, London, 2001

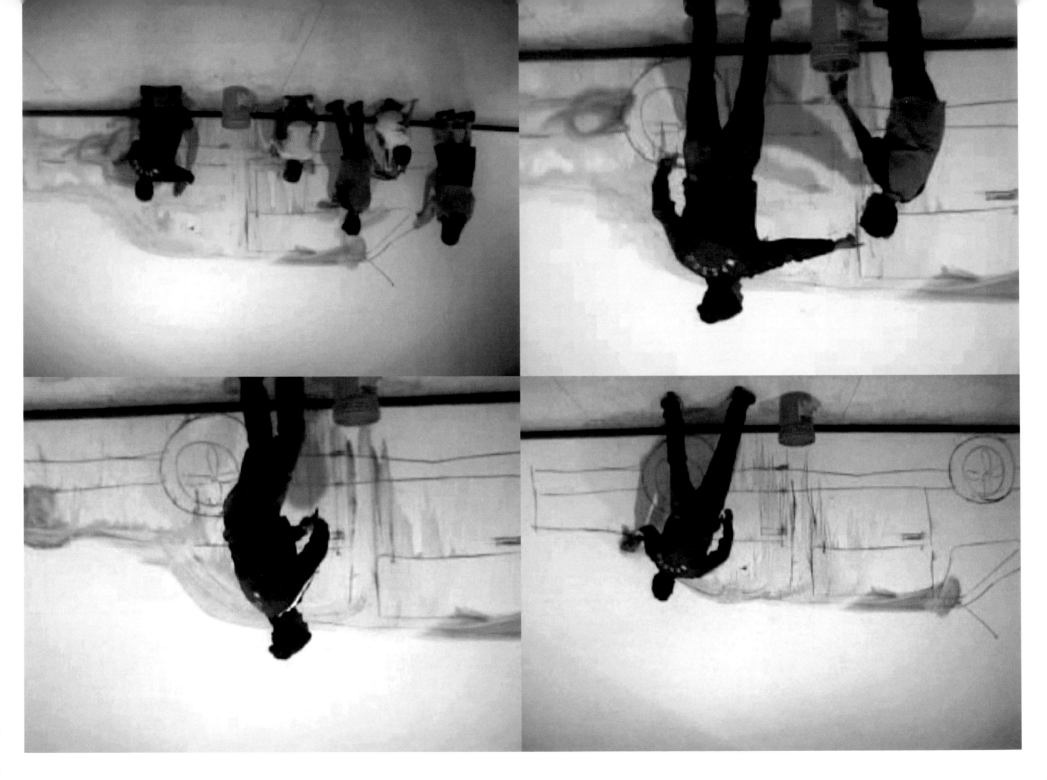

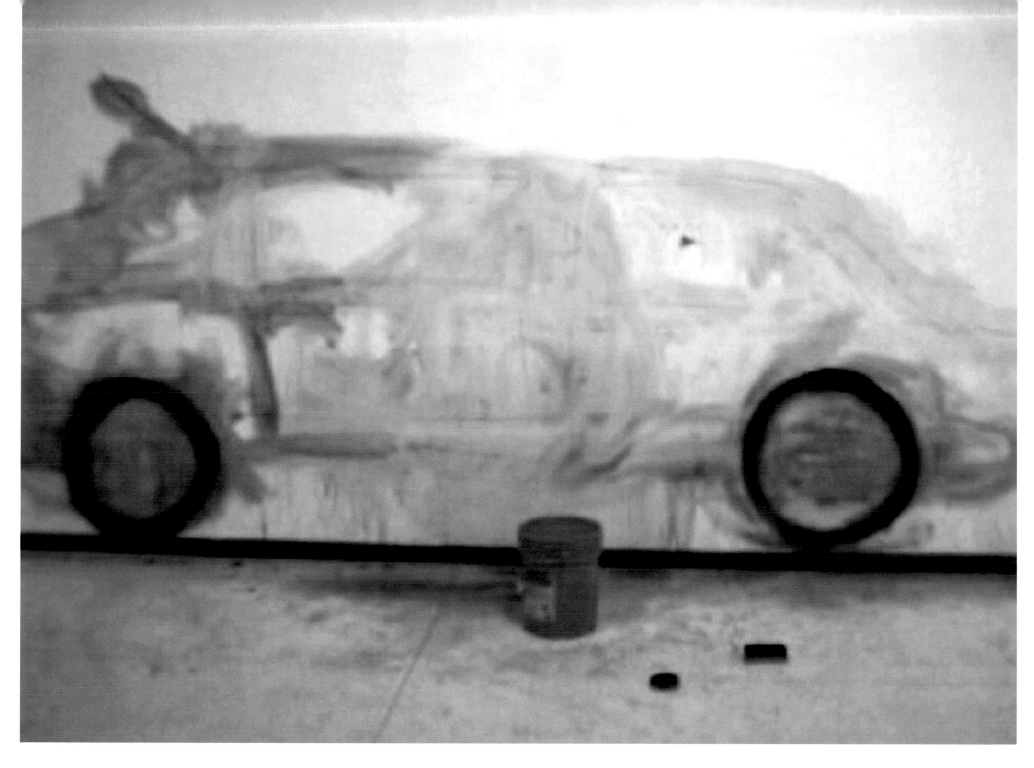

CAR WASH Walker Art Center, Minneapolis, 2003

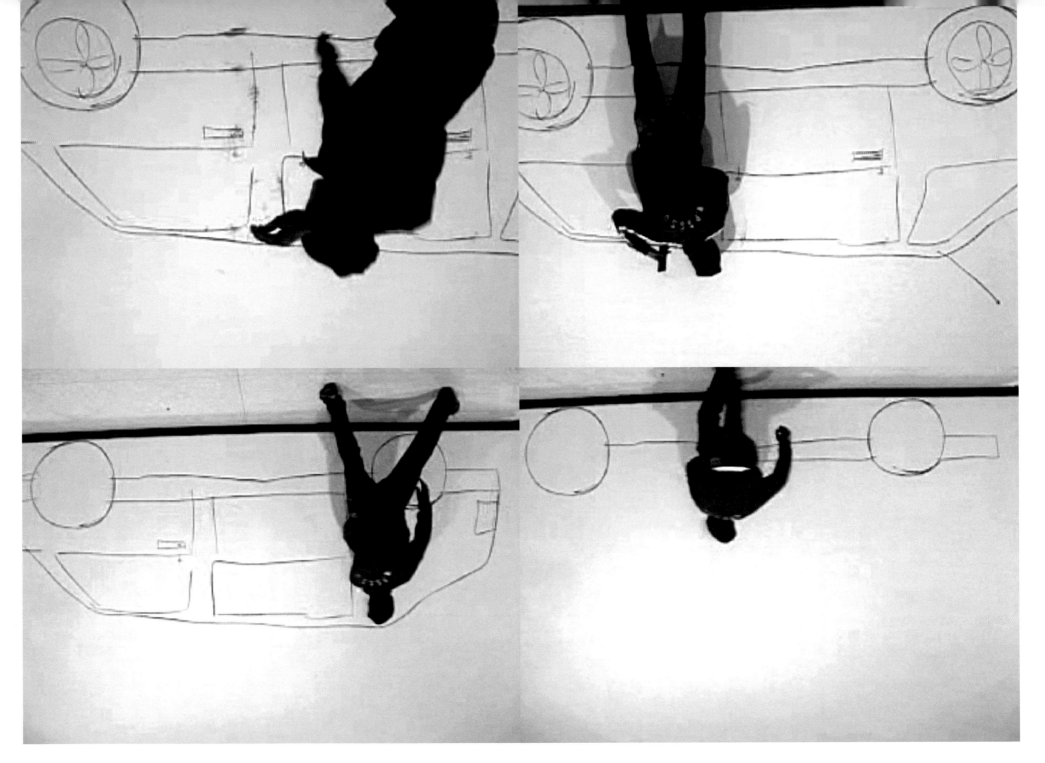

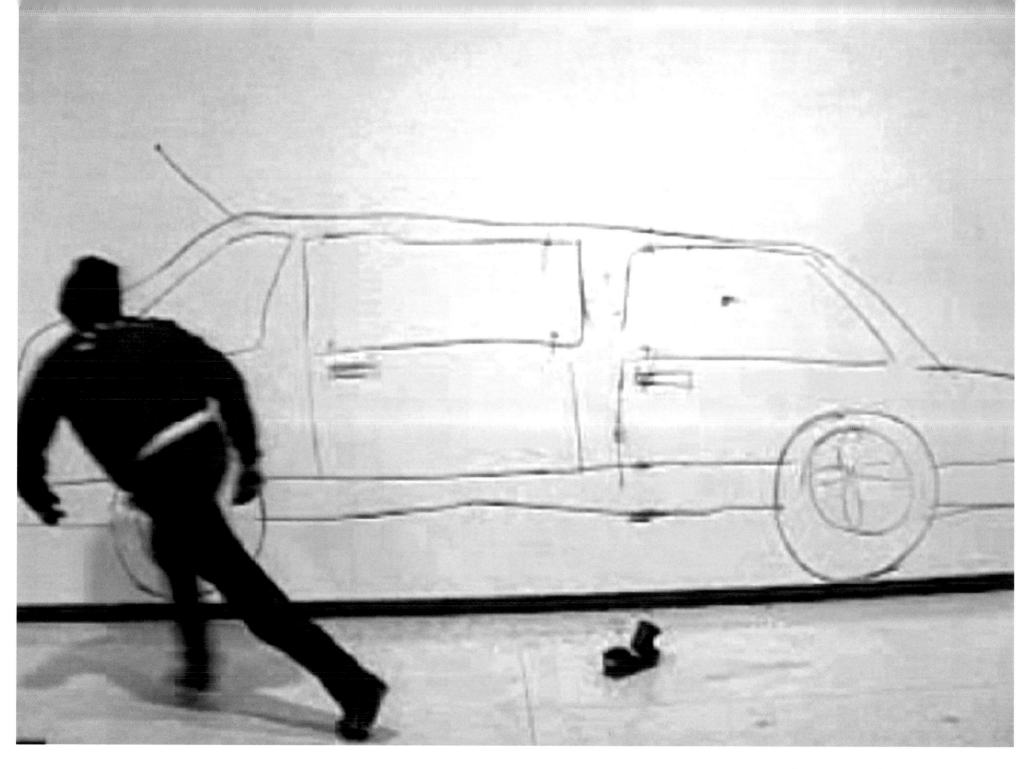

CAR THEFT Walker Art Center, Minneapolis, 2003

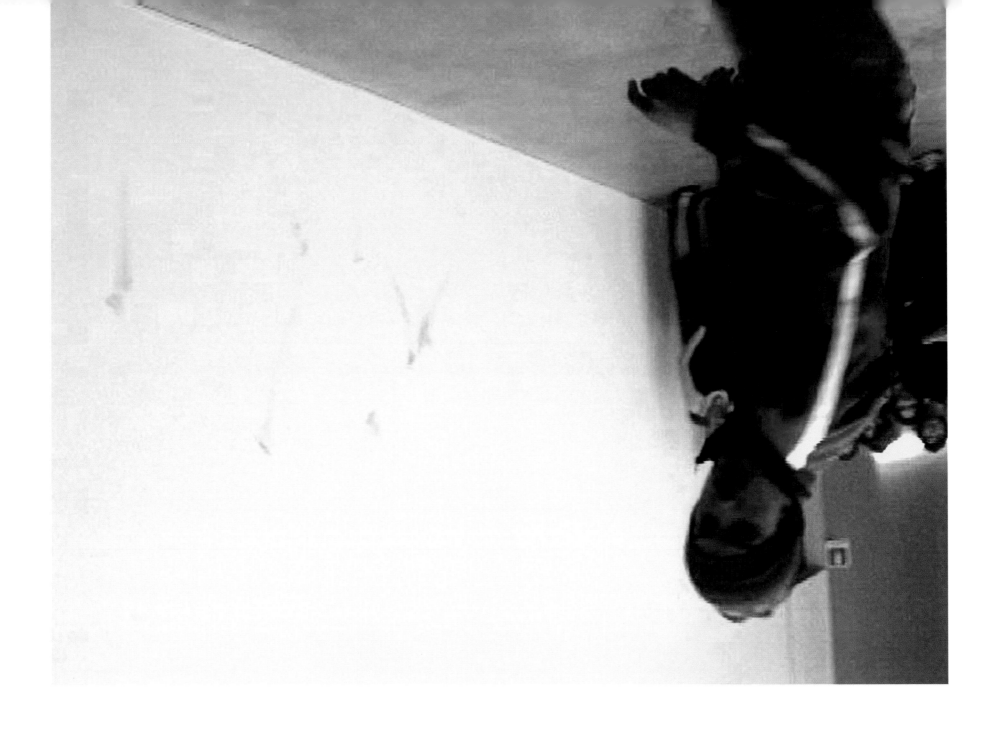

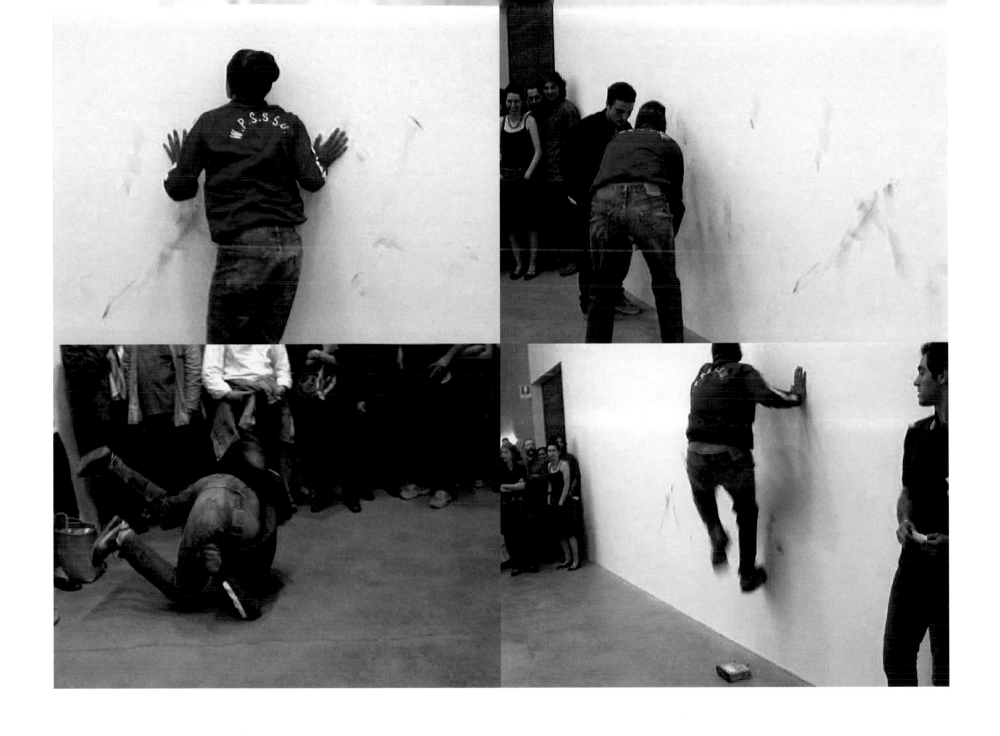

UNTITLED Fondazione Sandretto Re Rebaudengo, Turin, 2003

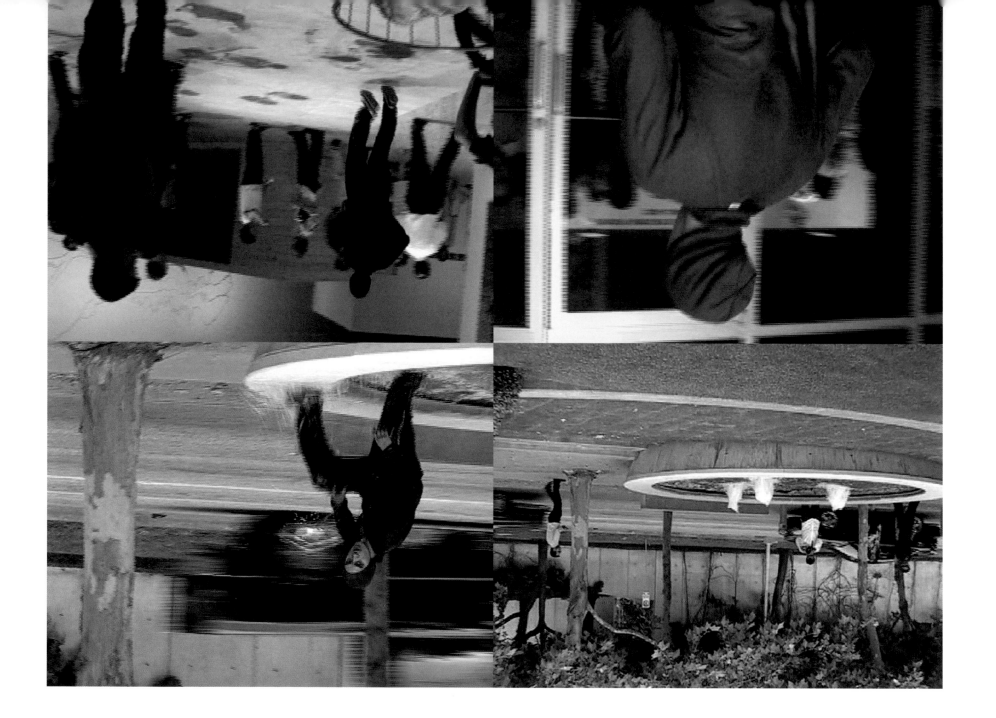

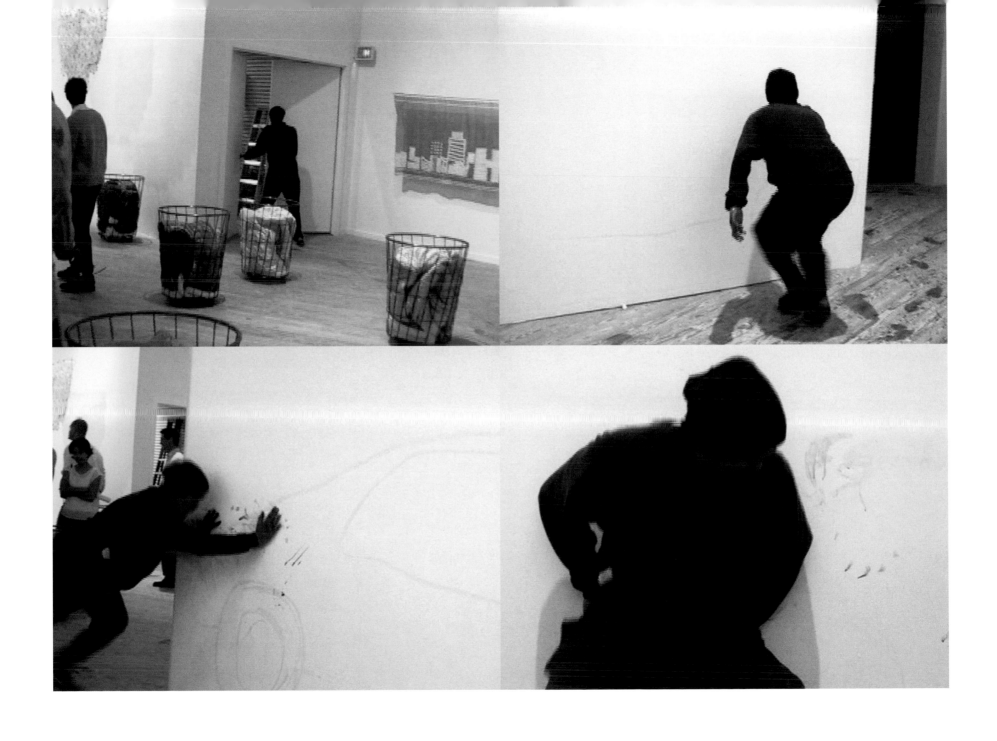

UNTITLED (EXIT/ENTRY) Contemporary Arts Museum, Houston, 2004

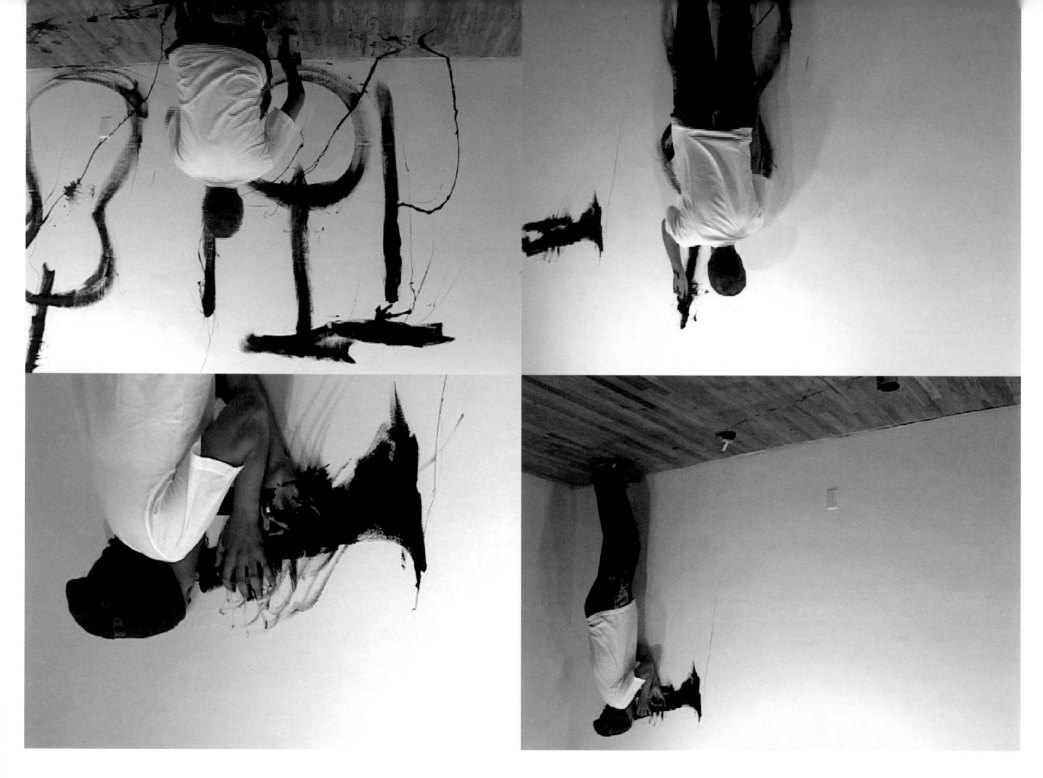

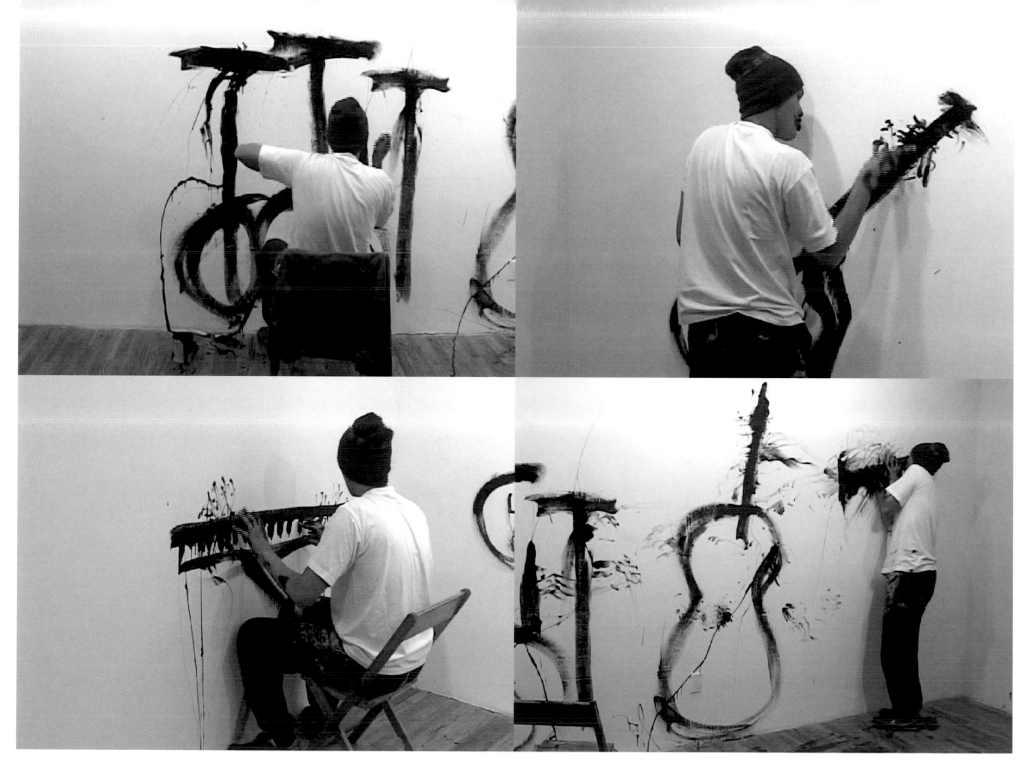

THE SCORE Artists Space, New York, 2004

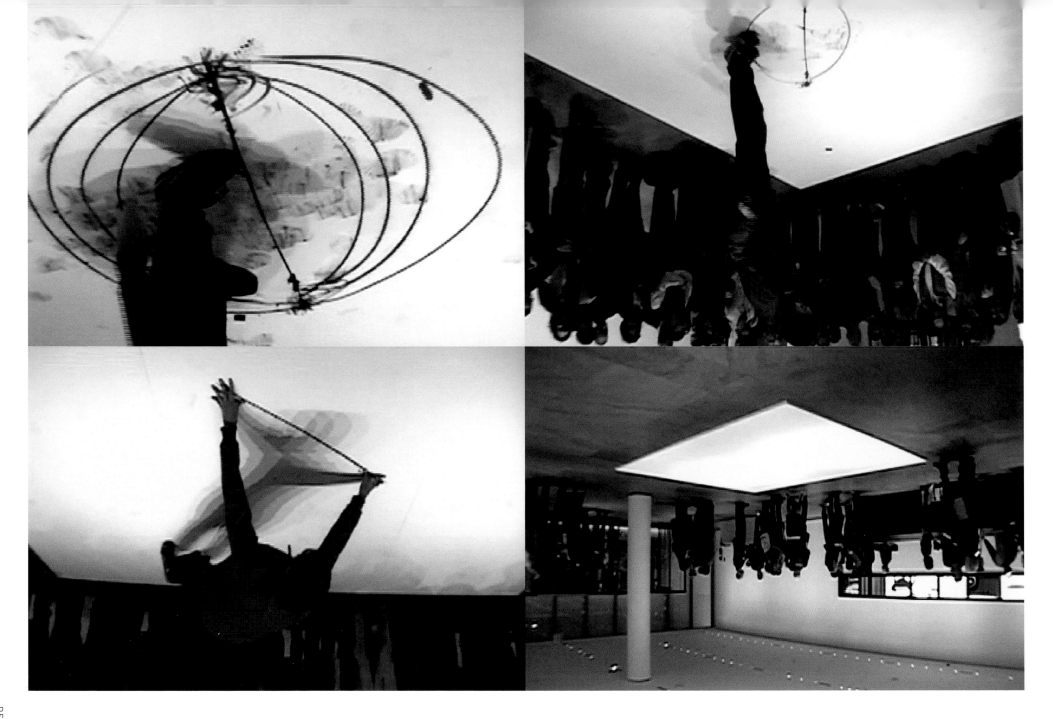

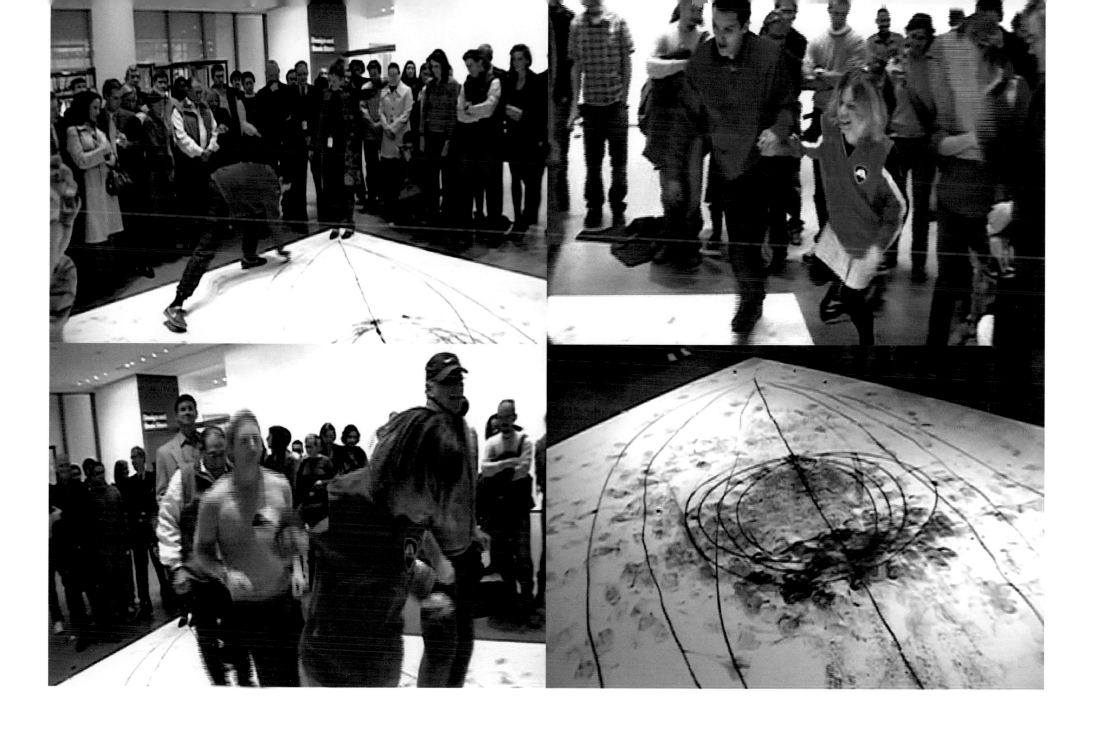

UNTITLED (SKIPPING ROPE) The Museum of Modern Art, New York, 2005

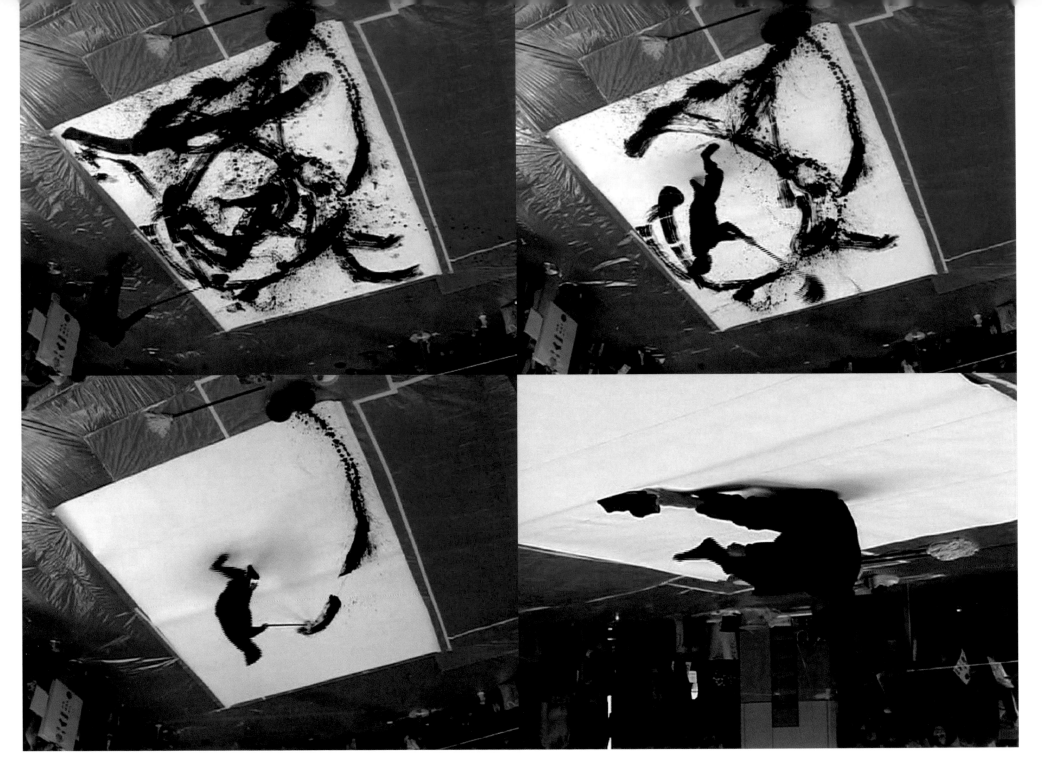

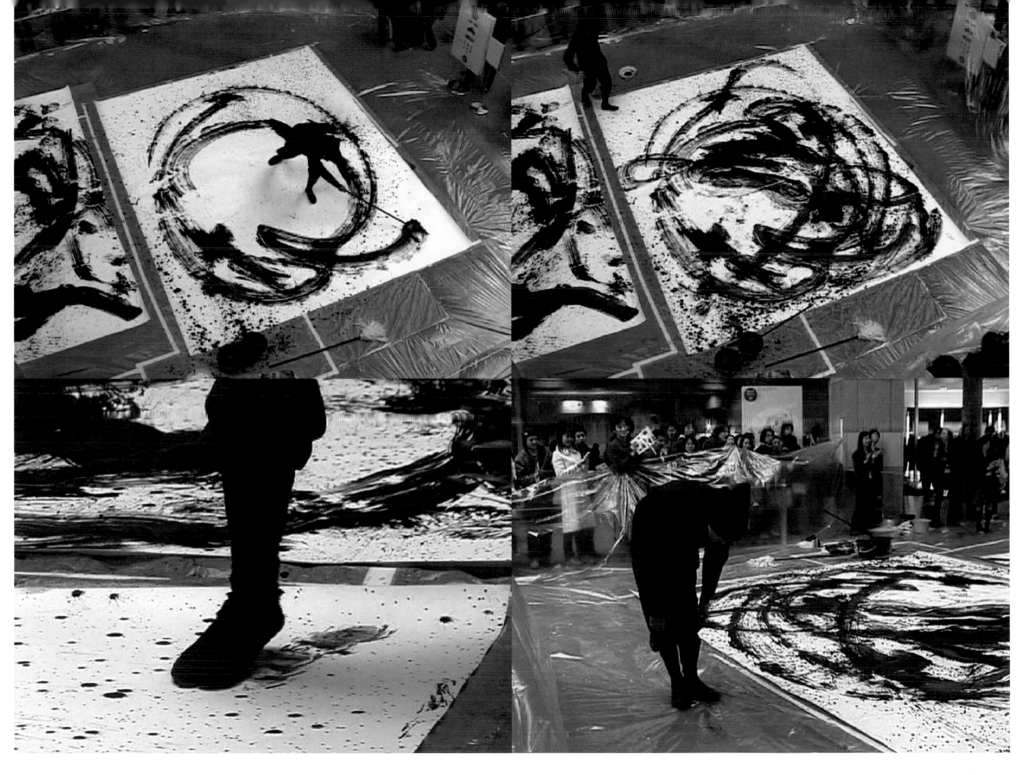

FILM PROJECTS

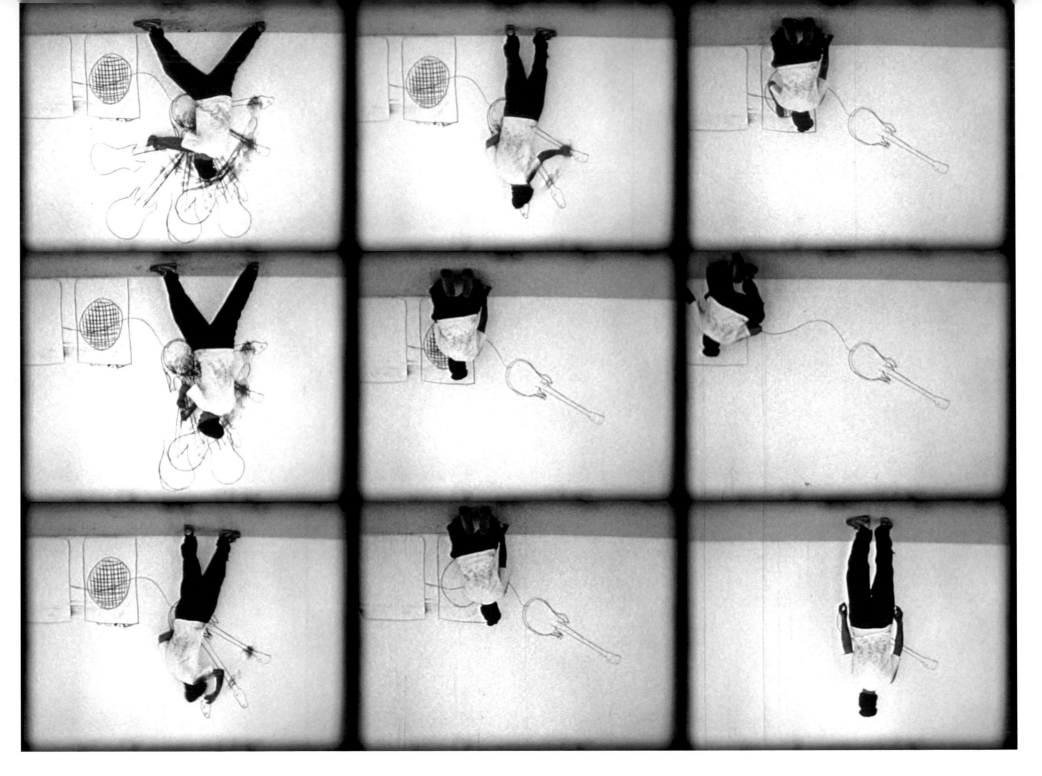

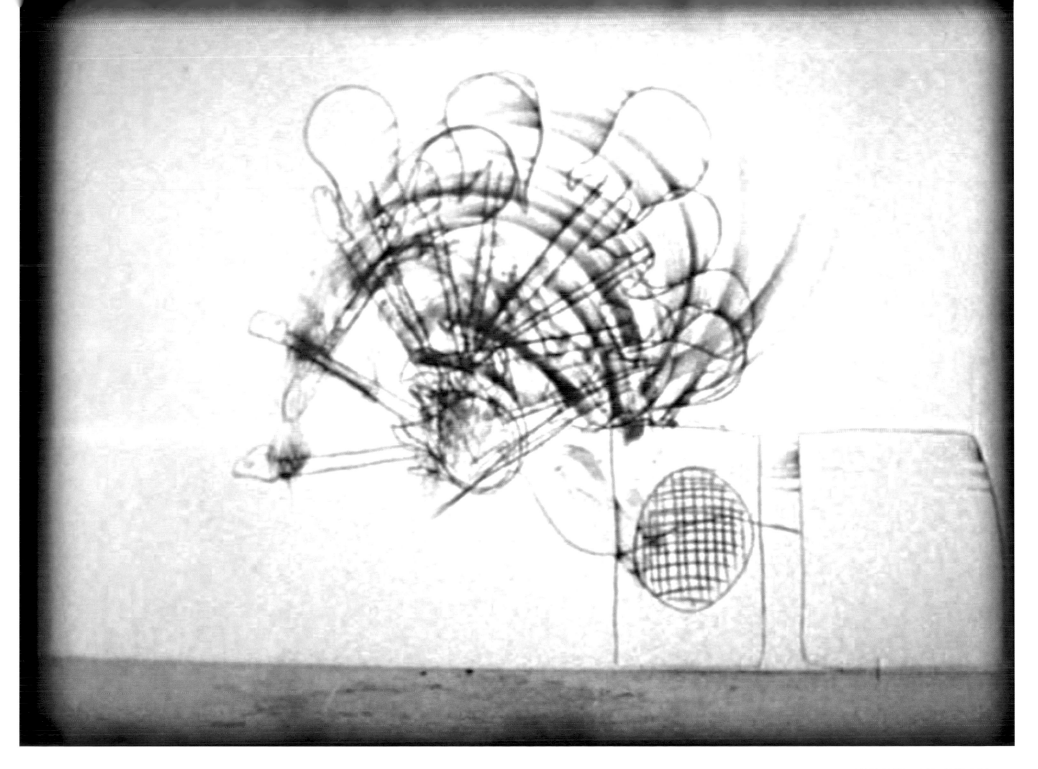

UNTITLED (AIR GUITAR) 2005

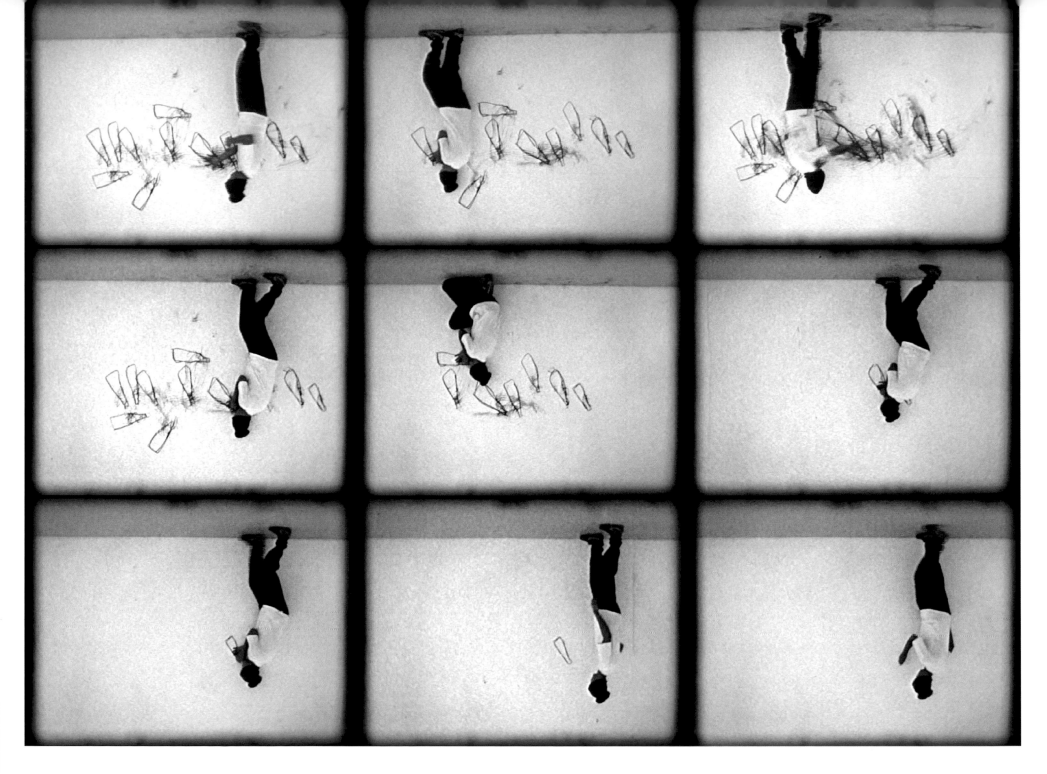

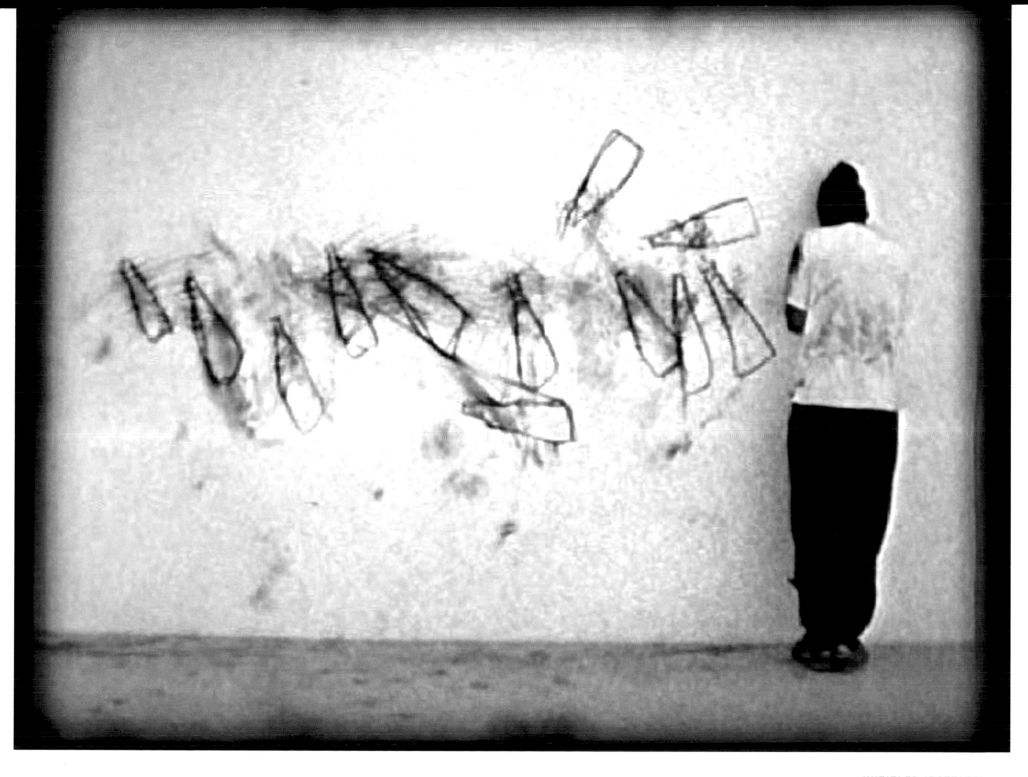

UNTITLED (BOTTLES) 2005

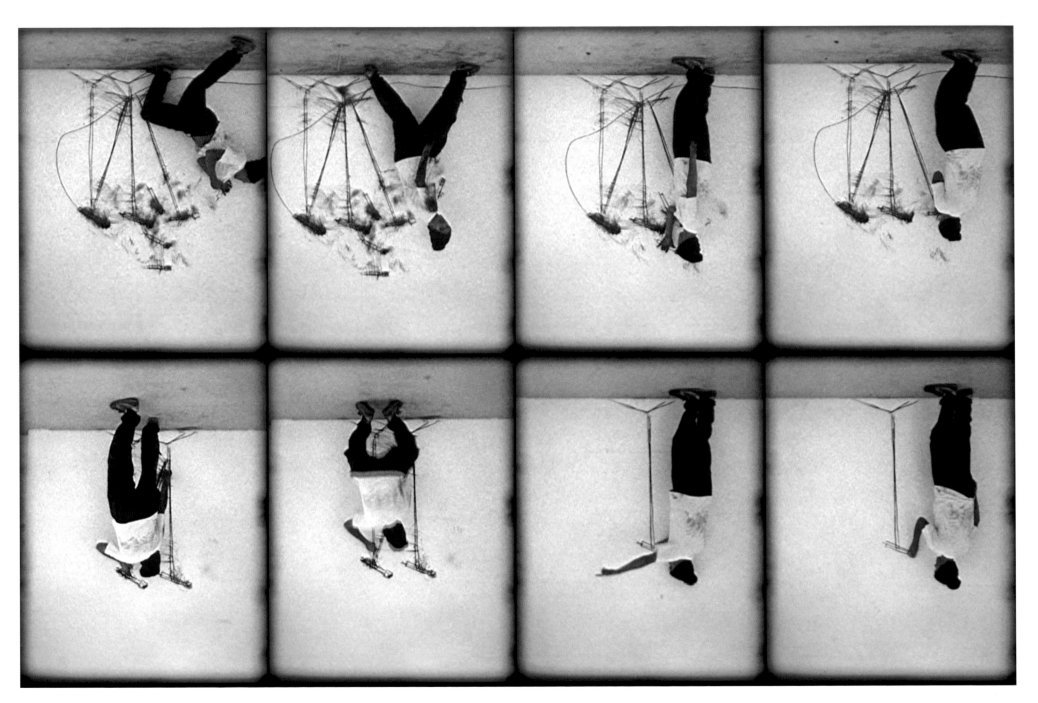

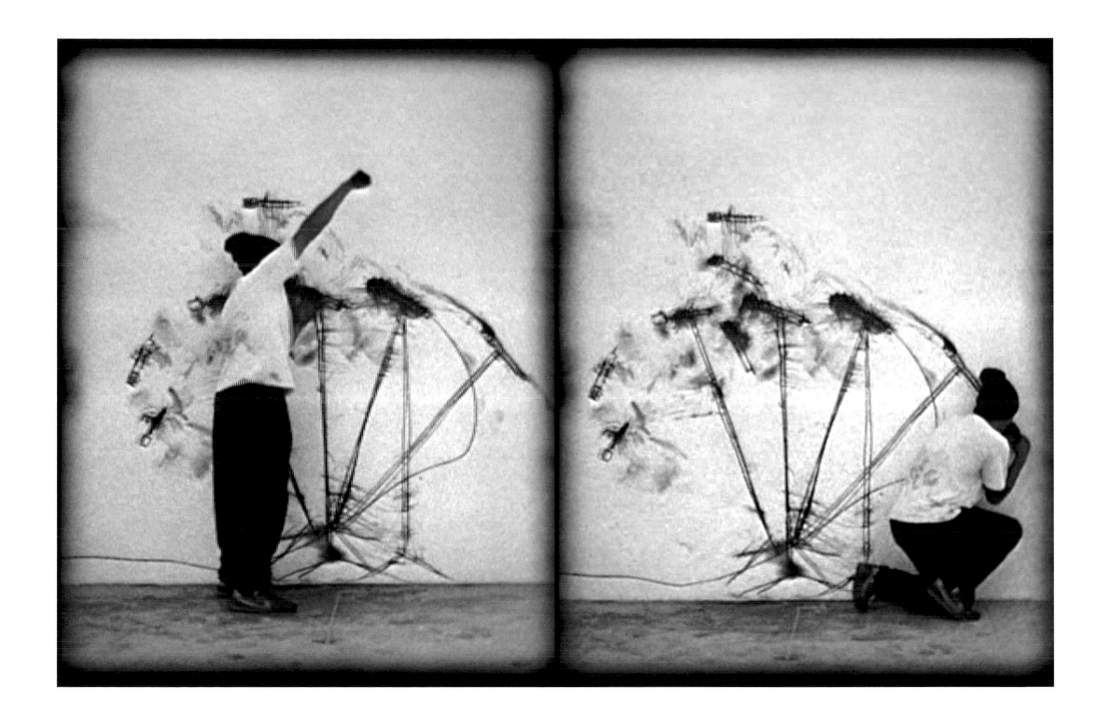

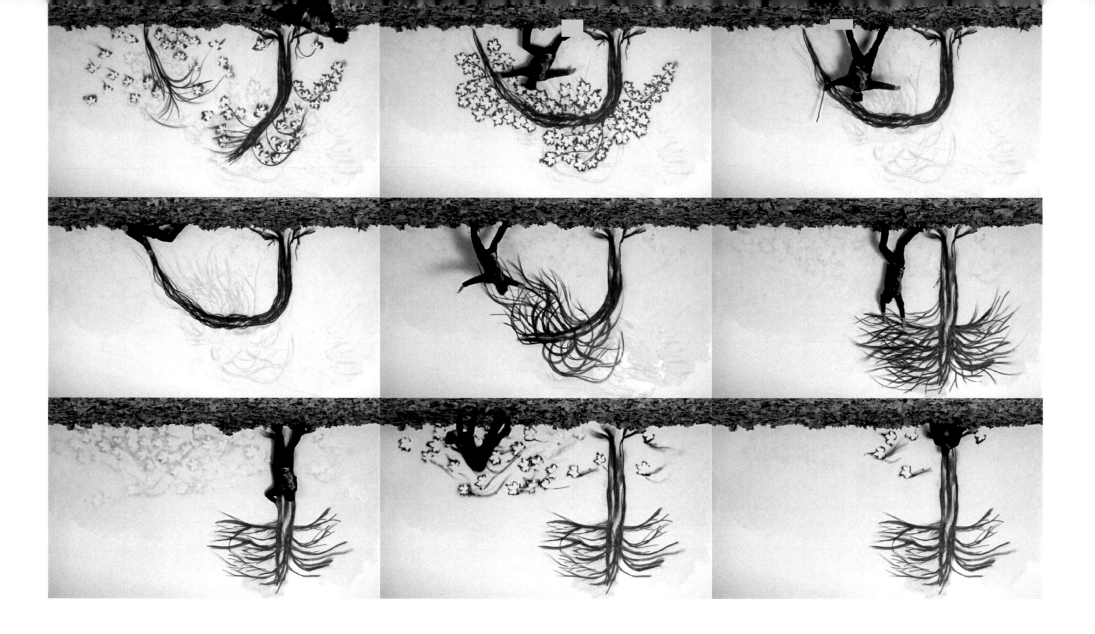

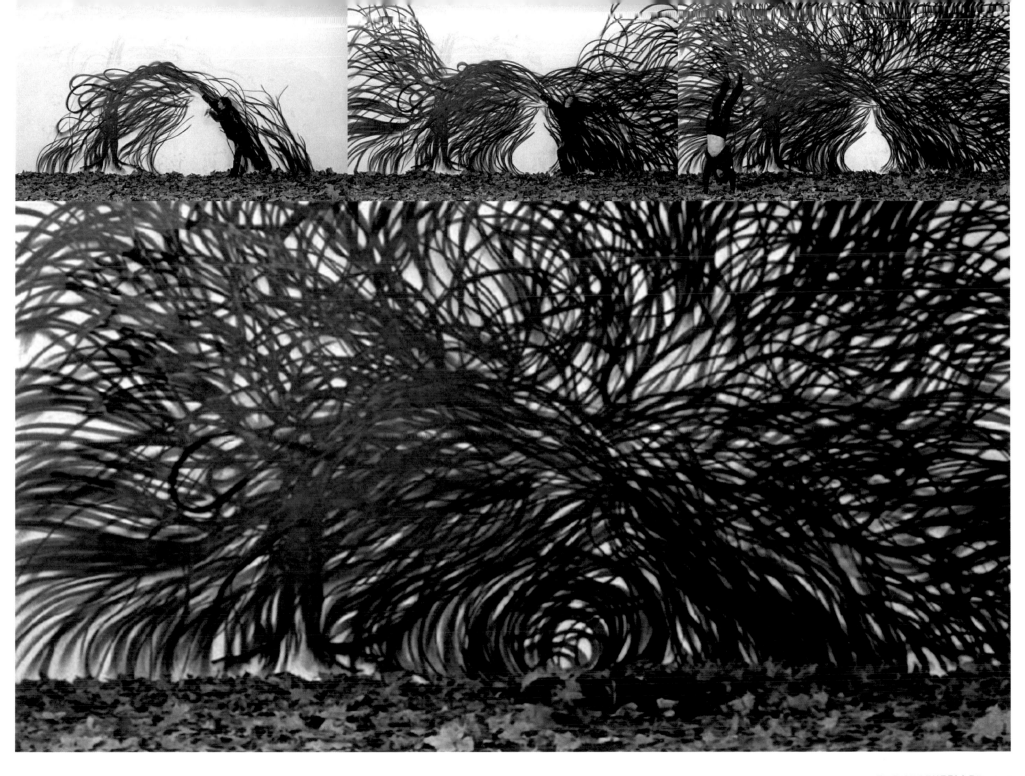

THE STORYTELLER 2006

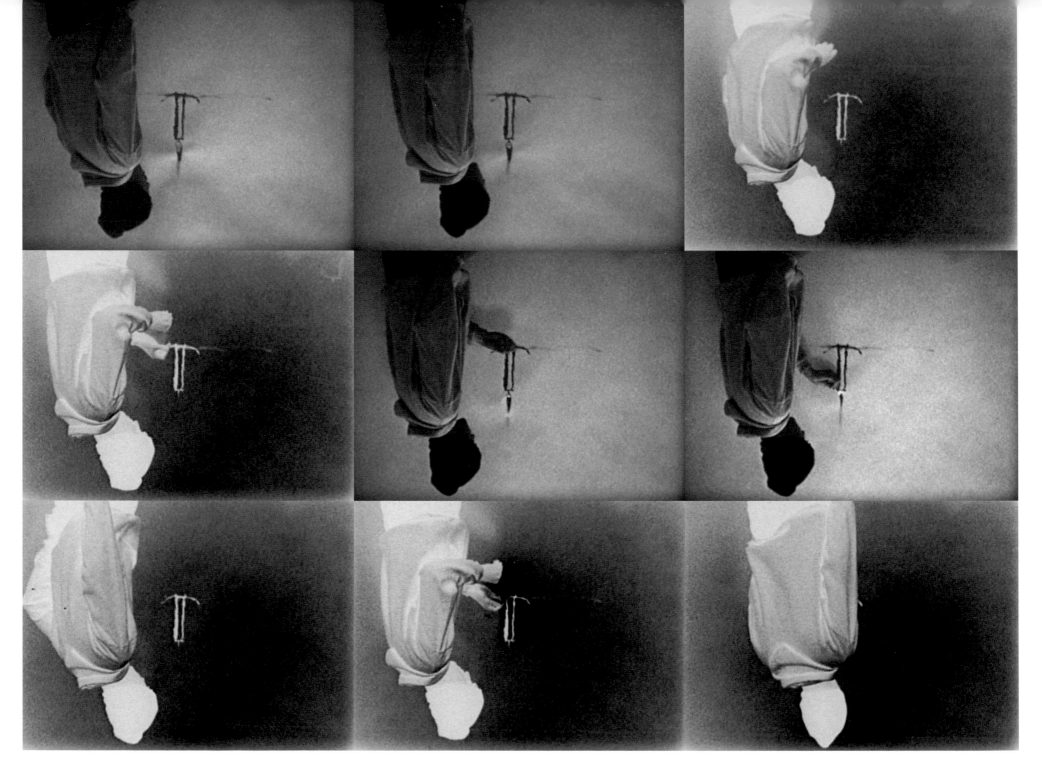

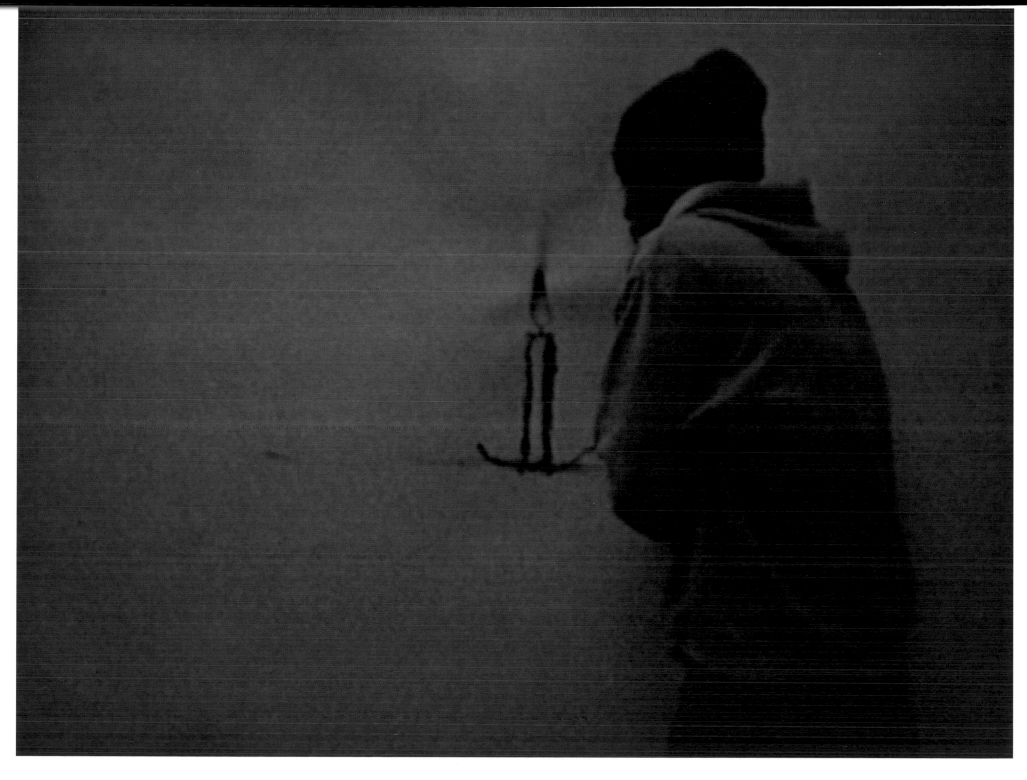

CANDLE 2007

SLIDE SHOWS

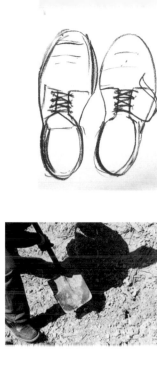
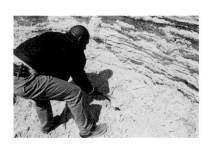
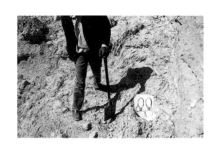
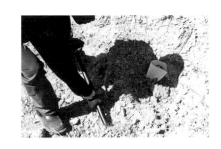
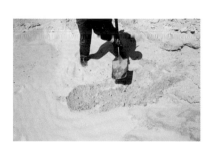

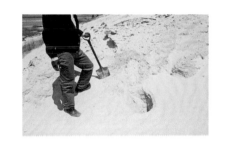
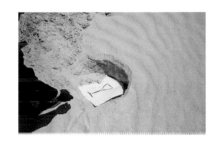

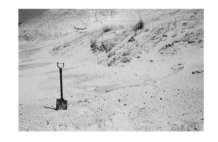
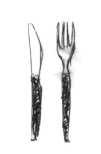

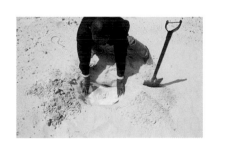

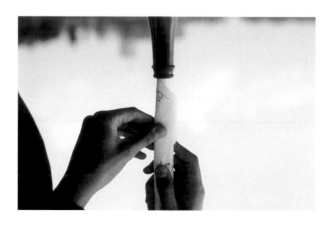

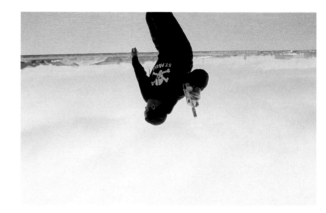

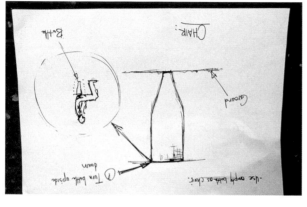
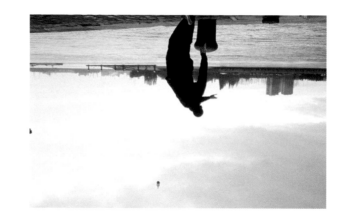

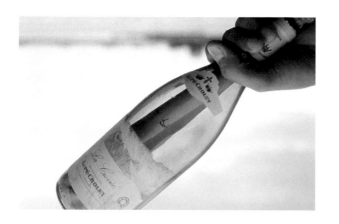
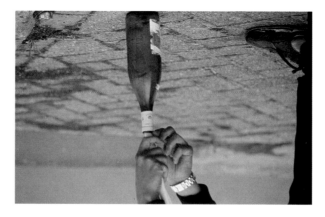

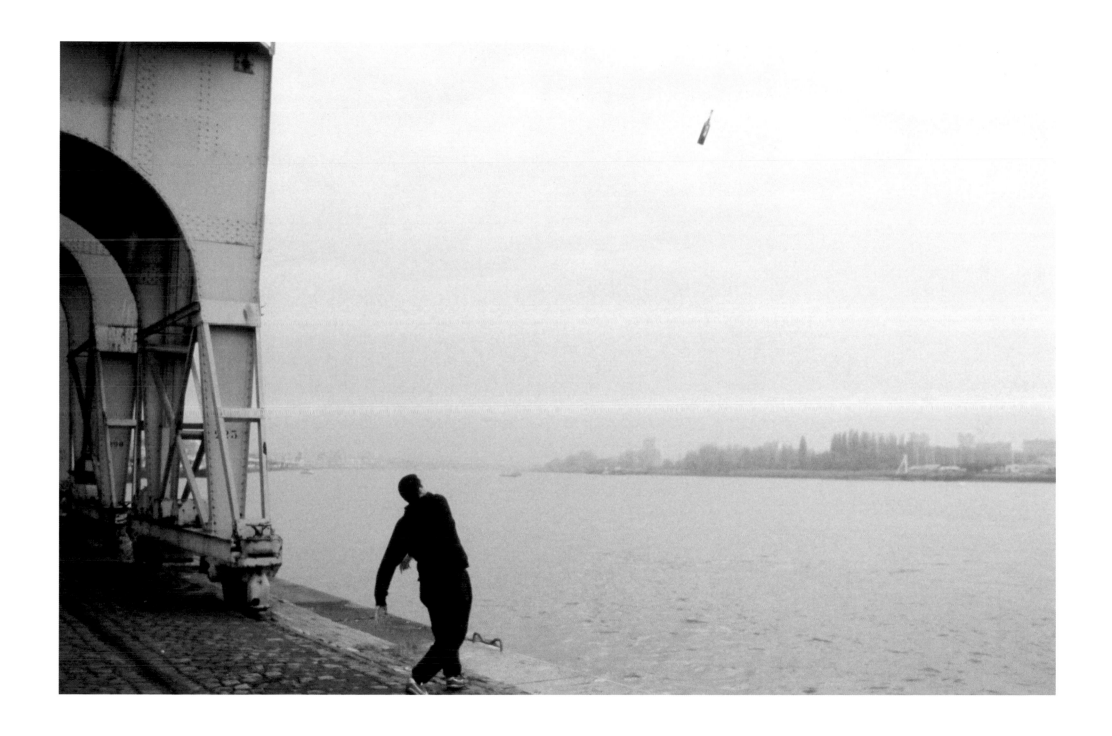

UNTITLED (WINEBOTTLES) 2004

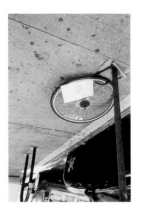
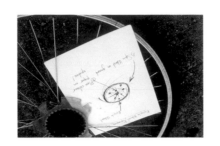

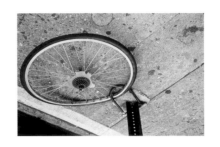

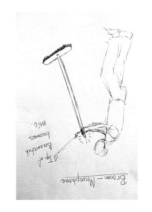

Pylon/Cone — Megaphone.

DRAWINGS

DESERT RABBIT

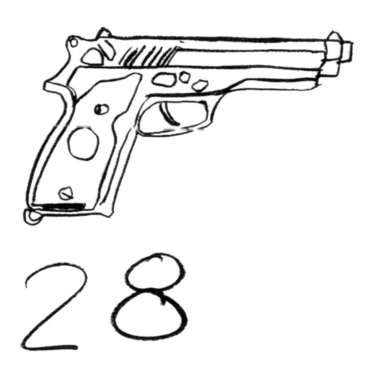

28

THE AMERICAN

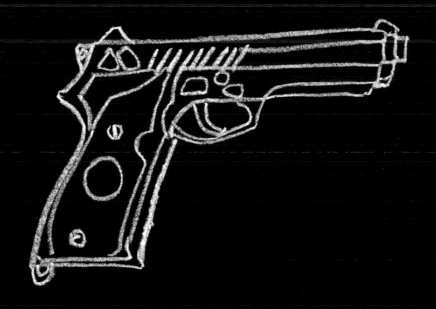

UNTITLED

Junior Funny Kids

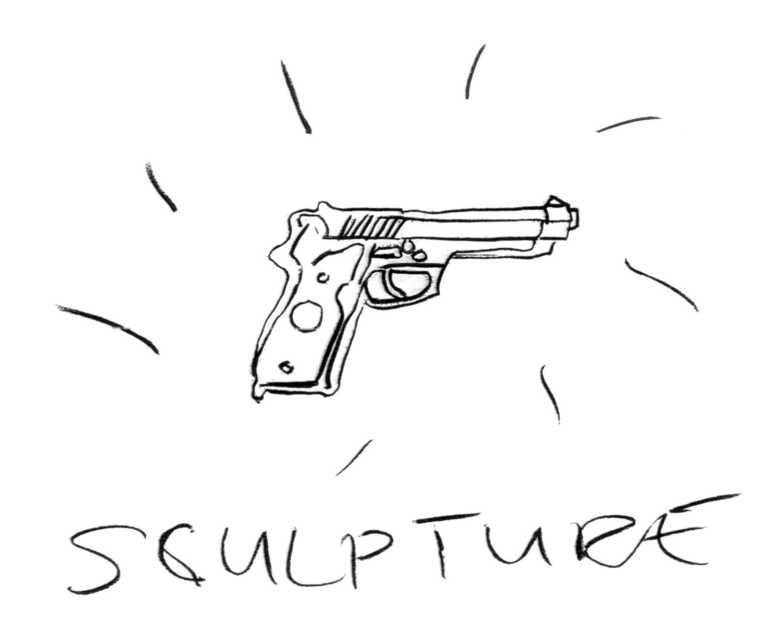

SCULPTURE

F.B.I.'s

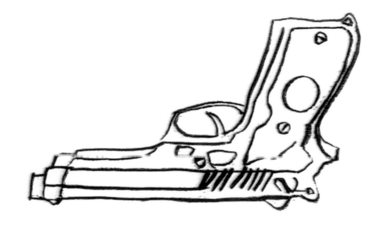

THE HARD LIVINGS

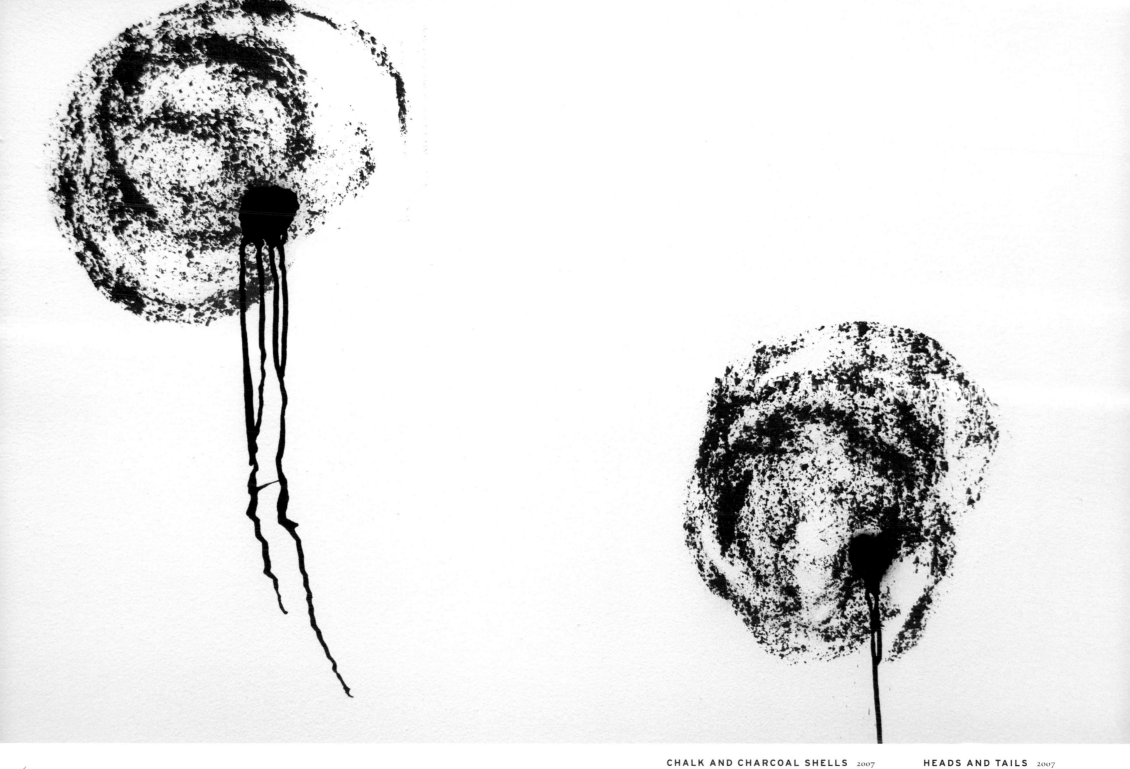

CHALK AND CHARCOAL SHELLS *2007* HEADS AND TAILS *2007*

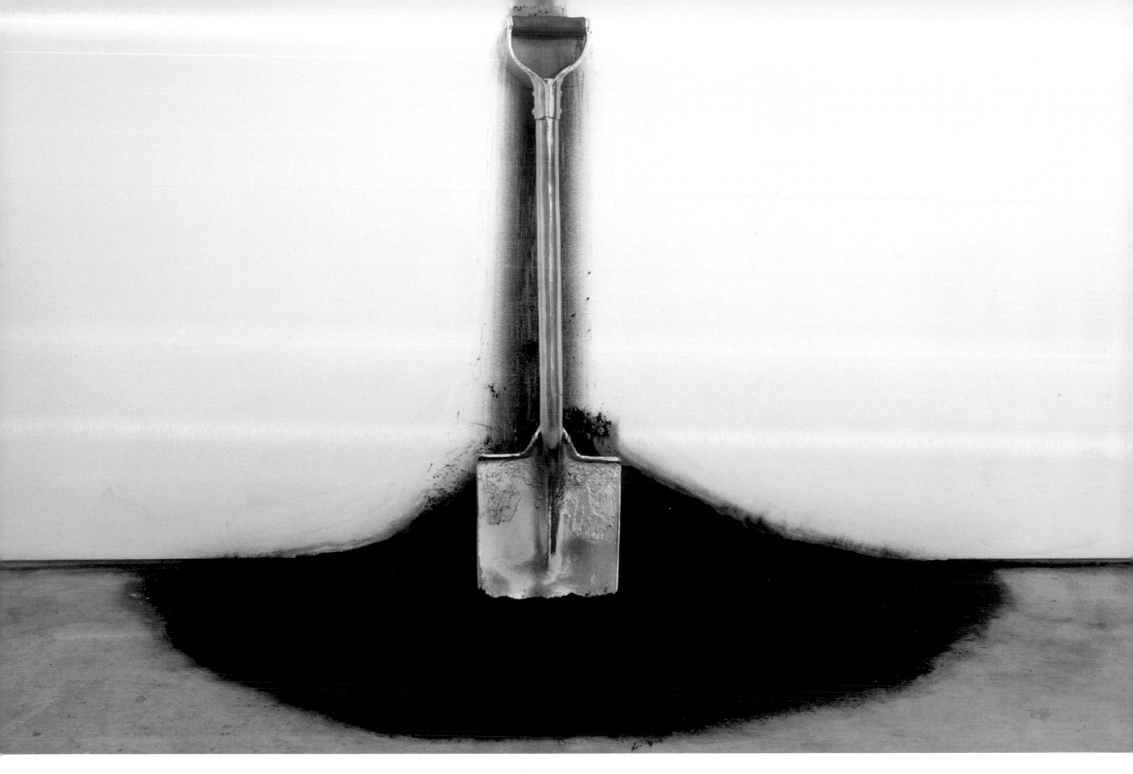

SPADE 2007

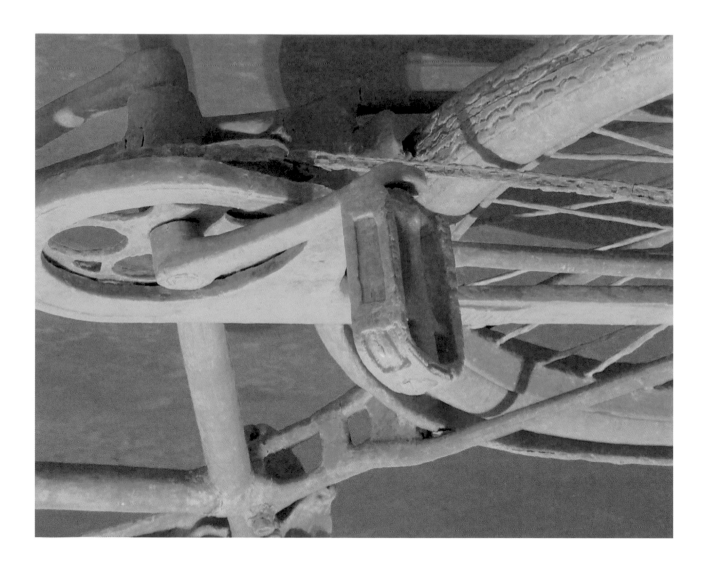

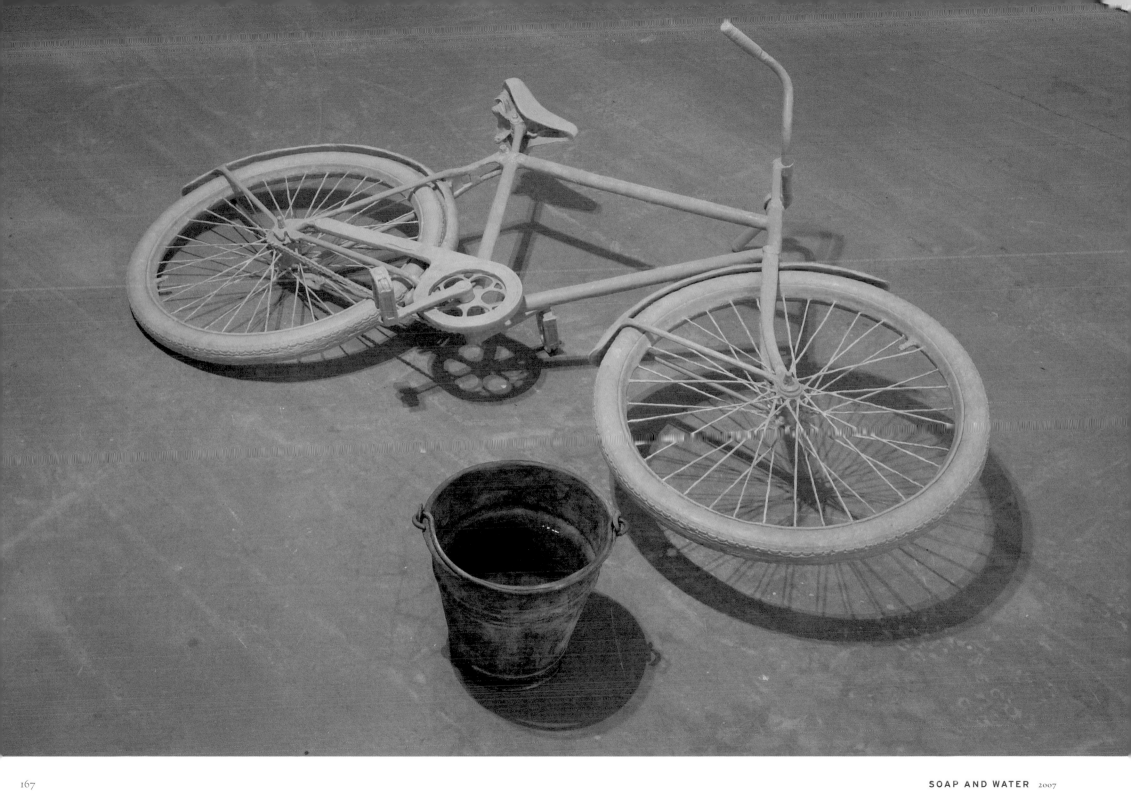

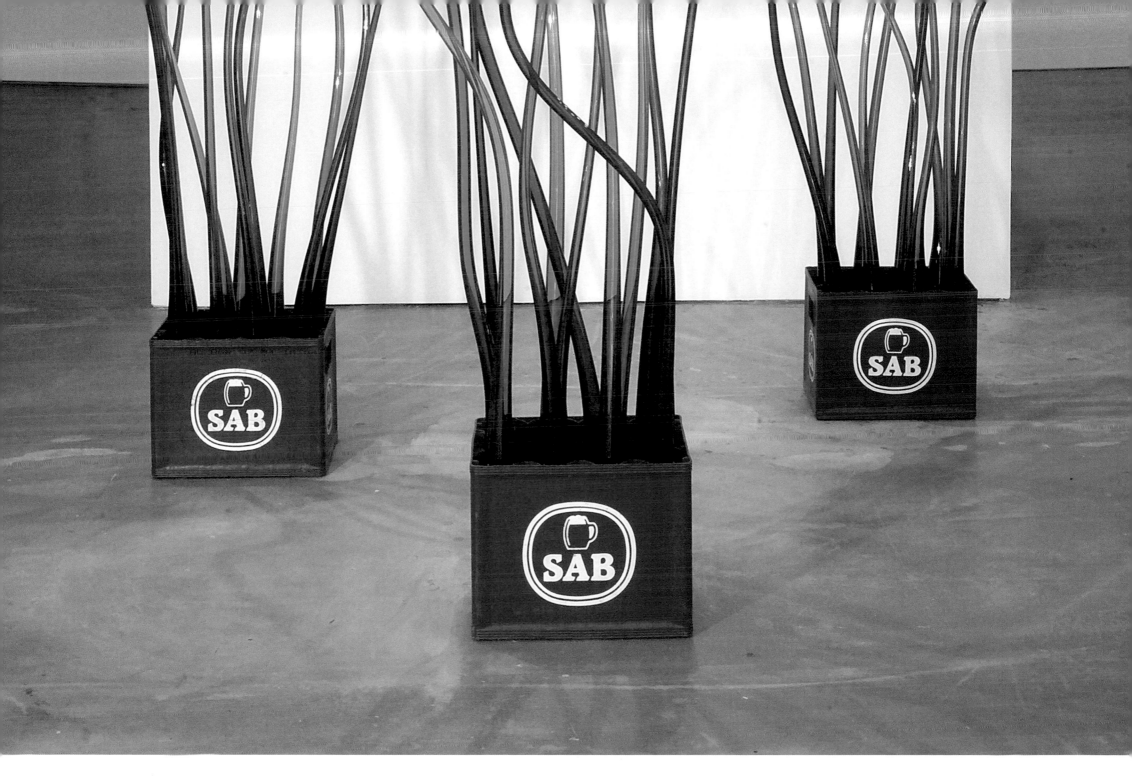

EMPTIES (GREEN) 2007

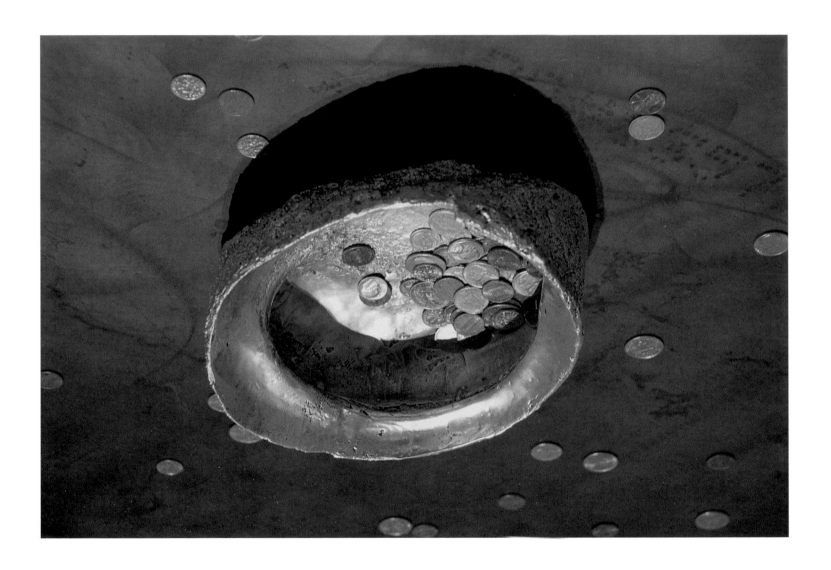

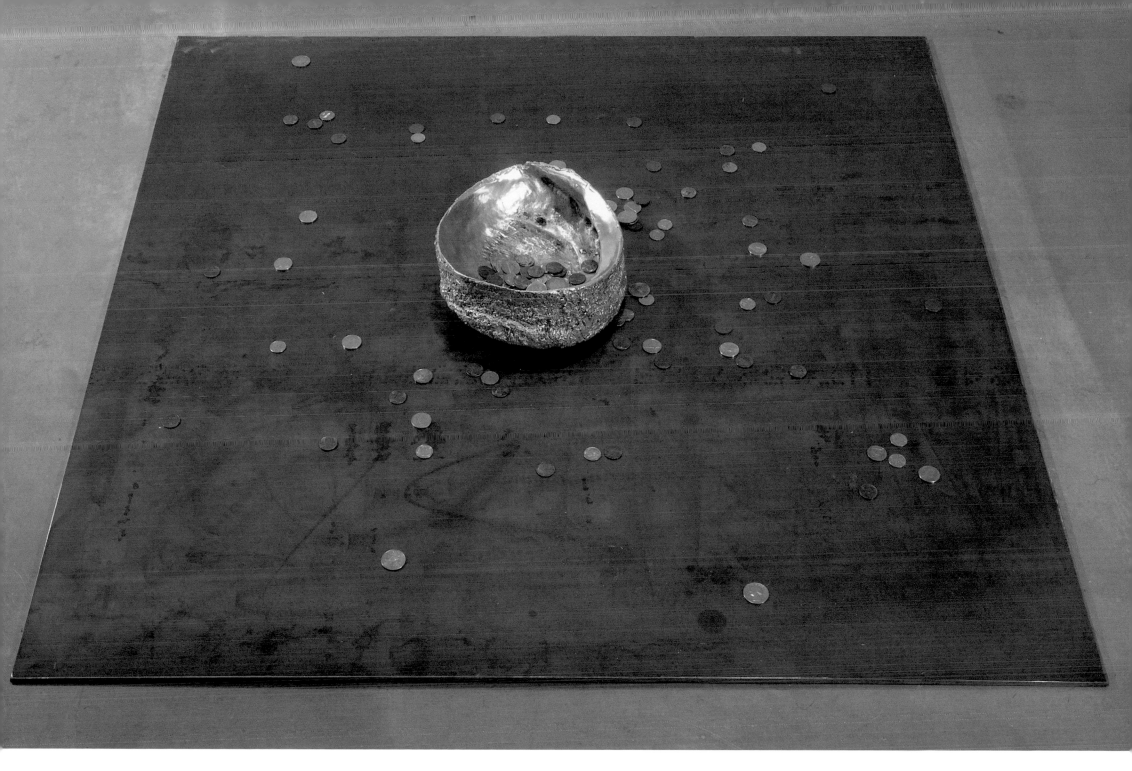

LIST OF WORKS

All works © Robin Rhode
* Works in the exhibition

PHOTOGRAPHIC SERIES

Unless stated otherwise:
Courtesy Perry Rubenstein Gallery, New York

JUGGLA 2007 *
20 digital pigment prints
53.3 × 35.6 cm each
Edition of 5 + 2 a.p.
pp. 88–89 (selection)

WALK THE DAWG 2007
12 C-prints
41.9 × 55.9 cm each
Edition of 5 + 2 a.p.
Courtesy Perry Rubenstein Gallery,
New York and carlier | gebauer, Berlin
Not illustrated

BLACKHEAD 2006 *
16 digital pigment prints
39.4 × 55.9 cm each
Edition of 5 + 2 a.p.
Courtesy Perry Rubenstein Gallery,
New York and carlier | gebauer, Berlin
pp. 78–79 (selection)

TABLE OF CONTENTS 2006
36 digital pigment prints
33 × 50.2 cm each
Edition of 5 + 2 a.p.
pp. 80–81

UNTITLED (RINGS) 2006
28 gelatin silver prints
45 × 30 cm each
Edition of 5 + 1 a.p.
Courtesy Perry Rubenstein Gallery,
New York and Tucci Russo Studio
per l'Arte Contemporanea, Torre Pellice
pp. 82–83 (selection)

UNTITLED (STREET LIGHT) 2006 *
24 gelatin silver prints
45 × 30 cm each
Edition of 5 + 1 a.p.
Courtesy Perry Rubenstein Gallery,
New York and Tucci Russo Studio
per l'Arte Contemporanea, Torre Pellice
pp. 84–85 (selection)

WHEEL OF STEEL 2006 *
9 gelatin silver prints
39.4 × 55.9 cm each
Edition of 5 + 2 a.p.
pp. 86–87 (selection)

UNTITLED (ANCHOR) 2005
9 C-prints
30.5 × 45.7 cm each
Edition of 5 + 1 a.p.
pp. 66–67

UNTITLED (BUCKET) 2005
10 C-prints
30.3 × 45.4 cm each
Edition of 5 + 1 a.p.
Not illustrated

UNTITLED (DREAM HOUSES) 2005
28 C-prints
31 × 46 cm each
Edition of 5 + 1 a.p.
pp. 68–69 (selection)

UNTITLED (HARD RAIN) 2005 *
16 C-prints
45.7 × 30.5 cm each
Edition of 5 + 1 a.p.
pp. 70–71 (selection)

UNTITLED (LANDING) 2005
20 C-prints
30.5 × 45.7 cm each
Edition of 5 + 1 a.p.
pp. 72–73 (selection)

UNTITLED (SCHOOLED CHAIRS) 2005
16 C-prints
30.5 × 45.7 cm each
Edition of 5 + 1 a.p.
pp. 74–75 (selection)

UNTITLED (STICKS) 2005
28 C-prints
30.3 × 45.4 cm each
Edition of 5 + 1 a.p.
Not illustrated

UNTITLED (TEAPOT) 2005
12 C-prints
30.5 × 45.7 cm each
Edition of 5 + 1 a.p.
Not illustrated

UNTITLED (YO YO) 2005
15 C-prints
30.5 × 45.7 cm each
Edition of 5 + 1 a.p.
pp. 76–77 (selection)

AUTOMATIC DROWNING 2004
18 C-prints
29.5 × 44.3 cm each
Edition of 5 + 2 a.p.
Courtesy carlier | gebauer, Berlin
pp. 50–51 (selection)

COLOR CHART 2004–6 *
192 C-prints
24.8 × 30.2 cm each
Edition of 5 + 2 a.p.
Not illustrated

DESCENDING A BRIDGE 2004
2 C-prints
30.5 × 48.9 cm each
Edition of 5 + 1 a.p.
Not illustrated

MASTER BLASTER 2004
6 C-prints
30.5 × 45.4 cm each
Edition of 5 + 1 a.p.
pp. 52–53

NIGHT BOARDING 2004
6 gelatin silver prints
40 x 26.7 cm each
Edition of 5 + 1 a.p.
pp. 54–55

NIGHT CALLER 2004
11 gelatin silver prints
30.5 × 45.7 cm each
Edition of 5 + 1 a.p.
pp. 56–57 (selection)

PULLING THE LOAD 2004
6 C-prints
30.5 × 47 cm each
Edition of 5 + 1 a.p.
pp. 58–59

SNAKE EYES 2004 *
12 gelatin silver prints
26.7 × 40 cm each
Edition of 5 + 1 a.p.
pp. 60–61

STACKED DRAWING 2004
10 gelatin silver prints
26.7 × 40 cm each
Edition of 5 + 1 a.p.
pp. 62–63

STONE FLAG 2004
9 C-prints
30.5 × 45.7 cm each
Edition of 5 + 1 a.p.
pp. 64–65 (selection)

BLACK TIE 2003
8 C-prints
36.8 × 24.1 cm each
Edition of 5 + 2 a.p.
pp. 46–47 (selection)

BOARD 2003
8 C-prints
29.9 × 45.7 cm each
Edition of 5 + 1 a.p.
Not illustrated

CATCH AIR 2003
12 C-prints
26 × 34.3 cm each
Edition of 5 + 1 a.p.
pp. 48–49

BENCH SLIDE 2003
6 C-prints
30.2 × 45.4 cm each
Edition of 5 + 1 a.p.
pp. 44–45

COMPANY BENCH 2002
6 C-prints
30.5 × 48.9 cm each
Edition of 5 + 1 a.p.
Not illustrated

BENCH PRESS 2001
9 C-prints
20 × 27 cm each
Edition of 3 + 2 a.p.
Courtesy carlier | gebauer, Berlin
Not illustrated

MOTORBIKE 2001
28 C-prints
21 × 30.5 cm each
Edition of 3 + 2 a.p.
Courtesy carlier | gebauer, Berlin
Not illustrated

STOOL 2001
6 digital pigment prints
30.5 × 32.5 cm each
Edition of 5 + 2 a.p.
Courtesy Perry Rubenstein Gallery,
New York and carlier | gebauer, Berlin
Not illustrated

THE MATRIKS 2001
12 C-prints
21.9 × 30.5 cm each
Edition of 5 + 1 a.p.
Courtesy Galerie Kamel Mennour, Paris
pp. 42–43

HE GOT GAME 2000
12 C-prints
22.9 × 29.8 cm each
Edition of 5 + 1 a.p.
pp. 40–41

CLASSIC BIKE 1998
12 C-prints
29.8 × 45.7 cm each
Edition of 5 + 1 a.p.
pp. 38–39 (selection)

ANIMATIONS
Unless stated otherwise:
Courtesy Perry Rubenstein Gallery, New York

HARVEST 2005 *
00:03:48
Edition of 5 + 2 a.p.
Courtesy Perry Rubenstein Gallery, New York,
carlier | gebauer, Berlin and Tucci Russo Studio
per l'Arte Contemporanea, Torre Pellice
pp. 106–107 (video stills)

UNTITLED (SPADE FOR SPADE) 2005
00:02:47
Edition of 5 + 2 a.p.
Courtesy Perry Rubenstein Gallery, New York and Tucci
Russo Studio per l'Arte Contemporanea, Torre Pellice
pp. 110–111 (video stills)

COLOR CHART 2004–6
00:04:50
Edition of 5 + 2 a.p.
pp. 108–9 (video stills)

HE GOT GAME 2004
00:01:04
Edition of 5 + 2 a.p.
Not illustrated

STREET GYM 2004
00:00:43
Edition of 5 + 2 a.p.
pp. 102–3 (video stills)

THE SHOWER 2004
00:03:42
Edition of 5 + 2 a.p.
Courtesy Perry Rubenstein Gallery,
New York and carlier | gebauer, Berlin
Not illustrated

THE STRIPPER 2004
00:02:22
Edition of 5 + 2 a.p.
pp. 104–5 (video stills)

HORSE 2002
00:00:53
Edition of 5 + 2 a.p.
pp. 92–93 (video stills)

MARONGRONG 2002
00:01:01
Edition of 5 + 2 a.p.
pp. 94–93 (video stills)

NEW KIDS ON THE BIKE 2002
00:01:21
Edition of 5 + 2 a.p.
pp. 100–101 (video stills)

SEE/SAW 2002
00:00:55
Edition of 5 + 2 a.p.
pp. 96–97 (video stills)

WHITE WALLS 2002
00:00:50
Edition of 5 + 2 a.p.
pp. 98–99 (video stills)

HONDJIE 2001
00:01:20
Edition of 5 + 2 a.p.
Not illustrated

PERFORMANCES

All performances:
Courtesy Perry Rubenstein Gallery, New York

UNTITLED 2007 *
Mori Art Museum, Tokyo
pp. 128–29 (video stills)

UNTITLED (SKIPPING ROPE) 2005 *
Musée d'Art Moderne de la Ville de Paris / ARC, Paris
Not illustrated

UNTITLED (SKIPPING ROPE) 2005 *
The Museum of Modern Art, New York
pp. 126–27 (video stills)

BREAK IN 2004 *
New Museum of Contemporary Art, New York
Not illustrated

NIGHT CALLER 2004 *
Perry Rubenstein Gallery, New York
Not illustrated

PULLING LOADS 2004 *
Museo Tamayo Arte Contemporáneo, Mexico City
Not illustrated

THE SCORE 2004 *
Artists Space, New York
pp. 124–25 (video stills)

UNTITLED (EXIT/ENTRY) 2004 *
Contemporary Arts Museum, Houston
pp. 122–23 (video stills)

CAR THEFT 2003 *
Walker Art Center, Minneapolis
pp. 118–19 (video stills)

CAR WASH 2003 *
Walker Art Center, Minneapolis
pp. 116–17 (video stills)

UNTITLED 2003 *
Fondazione Sandretto Re Rebaudengo, Turin
pp. 120–21 (video stills)

MOTORBIKE 2001 *
Gasworks Gallery, London
pp. 114–15 (video stills)

FILM PROJECTS

Unless stated otherwise:
Courtesy Perry Rubenstein Gallery, New York

CANDLE 2007 *
16-mm film
Black and white
00:02:15
Edition of 5 + 2 a.p.
Courtesy Perry Rubenstein Gallery, New York
and carlier | gebauer, Berlin
pp. 140–41 (film stills)

THE STORYTELLER 2006 *
16-mm film transferred to video
Color
00:13:18
Edition of 3 + 2 a.p.
Courtesy Perry Rubenstein Gallery, New York
and carlier | gebauer, Berlin
pp. 138–39 (film stills)

UNTITLED (AIR GUITAR) 2005
Super 8 film transferred to video
Black and white
00:07:15
Edition of 5 + 2 a.p.
Courtesy Perry Rubenstein Gallery, New York and Tucci
Russo Studio per l'Arte Contemporanea, Torre Pellice
pp. 132–33 (film stills)

UNTITLED (BOTTLES) 2005
Super 8 film transferred to video
Black and white
00:10:09
Edition of 5 + 2 a.p.
Courtesy Perry Rubenstein Gallery, New York and Tucci
Russo Studio per l'Arte Contemporanea, Torre Pellice
pp. 134–35 (film stills)

UNTITLED (MICROPHONE) 2005
Super 8 film transferred to video
Black and white
00:10:23
Edition of 5 + 2 a.p.
Courtesy Perry Rubenstein Gallery, New York and Tucci
Russo Studio per l'Arte Contemporanea, Torre Pellice
pp. 136–37 (film stills)

SPACE DRAWINGS 2004–2005
Video
Black and white
00:12:59
Edition of 5 + 2 a.p.
Not illustrated

SLIDE SHOWS

All slide shows:
Courtesy Perry Rubenstein Gallery, New York
and carlier | gebauer, Berlin

JUNE'S WINDOW 2006 *
160 transparencies (double projection)
Edition of 3 + 2 a.p.
pp. 144–45 (selection)

UNTITLED (BITS AND PIECES) 2004 *
80 transparencies
Edition of 3 + 2 a.p.
pp. 148–49 (selection)

UNTITLED (WINEBOTTLES) 2004 *
80 transparencies
Edition of 3 + 2 a.p.
pp. 146–47 (selection)

DRAWINGS

All drawings:
Courtesy Perry Rubenstein Gallery, New York

8 Drawings from the series **GUN DRAWINGS** 2004
69.9 × 100.3 cm each

28 2004
Charcoal on paper
p. 153

DESERT RABBITS 2004
Charcoal on paper
p. 152

F.B.I.'S 2004
Charcoal on paper
p. 158

JUNKY FUNKY KIDS 2004
Charcoal on paper
p. 156

SCULPTURE 2004
Charcoal on paper
p. 157

THE AMERICANS 2004
Charcoal on paper
p. 154

THE HARD LIVINGS 2004
Charcoal on paper
p. 159

UNTITLED 2004
Chalk on black paper
p. 155

SCULPTURES

Unless stated otherwise:
Courtesy Perry Rubenstein Gallery, New York

CAP N' COINS 2007 *
Silver plated bronze, steel and coins
Dimensions variable
Edition of 3 + 2 a.p.
Courtesy Perry Rubenstein Gallery,
New York and carlier | gebauer, Berlin
pp. 170–71

CHALK AND CHARCOAL SHELLS 2007 *
Chalk and charcoal
17.5 × 15 × 5.5 cm each
Courtesy Perry Rubenstein Gallery,
New York and carlier | gebauer, Berlin
p. 162

EMPTIES (GREEN) 2007 *
Set of 12 hand blown glass bottles with red plastic crate
Crate: 30.5 × 35.6 × 27.9 cm
Tallest bottle: 228.6 × 7.6 × 7.6 cm
Edition of 3 + 2 a.p.
pp. 168–69 (installation view **ROBIN RHODE**,
Perry Rubenstein Gallery, 2007)

HEADS AND TAILS (Detail) 2007
Charcoal and spray paint with charcoal shell
Dimensions variable
p. 163 (installation view **ROBIN RHODE**,
Perry Rubenstein Gallery, 2007)

SOAP AND WATER 2007 *
Soap, steel, bronze, and water
Bicycle: 188 × 114 × 64 cm
Bucket: 30 × 33 × 30 cm
Edition of 3 + 2 a.p.
Courtesy Perry Rubenstein Gallery,
New York and carlier | gebauer, Berlin
pp. 166–67 (installation view **ROBIN RHODE**,
Perry Rubenstein Gallery, 2007)

SPADE 2007 *
Gold plated bronze and charcoal
88 × 21 × 9 cm
Edition of 3 + 2 a.p.
Courtesy Perry Rubenstein Gallery,
New York and carlier | gebauer, Berlin
p. 165 (installation view **ROBIN RHODE**,
Perry Rubenstein Gallery, 2007)

ROBIN RHODE

Born 1976 in Cape Town, South Africa
Lives and works in Berlin, Germany

EDUCATION

2000
South African School of Film, Television and Dramatic Arts, Johannesburg, South Africa

1998
Diploma in Fine Art, Witwatersrand Technikon, Johannesburg, South Africa

SELECTED SOLO EXHIBITIONS

2007
Walk Off, Haus der Kunst, Munich, Germany
Robin Rhode, Perry Rubenstein Gallery, New York, USA

2006
The Storyteller, earlier | gebauer, Berlin, Germany
Robin Rhode, Shiseido Gallery, Tokyo, Japan
Robin Rhode, Le Collège / FRAC Champagne-Ardenne, Reims, France

2005
Street Smart, Rubell Family Collection, Miami, Florida, USA

2004
Robin Rhode, Perry Rubenstein Gallery, New York, USA
The Score, Artists Space, New York, USA (with Felipe Dulzaides)
Busted, New Langton Arts, San Francisco, California.
The Animators, The Rose Art Museum, Brandeis University, Waltham, Massachusetts, USA

2000
Fresh, South African National Gallery, Cape Town, South Africa
Living in Public, Market Theatre Galleries, Johannesburg, South Africa

SELECTED GROUP EXHIBITIONS

2007
Kunstpreis der Böttcherstraße in Bremen 2007, Kunsthalle Bremen, Germany
Street Level: Mark Bradford, William Cordova, and Robin Rhode, Nasher Museum of Art at Duke University, Durham, North Carolina, USA
Cape 07, University of Stellenbosch Gallery, Cape Town, South Africa
Momentary Momentum: Animated Drawings, Parasol Unit Foundation for Contemporary Art, London, UK
All About Laughter: The Role of Humour in Contemporary Art, Mori Art Museum, Tokyo, Japan

2006
Dirty Yoga: 2006 Taipei Biennial, Taipei Fine Arts Museum, Taipei, Taiwan
Venice-Istanbul: Selections from the 51st International Venice Biennale, Istanbul Museum of Modern Art, Istanbul, Turkey
Version Animée: Animation in Contemporary Art, Centre pour l'image contemporaine, Geneva, Switzerland
Street: Behind the Cliché, Witte de With Center for Contemporary Art, Rotterdam, The Netherlands
Out of Time: A Contemporary View, Museum of Modern Art, New York, USA
ars viva 05/06—Identität/Identity, KW Institute for Contemporary Art, Berlin, Germany
Echigo Tsumari Triennale 2006, Echigo-Tsumari, Japan
Human Game: Winners and Losers, Stazione Leopolda, Florence, Italy
Empieza el Juego, La Casa Encendida, Madrid, Spain
The Beautiful Game: Contemporary Art and Fútbol, BICA, Brooklyn Institute of Contemporary Art, New York, USA
Dak'Art, Biennale de l'Art Africain Contemporain, Dakar, Senegal
Collection in Context: Gesture, The Studio Museum in Harlem, New York, USA
Contemporary Masterworks: St. Louis Collects, Contemporary Art Museum St. Louis, St. Louis, Missouri, USA
mima Offsite: Animated Drawing, Middlesbrough Institute for Modern Art, Middlesbrough, UK

2005
Hidden Rhythms, Museum Het Valkhof & Paraplufabriek, Nijmegen, Netherlands
New Photography '05, The Museum of Modern Art, New York, USA
Sounds like Drawing, The Drawing Room, London, UK
Sculpture in a Non-Objective Way (S.N.O.W.), Tucci Russo Studio per l'Arte Contemporanea, Torre Pellice, Italy
ars viva 05/06—Identität/Identity, Kunsthalle Rostock, Germany
Art Circus, Yokohama Triennial, Yokohama Museum of Art, Yokohama, Japan
Irreducible: Contemporary Short Form Video, Miami Art Central, Miami, Florida, USA
The Experience of Art, Italian Pavilion, 51st International Art Exhibition: La Biennale di Venezia, Venice, Italy
I Still Believe in Miracles / Drawing Space (part 1), Musée d'Art Moderne de la Ville de Paris/ARC, Paris, France
Attention à la marche (histoires de gestes), La Galerie, Centre d'art contemporain Noisy-le-Sec, France
Tres Escenarios, Centro Atlántico de Arte Moderno (CAAM), Las Palmas, Gran Canaria, Spain
How Latitudes Become Forms, Museum of Modern Art, Monterrey, Mexico
Upon Further Review, Looking at Sports in Contemporary Art, The Bertha and Karl Leubsdorf Art Gallery at Hunter College, New York, USA

2004
Dedicated to a Proposition, Extra City Center for Contemporary Art, Antwerp, Belgium
How Latitudes Become Forms, Museo Tamayo Arte Contemporáneo, Mexico City, Mexico
Personal Affects: Power and Poetics in Contemporary South African Art, Museum for African Art, Long Island City, New York, and Cathedral of St. John the Divine, New York, USA
Personal Affects: Power & Poetics in Contemporary South African Art, The Contemporary Museum, Honolulu, Hawaii, USA
biennale cuvée, World Selection of Contemporary Art, O.K Center for Contemporary Art, Linz, Austria

Adaptive Behavior, New Museum of Contemporary Art, New York, USA

MINE(D)FIELDS, Kunsthaus Baselland, Muttenz/Basel, Switzerland; Stadtgalerie Bern, Switzerland

How Latitudes Become Forms, Contemporary Arts Museum, Houston, Texas

Tremor—Contemporary South African Art, Palais des Beaux Arts, Charleroi, Belgium

Things You Don't Know 2, Home Gallery, Prague, Czechoslovakia

Schizorama, National Centre for Contemporary Art (NCAA), Moscow, Russia

2003

Making Space, Platform Garanti Contemporary Art Center, Istanbul, Turkey

How Latitudes Become Forms, Fondazione Sandretto Re Rebaudengo, Turin, Italy

Things You Don't Know 2, Galerie K&S, Berlin, Germany

How Latitudes Become Forms, Walker Art Center, Minneapolis, Minnesota, USA

Coexistence: Contemporary Cultural Production in South Africa, The Rose Art Museum, Brandeis University, Boston, Massachusetts, USA

2002

Survivre à l'apartheid. De Drum Magazine à Aujourd'hui, Maison Européenne de la Photographie, and Le Studio—Yvon Lambert, Paris, France

Playtime: Video Art and Identity in South Africa, Museum Africa, Johannesburg, South Africa

Dislocation, Image and Identity in South Africa, Sala Rekalde, Bilbao, Spain

Shelf Life, Spike Island, Bristol, UK

2001

Shelf Life, Gasworks Gallery, London, UK

FNB Vita Art Prize, NSA Gallery, Durban, South Africa

Tour Guides of the Inner City, Market Theatre Galleries, Johannesburg, South Africa

Switch On/Off, Klein Karoo National Arts Festival, Oudtshoorn, South Africa

Light Sculptures, Klein Karoo National Arts Festival, Oudtshoorn, South Africa

Juncture, The Granary, Cape Town, South Africa; Studio Voltaire, London, UK

2000

Pulse: Open Circuit, NSA Gallery, Durban, South Africa

1999

Babel Tower—70 South African Artists, Johannesburg Civic Gallery, Johannesburg, South Africa

Softserve, South African National Gallery, Cape Town, South Africa

Visions of the Future: The World's Largest Canvas, Johannesburg Civic Gallery, Johannesburg, South Africa

Personal Concerns, Market Theatre Galleries, Johannesburg, South Africa

Truth Veils: The Inner City, Market Theatre Galleries, Johannesburg, South Africa

Channel: South African Video Art, Association for Video Art (AVA), Cape Town, South Africa

Unplugged IV, Market Theatre Galleries, Johannesburg, South Africa

1998

Human Rights Day Exhibition, Hillbrow Fort, Johannesburg, South Africa

Technikon Witwatersrand Final Year Exhibition, Market Theatre Galleries, Johannesburg, South Africa

PERFORMANCES

2007

UNTITLED, *All About Laughter: The Role of Humour in Contemporary Art*, Mori Art Museum, Tokyo, Japan

2005

UNTITLED (SKIPPING ROPE), *New Photography '05*, The Museum of Modern Art, New York, USA

UNTITLED (SKIPPING ROPE), *I Still Believe in Miracles / Drawing Space (part 1)*, Musée d'Art Moderne de la Ville de Paris / ARC, Paris, France

2004

PULLING LOADS, *How Latitudes Become Forms*, Museo Tamayo Arte Contemporáneo, Mexico City, Mexico

BREAK IN, *Adaptive Behavior*, New Museum of Contemporary Art, New York, USA

NIGHT CALLER, *Robin Rhode*, Perry Rubenstein Gallery, New York, USA

UNTITLED (EXIT/ENTRY), *How Latitudes Become Forms*, Contemporary Arts Museum, Houston, Texas, USA

THE SCORE, *The Score*, Artists Space, New York, USA

2003

UNTITLED, *How Latitudes Become Forms*, Fondazione Sandretto Re Rebaudengo, Turin, Italy

CAR THEFT, **CAR WASH**, *How Latitudes Become Forms*, Walker Art Center, Minneapolis, Minnesota, USA

2001

MOTORBIKE, *Shelf Life*, Gasworks Gallery, London, UK

2000

LEAK, **UPSIDE DOWN BIKE**, **BENCH**, *Fresh*, South African National Gallery, Cape Town, South Africa

UNTITLED, *Living in Public*, Market Theatre Galleries, Johannesburg, South Africa

AWARDS AND RESIDENCIES

2007

Winner, *illycaffè Prize*, artbrussels 2007, Brussels, Belgium

2006

Winner, *W South Beach Commission*, Art Positions at Art Basel Miami Beach 2006, Miami, Florida, USA

2005

ars viva 05/06—Identität/Identity Award, Kulturkreis der Deutschen Wirtschaft, Berlin, Germany

2003

Artist-in-Residence, Walker Art Center, Minneapolis, Minnesota, USA

Artist-in-Residence, The Rose Art Museum, Brandeis University, Boston, Massachusetts, USA

2001

Artist-in-Residence, Karl Hofer Gesellschaft, Universität der Künste, Berlin, Germany

Artist-in-Residence, Gasworks Gallery, London, UK

2000

Artist-in-Residence, South African National Gallery, Cape Town, South Africa

CATALOGUES & BOOKS

(S) Solo exhibitions
(G) Group exhibitions

2007

All About Laughter: Humor in Contemporary Art. Edited by Mami Kataoka. Exh. cat. Mori Art Museum, Tokyo. (G)

Kunstpreis der Böttcherstraße in Bremen 2007. Edited by Michael Sauer. Exh. cat. Kunsthalle Bremen, Bremen. (G)

Momentary Momentum: Animated Drawing. Edited by Ziba de Weck Ardalan. Exh. cat. Parasol Unit Foundation for Contemporary Art, London. (G)

Street Level: Mark Bradford, William Cordova, and Robin Rhode. Edited by Trevor Schoonmaker. Exh. cat. Nasher Museum of Art at Duke University, Durham, North Carolina. (G)

2006

Animated Drawing. Edited by Judith Winter. Exh. cat. mima:offsite, Middlesbrough Institute for Modern Art, Middlesbrough. (G)

Ashida, Monica. Casa Del Lago Juan José Arreola: Memoria de Exposiciones '06. Mexico City. (G)

Biennale Cuvée: World Selection of Contemporary Art. Edited by Ingrid Fischer-Schreiber. Exh. cat. O.K Center for Contemporary Art, Linz. (G)

Contemporary Masterworks: Saint Louis Collects. Edited by Paul Ha. Exh. cat. Saint Louis Art Museum, St. Louis. (G)

Das Schicksal des Paradieses liegt in seiner Geometrie. Edited by Philippa Walz. Exh. cat. Kunstverein KISS Temporäres Museum, Kunst im Schloss Untergröningen, Abtsgmünd-Untergröningen e.V. (G)

Dirty Yoga: 2006 Taipei Biennial. Edited by S. Yu and F. Chou. Exh. cat. Taipei Fine Arts Museum, Taipei. (G)

Inéditos 2006. Edited by Obra Social Caja Madrid. Exh. cat. La Casa Encendida, Madrid. (G)

Human Game: Winners and Losers. Edited by Francesco Bonami, Maria Luisa Frisa and Stefano Tonchi. Exh. cat. Fondazione Pitti Discovery, Florence. (G)

Robin Rhode. Edited by T. Okamura. Exh. cat. Shiseido Gallery, Tokyo. (S)

Robin Rhode: The Storyteller, une légende d'automne. Edited by G. Menou. Exh. cat. Le Collège FRAC Champagne-Ardenne, Reims, published in the series: Editions Analogues, Semaine 08.06, No. 84, Arles. (S)

Street: Behind the Cliché. Edited by Nicolaus Schafhausen. Exh. cat. Witte de With Center for Contemporary Art, Rotterdam. (G)

2005

ars viva 05/06 – Identität/Identity. Edited by Kulturkreis der deutschen Wirtschaft im BDI e.V. Exh. cat. Kunsthalle Rostock; Extra City – Center for Contemporary Art, Antwerp; and KW Institute for Contemporary Art, Berlin. Frankfurt am Main. (G)

Attention à la marche (histoires de gestes). Edited by Julie Pellegrin. Exh. cat. La Galerie, Centre d'art contemporain Noisy-le-Sec. (G)

Demos, TJ. Vitamin Ph. New York.

Hidden Rhythms. Edited by Hilde De Bruijn. Exh. cat. Museum Het Valkhof & Paraplufabriek, Nijmegen. (G)

Hoffmann, Jens, and Joan Jonas. Art Works: Aktion. Hildesheim.

S.N.O.W.: Sculpture in Non-Objective Way. Edited by hopeful-monster. Exh. cat. Tucci Russo Studio per l'Arte Contemporanea. Torre Pellice. (G)

Tres escenarios. Edited by Elvira Dyangani. Exh. cat. Centro Atlántico de Arte Moderno. Gran Canaria.

Venice-Istanbul: A Selection from the 51st International Venice Biennale. Edited by Cem Ileri. Exh. cat. Istanbul Museum of Modern Art, Istanbul. (G)

2004

Adaptive Behavior. Edited by Yukie Kamiya. Exh. cat. New Museum of Contemporary Art, New York.

Personal Affects: Power and Poetics in Contemporary African Art, 2 vols. Edited by Sophie Perryer. Exh. cat. Museum for African Art, Long Island City, New York. (G)

Tremor. Contemporary South African Art. Edited by Emma Bedford. Exh. cat. Palais des Beaux Arts, Charleroi. Brussels. (G)

2003

How Latitudes Become Forms. Edited by Philippe Vergne. Exh. cat. Walker Art Center, Minneapolis, Minnesota. (G)

Things You Don't Know. Edited by Karel Císar. Exh. cat. K & S Gallery, Berlin. (G)

2001

Fresh. Robin Rhode. Edited by Emma Bedford. Exh. cat. South African National Gallery, Cape Town. (S)

SELECTED ARTICLES

2007

Genocchio, Benjamin. "Robin Rhode." *The New York Times*, June 8, 2007, p. E27.

Williamson, Sue. "Robin Rhode at Perry Rubenstein." *ARTTRHOB*, June 8, 2007, http://www.artthrob.co.za/07jun/reviews/perry.html.

Stringfield, Anne. "Robin Rhode." *The New Yorker*, June 4, 2007, p. 17.

Kino, Carol. "Something There Is That Loves a Wall." *The New York Times*, May 13, 2007, p. AR24.

Amado, Miguel. "Street Level." *Artforum.com*, Critics' Picks, May 2007, http://artforum.com/archive/id=15286 (accessed June 4, 2007).

Quintin, François. "Robin Rhode." *UOVO #13: Spectrum* (April 2007), pp. 114–147.

Birmingham Fujii, Lucy. "Funny and Dark, the Mori Laughs." *The Japan Times*, February 8, 2007, p. 17.

2006

Minaar, Melvyn. "SA Artist's Work a Knock-out at International Miami Fair." *CapeTimes*, December 14, 2006.

Ruiz, Christina. "Punching Well Above His Weight." *The Art Newspaper*, Art Basel/Miami Beach Daily Ed., December 7, 2006, p. ?

Villarreal, Ignacio Jr. "Art Basel Miami Beach—Art Perform." *ArtDaily.org*, November 8, 2006, http://artdaily.com/section/news/index.asp?int_sec=2&int_new=18065&b=robin%2orhode (accessed June 4, 2007).

Tancons, Claire. "One to Watch: Robin Rhode." *ArtKrush*, May 3, 2006, http://beta.artkrush.com/12194 (accessed June 4, 2007).

Auslander, Philip. "Straight Out of Cape Town." *Art Papers*, March/April 2006, pp. 17–19.

Bakhtin, Filipp. "Sport: Street Games." *Esquire Magazine* (Russia), January 2006, p. 234.

2005

Bellini, Andrea. "Robin Rhode: The Dimension of Desire." *Flash Art* 244 (October 2005), pp. 90–93.

Firstenberg, Lauri. "Robin Rhode." *Contemporary* 21, no. 74 (September 2005), pp. 86–89.

O'Toole, Sean. "At the Centre's Edge." *Art South Africa* 1, no. 4 (spring 2005), pp. 24–29.

Glueck, Grace. "The Listings." *The New York Times*, February 11, 2005, p. E28.

Hirsch, Faye. "Subjective State: Recently on View in New York, a Two-Venue Exhibition of Contemporary Art from South Africa Conveyed a Refreshing Cultural Openness 10 Years after the Demise of Apartheid." *Art in America*, February 2005, p. 131.

O'Toole, Sean. "Robin Rhode at Perry Rubenstein." *Art in America*, February 2005, p. 131.

Ratner, Megan. "Robin Rhode." *frieze* 88, January/February 2005, pp. 120–121.

Turner, Jonathan. "Review: Robin Rhode at Perry Rubenstein Gallery." *Artnews*, January 2005, pp. 123–24.

2004

Goldberg, RoseLee. "Robin Rhode: New Museum of Contemporary Art/Perry Rubenstein Gallery/Museum for African Art." *Artforum*, December 2004, pp. 196–197.

Smith, Roberta. "Art in Review." *The New York Times*, October 29, 2004, p. E38.

Farrell, Laurie Ann. "At the Centre's Edge." *Art South Africa*, 4, issue 1 (spring 2005), p. 68.

Mecl, Ivan. "Street Animation." *Umelec*, 2 (summer 2004), pp. 78–79.

2003

Kerkham, Ruth. "Coexistence: Contemporary Cultural Production in South Africa." *NKA Journal*, spring/summer 2003, pp. 92–93.

Tancons, Claire. "Fugitive: Robin Rhode Drawings and Performances." *NKA Journal*, spring/summer 2003, pp. 66–71.

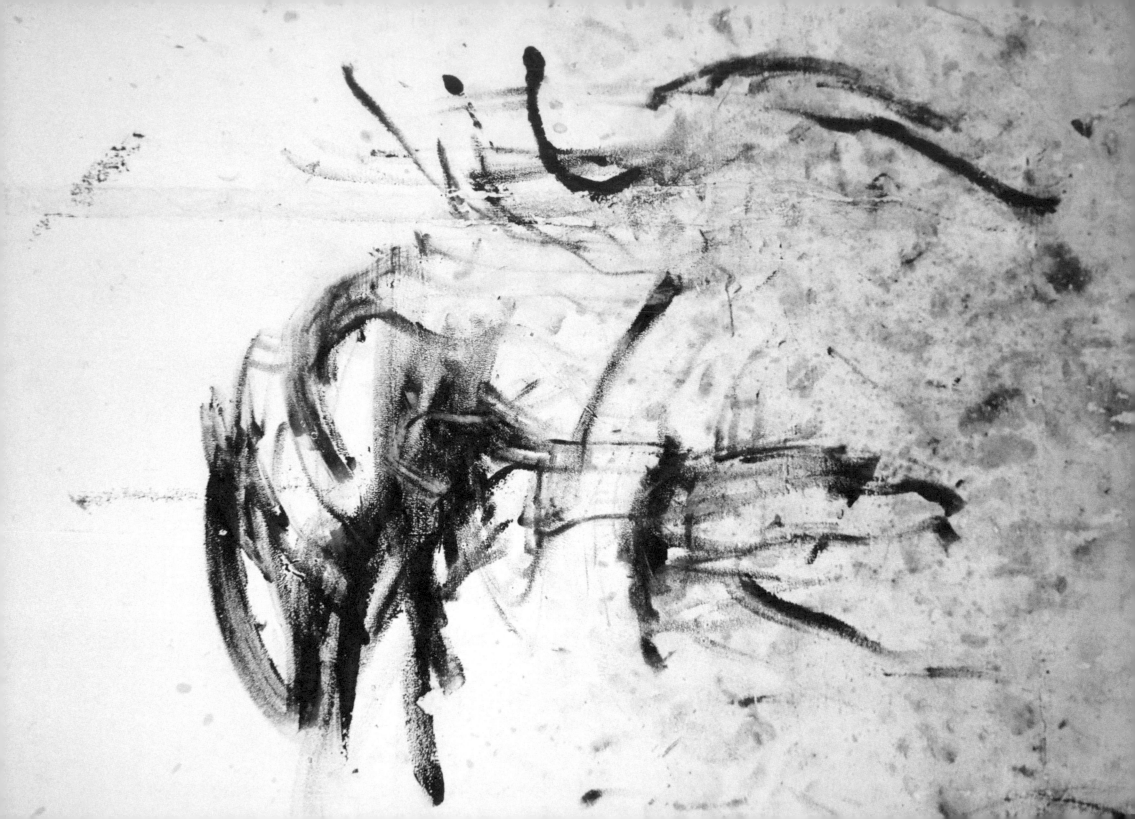

COLOPHON

Edited by Stephanie Rosenthal

EDITING
Patrizia Dander, Stephanie Rosenthal

COPYEDITING
Mary Christian

TRANSLATION
Fiona Elliott

GRAPHIC DESIGN
Stephan Fiedler

REPRODUCTIONS
hausstætter herstellung

TYPEFACE
Century, Interstate

PAPER
Galaxi Supermat, 150 g/m², Alster Werkdruck, 120 g/m²

BINDING
Verlagsbuchbinderei Dieringer, Gerlingen

Printed by Dr. Cantz'sche Druckerei, Ostfildern
© 2007 Hatje Cantz Verlag, Ostfildern
© 2007 for the reproduced works by Robin Rhode:
the artist

Published by
Hatje Cantz Verlag
Zeppelinstrasse 32
73760 Ostfildern
Germany
Tel +49 711 4405-200
Fax +49 711 4405-220
www.hatjecantz.com

A special Collector's Edition is available. Please contact
Hatje Cantz for more information.

This catalogue is published in conjunction
with the exhibition
ROBIN RHODE. WALK OFF
Haus der Kunst, Munich
September 16, 2007–January 6, 2008

DIRECTOR
Chris Dercon

BUSINESS MANAGEMENT
Marco Graf von Matuschka

CURATOR
Stephanie Rosenthal

ASSISTANT
Patrizia Dander

ORGANIZATION
Tina Köhler with Cassandre Schmid

CONSERVATION SUPERVISION
Jesús del Pozo

TECHNICAL SUPERVISION
Anton Köttl with Glenn Rossiter

LIGHTING
Rudolf Ortner with Harald Magiera

CULTURAL PROGRAM
Swantje Grundler

CHILDREN'S PROGRAM
Anne Leopold

PRESS
Elena Heitsch

PR
Anna Schüller

Hatje Cantz books are available internationally
at selected bookstores and from the following
distribution partners:

USA/North America – D.A.P., Distributed
Art Publishers, New York, www.artbook.com
UK – Art Books International, London,
www.art-bks.com
Australia – Tower Books, Frenchs Forest (Sydney),
www.towerbooks.com.au
France – Interart, Paris, www.interart.fr
Belgium – Exhibitions International, Leuven,
www.exhibitionsinternational.be
Switzerland – Scheidegger, Affoltern am Albis,
www.ava.ch

For Asia, Japan, South America, and Africa, as well as
for general questions, please contact Hatje Cantz
directly at sales@hatjecantz.de, or visit our homepage
at www.hatjecantz.com for further information.

ISBN 978-3-7757-2069-4

Printed in Germany

COVER ILLUSTRATIONS
Images from Robin Rhode's photographic series
BLACKHEAD 2006
(see also pp. 78–79)

Photographs on pp. 2–3, 6, 10, 12, 14, 18, 22, 26, 30, 173, 182
are made by Robin Rhode for the layout of this book.

**ROBIN RHODE, HATJE CANTZ VERLAG AND
HAUS DER KUNST WISH TO THANK:**

Thomas Boutoux, Mr. & Mrs. Brignone, Michael Franke,
Serge Hasenboler, Tony Hernandez, Stephen Hobbs,
André Lepecki, Brenton Maart, Nathan Meadows,
David Miller, the staff of Museo Tamayo Arte
Contemporáneo, Mexico City, Paolo Mussat Sartor
(a.k.a. Mr. Mussat), Bildgießerei Hermann Noack,
Sabinah Odumosu, Will Rogan, Ernest Swartz,
Atelier Joost van der Velden, Vladimir Vidakovic,
Barend de Wet, Cameron Wittig, Martin & Danielle
Zimmerman, as well as: Perry Rubenstein Gallery,
New York; cueller | gebauer, Berlin; Tucci Russo Studio
per l'Arte Contemporanea, Turin; Galerie Kamel
Mennour, Paris; the entire Haus der Kunst team
and all those who wish to remain anonymous.